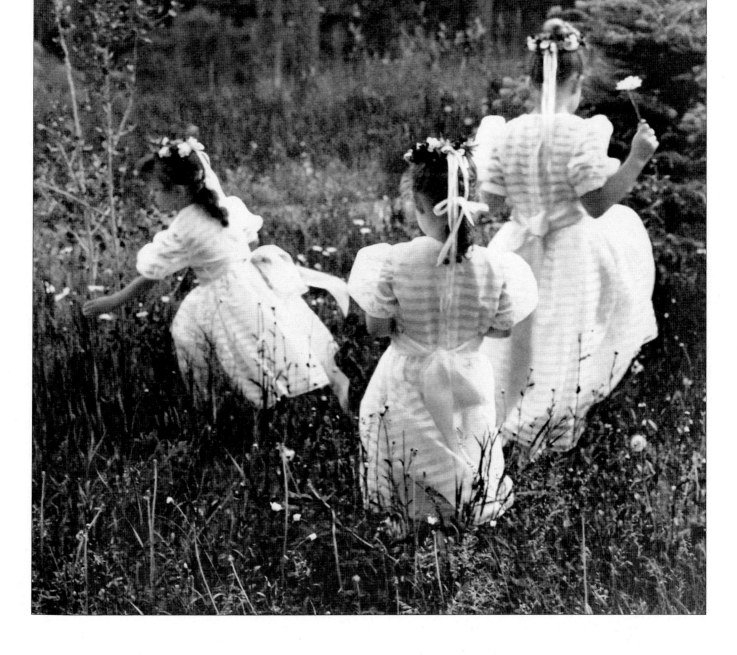

ELEGANT BLACK & WHITE
WEDDING PHOTOGRAPHY

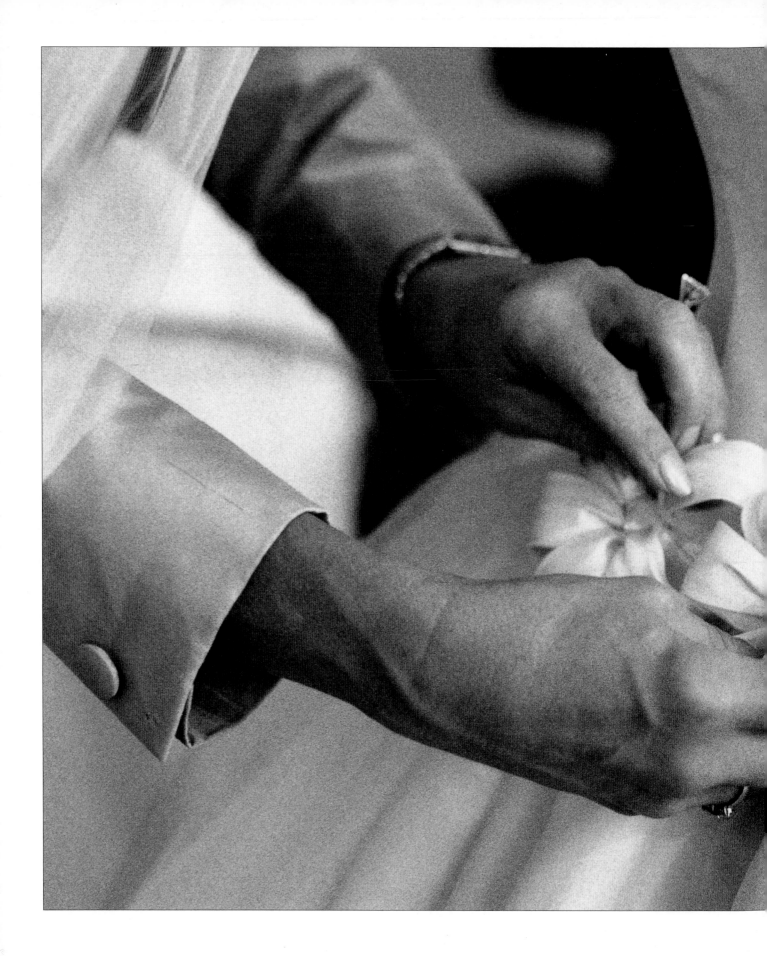

ELEGANT
BLACK & WHITE
WEDDING
PHOTOGRAPHY

SARA A. FRANCES

AMPHOTO BOOKS

An imprint of Watson-Guptill Publications ~ New York

A photographer since 1972, *Sara Frances* is president and chief photographer of The Photo Mirage Inc., located in Colorado and specializing in people photography for both commercial and personal applications. She is recognized for the style of both her commercial and art photography due to her background in the arts and her eclectic approach to technique and alternative photographic media. The winner of Kodak's Impact in Applied Photography award, she has also received a number of Kodak Gallery and Fuji Masterpiece trophies and recently won a millennium competition from Popular Photography. Art Leather, The Pro Lab, Hasselblad USA, Polaroid, Mamiya, SpotPen, Eastman Kodak, and Fuji are among her sponsors, and she is a Polaroid Creative Uses Consultant. She taught at the University of Colorado and presently gives approximately thirty seminars and workshops annually on subjects ranging from commercial portrait photography, handcoloring and print enhancement, and photojournalism to black-and-white wedding photography.

Senior Editor: Victoria Craven • Project Editor: Alisa Palazzo
Designer: Leah Lococo • Production Manager: Hector Campbell

Copyright © 2003 Sara A. Frances

The images in this book were printed by The New Lab Ltd. (833 Santa Fe Drive, Denver, CO 80204; 303-825-1700). Sponsors were Hasselblad USA and Art Leather Manufacturing Company.

First published in 2003 by Amphoto Books, an imprint of Watson-Guptill Publications, a division of VNU Business Media, Inc., 770 Broadway, New York, NY 10003
www.watsonguptill.com

Library of Congress Cataloging-in-Publication Data
Frances, Sara A.
 Elegant black-and-white wedding photography / Sara A. Frances.
 p. cm.
 ISBN 0-8174-3820-3
 1. Wedding photography. I. Title.
 TR819 .F75 2003
 778.9'93925—dc21
 2002011918

Manufactured in Italy

1 2 3 4 5 6 7 8 9 / 11 10 09 08 07 06 05 04 03

CONTENTS

Foreword

Here is an excellent book on wedding photography by the personable Sara Frances that is scholarly written, comprehensive, and timely. Undoubtedly, it is an apodictic how-to-do-it treatise on black-and-white photography of the nuptial celebration. However, it is much more than that, as Sara Frances presents an encyclopedic discourse on almost every aspect of the craft—including technique, philosophy, and practice—addressing the myriad complexities of the medium in a precise, concise, and well-organized and well-articulated manner.

It is a book that should not be flipped through just to look at the illustrations, but should be read and reread assiduously as one would James Beard's or Julia Child's classic cookbooks (that is, if one were interested in excelling at the art of cooking). In fact, Sara Frances' book has the potential to become *the* authoritative reference manual on wedding photography for anyone interested in the craft.

Weddings galore! More and more weddings today than ever before! In recent years, despite the high divorce rate and relaxed family values in America, the vogue of the wedding has grown historically popular. Aggressive commercialism has created a booming wedding business, of which photography is a vital part. The wedding photographer of the late twentieth century is often the most valuable person at the wedding. No one beside the competent photographer is witness to all the memorable, personally historic moments of the ceremony and celebration. The photographer must be a master technician, psychologist, poet, director, and visual artist all in one.

To be sure, Sara Frances is a consummate artist. In all of her professional work, as well as her personal photographic endeavors, she strives always for aesthetic and creative excellence. This means not only taking extra time and effort, but always being mindful that the viewer or client is the final arbiter. The salient precept of creating art is artistic intent and attitude. Sara, with her endearing enthusiasm, stresses these qualities of artistic attitude throughout her book with clarity and conviction. Almost every aspect of style, technique, procedure, and practice relating to wedding photography is examined here. Wouldn't it be wonderful to make it required reading for anyone involved in the business of wedding photography!

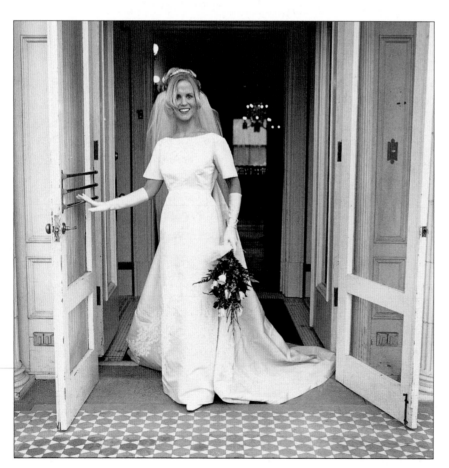

HAL D. GOULD
Master Photographer
Director, Camera Obscura Gallery

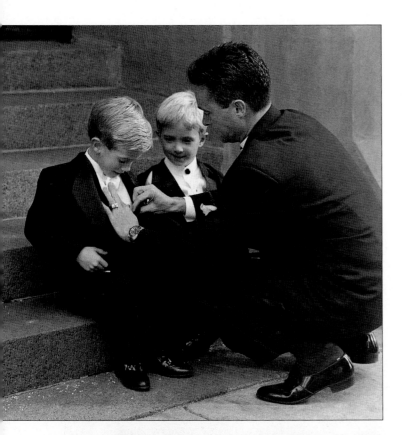

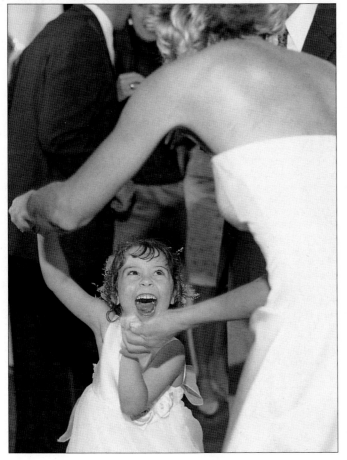

Introduction

Most photographers would say from experience that the expression and emotion in a photograph close a sale more quickly than the visual values of proper focus, exposure, and composition.

High fashion magazines drive the desire for black and white in contemporary style, as do advertisements and movies. Clients relish the cachet of something that seems to be more handmade and with the elegance of the past, even though photographs are produced with modern equipment. They see black-and-white photography as simpler and plainer, definitely a reaction to the frou frou dress-up scenario of make-believe prince-and-princess weddings. Clients also like to be thought of as gallery patrons commissioning art. In addition, market analysis shows that many clients can remember archival concerns from the sixties and seventies when color faded badly. Kodak surveys from 2000 indicate that now 40 to 50 percent of American brides have at least some black-and-white photos. Nevertheless, only a small number of couples, perhaps 2 percent, choose black and white exclusively.

Consumer acceptance of black-and-white photography is growing, in spite of the cyclical nature of fashion. On the scale of impact, color is real and evokes an immediate, in-your-face reaction. Black and white, on the other side, is interpretive, and the viewer's involvement with an image must grow over a longer term. How, then, can the quiet, interpretive imagery of black and white ever equal the overwhelming immediacy of color? A recognizable style will begin to tip the balance of impact in favor of black and white. Style starts with precise exposure, creative lensing, calculated use of depth of field, selective focus, full focus, and motion—captured both sharp and blurred. In-camera composition with creative angles, as well as exceptional image-cropping, are a must. Sequences of action that record genuine emotion will accelerate visual excitement. And, the final presentation must be a design masterpiece, as eloquent as a poem.

The bride's youngest dance partners (left) often afford good candid material. Captured from a child's perspective, this photograph shows the flower girl's enthusiastic energy beautifully framed by the bride's arms. The top image shows a personal moment as an attentive father helps two young pages with their tuxedos.

Black-and-white wedding photography will help you create a lucrative niche market that can both insulate your business from inevitable changes in the portrait marketplace and replace lost revenues from dwindling commercial contracts. This book will help you work toward an individual style and client-buying experience that are not only your privilege to develop but also your responsibility, if you wish to be worthy of the title and pay scale of a photographic artist. Don't try to compete in a saturated market where a homogeneous, low-priced, repetitious product is the norm! Brides and grooms who follow current fashion trends are not just admiring the unusual but putting down good money for it.

Black and white photographs may at first seem plain or overly simple. The dimension of color, which in and of itself brings so much intrinsic interest to an image, often masks a multitude of technical faults. Black-and-white images, however, cannot survive such imperfections; to succeed they must be doubly precise in concept and execution. Good composition will come of its own accord when technical faults are corrected and extraneous elements eliminated.

The artistic business of black-and-white wedding photography is full of contrasts and comparisons. As much as color and black-and-white wedding albums may seem, on the surface, to depict similar scenes, they can be miles apart in artistic style.

Approached as a minimalist art form, black-and-white wedding photography produces a mighty emotional impact, unmatched by the "mere" reality of color.

They are really two different mediums, yet fine photographic craft and personal memories form the basis for both. Black-and-white albums should be viewed as a very different facet of the same product.

Black and white forces the photographer to make not only a larger number of choices, but also more critical ones—in all areas of planning and previsualization, in equipment, in materials, and in the actual photography. There's a place both for dramatic, glamorous posing and for capturing the decisive moment on the

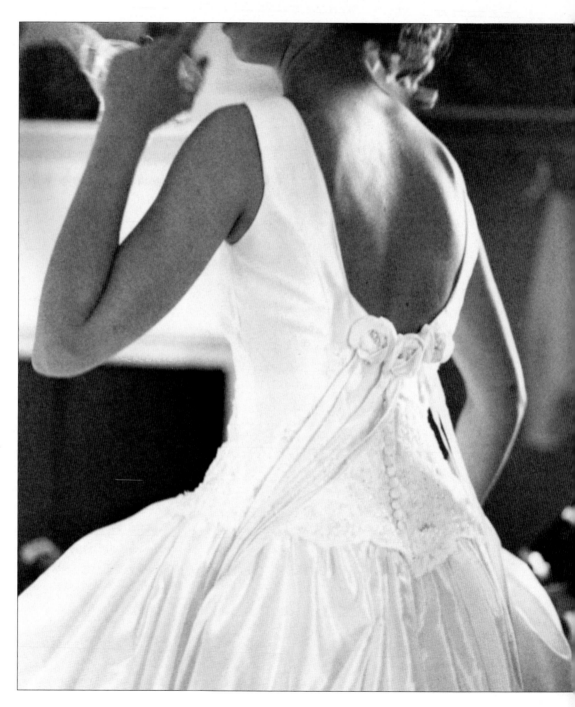

PROS AND CONS OF BLACK AND WHITE

THE PROS

Design elegance results in lasting beauty; this is your chance to make art for profit.

Black and white is distinctive, memorable, responsive, and artistic.

It's niche marketing made easy.

Everything can be hand produced, without mechanization, but you or an employee must be a really good printer.

Technical skills will improve dramatically through working in black and white and personally making the prints.

You don't have to work in black and white all the time to benefit from it. Many clients book because they see what the photographer *can* do and then choose a more conventional style for themselves.

Proficiency in black and white allows you to charge more and work less!

THE CONS

Black and white is a highly customized, technique-driven medium.

When requesting both color and black and white, clients most often can't give very good clues about what part will be black and white.

If all images have been proofed in color, a client will need a lot more coaching to select ones to print in black and white later. Use computerized presentations to instantly display color as black and white or sepia.

It's exceptionally difficult to photograph successfully in both mediums at one time.

Just as photography, in general, often shows poorly in exhibition with other art mediums, it's hard to design a wedding album that does justice to black and white and color simultaneously.

Black-and-white samples must be shown both by themselves and in combination with color.

Clients buy for a wide variety of individual reasons and incentives—and many do want art; they're not sure why, and they often become confused when seemingly high "art pricing" is quoted for what they still think of as "just photos."

Most clients don't know how to use art at all, much less photographic art, and must be instructed in the appropriate minimalist presentation, as well as in storybook sequencing.

Much more customer service time is required in order to reap the higher dollar returns fine-art photography will eventually bring.

fly. A photographic artist develops the elements of personal style by bringing practiced knowledge of skills to bear on instinct, experience, and commitment. This is good advice for both black-and-white and color wedding photography.

With black and white, there are also more postproduction and presentation choices—the job phase during which a large percentage of studios pay little attention to available options. Every bit of design and technique a photographer can muster in black and white is needed just to equal the immediacy of color. To outweigh the effect of color requires consummate artistic intuition.

In addition, when you're commissioned to photograph staged events, you need special inspiration to move past superficial picture-taking into memorable image-making. A wedding isn't a Broadway musical repeated night after night by professionals with such charisma and emotion that they consistently convey that emotion and action to the guests. The freshness of a wedding script comes from the wonderful variety of people, customs, places, and serendipitous occurrences brought on by the very fact that all the "actors" are amateurs. The successful wedding photographer intuits when to direct the event and when to let the "actors" improvise. Learn when it's appropriate to arrange the dress, straighten ties, and comb stray curls—and when to leave them alone.

The purpose of this book is threefold: to help you deflect the immediate appeal of color, to sharpen your skills as a photographic artist, and to create a lucrative niche market. The skills you'll gain here are not an end in and of themselves. But, they *are* the essential tools you'll need to work hard, fast, and spontaneously every time you go out on a job.

WHAT MAKES BLACK AND WHITE DIFFERENT

Just how does black-and-white photography differ from color in the wedding application? The following makes it easy to compare and contrast these two mediums.

COLOR	BLACK AND WHITE
APPEARANCES	**APPEARANCES**
Immediate impact, intrinsic interest	Deceptively simple at first glance
Color masks technical faults	Black and white reveals imperfections
Heavy saturation is luscious and luxurious	Accuracy of exposure/printing nets a long range of spectacular gray tones
Ubiquitous, more superficial	Unusual, due to fascinating crispness, depth, and physical detail
Difficult to hold both ends of light/dark scale	Can show a longer scale of contrast
Feeling of projection; image advances	Feeling of recession; must look into photo
COMPOSITION	**COMPOSITION**
Important. Clutter can be cropped, darkened, minimized; empty space eliminated	Critical. Best to show no clutter at all; empty space used to style advantage
POSING	**POSING**
Usually more balanced, centered; more traditional "still" feel; any competent posing looks good	Design elements often fall at edges of image; posing incorporates blurring, movement, tilts, backs of subjects; inept arrangement looks awkward or ridiculous; either extreme of detail—posed perfection or very casual—is good
LIGHTING	**LIGHTING**
Flash shadows regrettable; dimensionality very necessary	Shadows are looming black holes, dead/ugly space; flat light
CHALLENGING LOCATIONS	**CHALLENGING LOCATIONS**
Ugly colors and architecture detract heavily	Color and architectural problems are neutralized
Perfect settings—flower gardens, mountain scenes, even amusement parks—look lush and full of nature	Beautiful locations lose some natural beauty, which must be made up for in detail, print tone, and composition
FILM	**FILM**
ISO 160 to 400 good selection of very similar films, more and less contrast, and color rendition	ISO 100 or 400 regular or T-Grain/Delta, either manipulatable contrast, or more uniform under variable conditions
ISO 1000 very good low light films; Kodak PMZ can be pushed to ISO 2000	Excellent ISO 3200 (Kodak and Ilford) makes flashless photography possible in "available darkness"
In mixed or low lighting: color as well as contrast and exposure problems	In mixed or low lighting: exposure problem only
	TCN sepia, infrared, and lots of options
FORMAT	**FORMAT**
35mm (color)	6 x 6, 6 x 7 (b/w)
Still seen by public as mostly amateur, novice	Most desired format; the square offers cropping flexibility
Has a less rich tone; is grainier, less crisp	When shot well, has lots of depth and detail
Accepted as photojournalists' equipment	Required for fine portraiture; few photographers have ability to use medium format in photojournalistic style
Multiple film use necessitates multiple cameras	Interchangeable camera backs make multiple film use easy
EXPOSURE	**EXPOSURE**
Wide latitude: 2 stops over to 1 1/2 stops under	Exposure abuse brings contrast, grain; 1 stop latitude gives best results

Contrast level set mainly by film type	Contrast comes from exposure and projected print size, as well as from T-Grain/Delta's finer grain structure and greater exposure latitude that will combat lighting vagaries of location photography
Exposure problems mitigated with retouching	Extremely wide tonal range possible or color washes with split contrast printing
Kodak Portra films can experience color crossover due to over exposure; Fuji has contrast and color biases	In black and white, it's all about exposure

TONAL REPRODUCTION

Records all visible wavelengths equally	Not equally sensitive to all wavelengths
Colors don't all reproduce perfectly in relation to one another	Faces record too dark
Hard to hold detail in contrast extremes	Usually holds longer contrast scale in negative; can be brought out with custom printing
Hard to burn in details and hold color tones	Easier to burn in believably
Filters can be used to aid in reproduction	

CONSISTENT PRINTING

Must print for overall believability and consistency	Contrast level (due to print size and negative exposure) followed by density are the concerns
Dress color may be more important than faces	Faces must not be allowed to go too dark; dress may need burning or split-contrast technique
Hard to preserve continuity among lighting types	Easier to reserve similar tonal range overall

PAPER CHOICES

Lab sets choice, contrast differences only: Kodak Portra sets standard level of contrast	Variable-contrast paper a must for economy, speed, and a homogeneous look
Matte or slight granular surface, some glossy	Matte or slight granular; glossy not recommended
(No equivalent)	Warm, cool, wide variety
Lacquer recommended, especially new water-base finishes	Not often lacquered, water-base finish excellent so far
Color reputed to be less lasting; much argument	Perceived as much more lasting by all

MAKEUP

Normal to slightly tan tones	Paler-than-normal base makeup
Avoid heavy blush, eye shadow under eyes	Deeper tones of lipstick are a must
Too-heavy application looks like TV makeup	Facial features disappear if makeup is too light

RETOUCHING

Many options for spotting colors; not too critical	Pêbêo dyes offer best tonal match; very critical
Moderate print enhancement fairly easy	Print enhancement can be very visible
Requires more smoothing out of shiny facial highlights	Highlights seem more natural, need less work to seem natural

PRESENTATION

Many albums styles, but none are really distinct	Begs for creative alternative presentation
Art, album match interior decor and style	Demands to have a distinctive style
Traditional, measured, ornamented	Variety inspired by commercial designers
Slight variation of size, color, page type	Simpler, often handmade, understated
Most traditional picture framing works	Minimalist framing is usually best
More conventional frames, often unmatted, though variations of fabric mats and fillets can produce spectacular design	Unusual frame materials, specialty frames, off-centering, unusual mat textures

Chapter 1

STYLE, POSE & COMPOSITION

The Six Styles of Wedding Photography

Here are the pros and cons of the six main wedding photography styles, to which black-and-white work will be as equally well suited as color.

~ WEDDING PORTRAITURE ~

The time-honored tradition of the wedding and the careful posing of every detail give this style its aura of perfection. As early as the 1880s in England, the home portrait was becoming fashionable. American painter John Singer Sargent (1852–1925) is often credited as the major influence on all modern portraiture. Much later, in the 1940s and '50s, the new affordability of photography and the press camera easily brought the portraitist right to the wedding venue. More than twenty-five years ago, photographer Monte Zucker began to teach his technique and philosophy that have contributed greatly to the foundations of contemporary wedding-portrait style.

Advantages

❖ Traditional posing provides a visual link to both the community and the past that a very large percentage of families crave.

❖ A good portraitist can make each image close to perfect.

❖ The overall presentation will be polished and complete.

Disadvantages

❖ It takes a good deal of time to pose photos with this degree of detail.

❖ The number of photos that can be made is severely limited by time, photographer energy, and client patience.

❖ The photographer invariably relapses into standardized posing; most photos are very similar in background and symbolism; most albums look alike, with identical poses and sequences of images.

~ CANDID ~

Leaving the photographer free to capture people just as they are, and without the emotional baggage of traditions, the candid style concentrates on faces. The idea is to catch not only unguarded expressions and actions, but also any mugging for the camera. This trend is driven by the entertainment industry and is certainly a reaction to the perceived stuffiness of traditional portraiture. Bride, groom, and guests alike become the celebrities captured by the paparazzi.

Advantages

❖ It's possible to capture great expressions and action without disturbing people.

❖ None of the clients' time is wasted on posing.

❖ Well-captured candid photos (or candids) feel very real.

Disadvantages

❖ Few photographers or clients are fully comfortable with candids as the only record of the wedding day. Most people will want to be smiling into the camera at least part of the time.

❖ Traditional and symbolic parts of the day are often not photographed.

❖ Clients usually find it hard to be natural and graceful in front of the camera; without any coaching or posing, much film will be entirely wasted or need severe cropping.

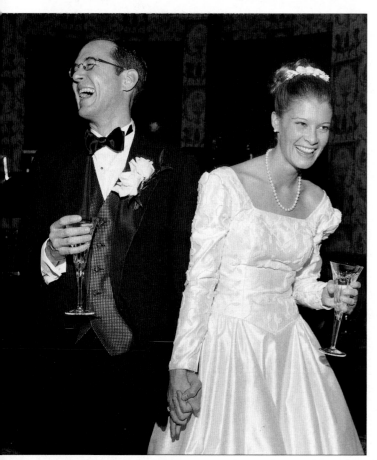

Guests and principal players alike are less self-conscious during toasting. Body language, expression, and composition combine to make this candid unaffectedly genuine and memorable. This image is one of a long series made with a single strobe on-camera during a very short period of time (see pages 34–35).

~ SPECIAL EFFECTS ~

Special effects can incorporate the use of specialty filters, infrared film, double exposures, vignettes, soft or selective focus, and overlay printing. It's a fanciful, illustrative style. The late photographer Bill Stockwell, as well as photographer Jack Curtis, pioneered these often heavily symbolic effects. There is a resurgence of interest in this style through use of commercial light-painting techniques in which one image will have both sharp and soft elements. Digitally altered images have become a major alternative.

Advantages

❖ Special effects, especially soft or selective focus, result in a romantic, Hallmark-card feel.

❖ Well-crafted double exposures can be very dramatic when showing two aspects of the same action at once.

❖ Facial blemishes are minimized and older faces softened.

Disadvantages

❖ The style can easily take precedence, with people becoming secondary or even incidental to the overall scene.

❖ Since things can't be seen clearly, there's no crisp and clean reality.

❖ The special effects style will date wedding images according to the fad of the times.

~ NATURAL LIGHT ~

Natural-light photographers have their artistic roots in both old master and impressionist painting but take their best cues from the contemporary movie industry. Posed natural-light portraits require more subject involvement and slower shutter speeds. High-speed films now allow for a seamless look in fast action and lower ambient light conditions. If flash is used, no typical flash shadow may appear.

Advantages

❖ "Painting with light" results in a much more artistic or fine-art style.

❖ With proper exposure, tones gain depth and rich dimensionality.

❖ Harsh, snapshot shadows simply do not appear.

Disadvantages

❖ Lower overall light levels and critical composition often require a tripod and/or fast films.

❖ Contrasty situations and very dark areas impose great technical difficulties.

❖ Aspects of this style resemble portrait painting and may require more posing time.

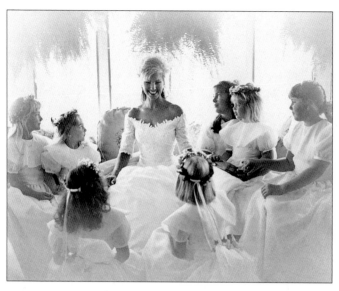

I carefully but casually arranged a "circle of angels" in a bay window seat and softened the edges with a white Lindahl oval mesh vignetter, used horizontally. Bounce light from the children's dresses illuminated the bride's face. I made an exposure reading off the bride's face and increased by one *f*-stop to appropriately record the skin as a middle tone value of Zone V. (See page 96 for Zone System information.)

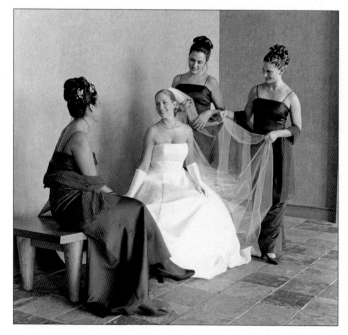

This group, posed in a high-ceilinged hotel hallway, had excellent overall illumination from floor-to-ceiling windows to image right, but the meter reading for ISO 400 was *f*/5.6 at 1/30 sec.—too slow to handhold with sufficient depth of field. Adding strobe would have left harsh shadows on the wall and destroyed the dimensionality of the side lighting. The subjects easily held still for the 1/15 sec. tripod exposure needed to render everyone sharp. I always photographed the same pose with everyone smiling into the camera to give the client a choice.

∼ GLAMOUR/FASHION ∼

The client who desires a "fashion spread" will probably bring a handful of tear sheets from magazines to show how she wants to look. The Golden Age glamour of the '30s and the modern majestic posing of Richard Avedon are always popular. Images made in this style evoke a Hollywood feel, not real life. Movement, backs of subjects, high grain, and angled views are all characteristics of this style. While less common in the United States, a lengthy photo session featuring dramatic backgrounds is de rigueur for many foreign couples, especially in Asia.

Advantages

❖ A properly constructed series of fashion images is an art form all on its own.

❖ The client is elevated to the status of celebrity; the session becomes an experience.

❖ Individual images evoke "wow" reactions.

Disadvantages

❖ Intense planning, elaborate lighting, dramatic locations, and multiple outfits are required.

❖ Precise posing and many images of the same scene are required to achieve the quality of a fashion layout.

❖ The photographer must become a theater director; clients must often endure unnatural poses and hard-to-understand instructions.

∼ WEDDING PHOTOJOURNALISM ∼

This newest trend, which appears here to stay, demands that the photographer treat the wedding event as both a feature and a news story. Posing is minimized; real moments and actions are emphasized, captured by a photographer who blends in with the background. Photographers Gary Fong, Greg Geiger, Denis Reggie, and a host of other excellent artists have brought the photojournalism style to national attention. Every part of the event is examined by the camera with the goal of making memories that are clear, complete, and full of real feelings—without much posing or coaching of subjects. Photojournalism does not, however,

The pose, an old-fashioned balustrade, and romantic backlighting—augmented by a reflector to camera left—bespeak the elegance of yesteryear. An incident meter reading was taken at subject position, the camera was on a tripod for stability, and exposure was 1/60 sec. at f/5.6. The back camera gate released before the actual exposure to minimize the potential for blur due to mirror shake or slight subject movement in reaction to the shutter noise.

exclude some formal posing as part of the total story. The secret is that this style embraces aspects of all the others, yet creates a vastly different look all its own.

Advantages

❖ The mixture of angles, distances, backgrounds, action, and reaction results in total coverage that's interesting and uniquely personal to the client.

❖ Some posing or coaching of people is not precluded, but groups are photographed more loosely; individual character is recognized, with less role playing.

❖ The camera follows events as they unfold and shows the natural reaction of the participants.

Disadvantages

❖ Since images are very real, they may seem to lack the drama of glamorous fashion that many clients desire.

❖ The photographer must work much more intensely over a longer period of time and must anticipate action and reaction.

❖ The much larger number of photographs required to execute this style results in higher costs to the client.

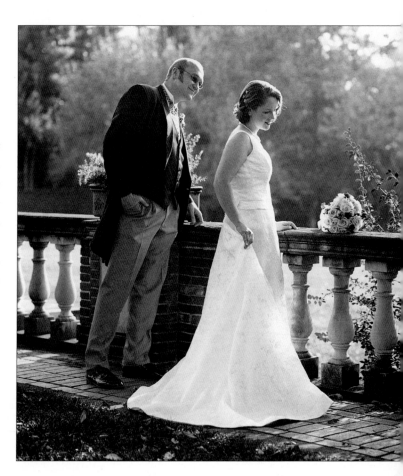

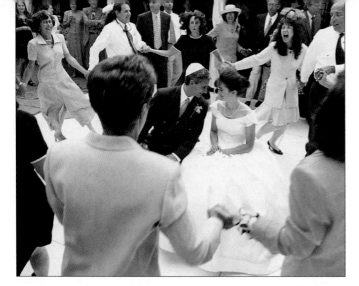

The extraordinary depth and motion captured in this composition are a near-perfect setting for both the couple's interaction and the guests' reactions. I held a Hasselblad with a 50mm wide-angle lens upside down at arm's length above my head to gain height, and chose the moment of exposure by looking at the subjects since it was impossible to look through the camera. ISO 400 film exposed at 1/125 sec. stopped some, but not all, of the action. An aperture of f/11.5 allowed for great depth of field with the lens set for hyperfocal focusing.

STYLE & THE WEDDING ALBUM

THE PROBLEM From an artistic point of view, most photographers' final product—the wedding album—suffers from one of two ailments. Either it has no style at all, no homogenous look, and is stiff and disjointed with no flow to the story. Or, it has a style, but the photographer has repeated the same photographs in the same album for the last twenty-five weddings. You might just as well cut out different dresses to put on the "paper doll" heads; the dresses differ more than the expressions and action portrayed. While this might not seem like a huge problem, as each couple only gets their own album (and is not continually comparing it to others), most brides wish to be unique and don't want someone else's wedding album to be too similar to their own.

THE SOLUTION Constantly reevaluate your work, first for technical and stylistic consistency, and later for completeness of coverage, uniqueness to the individual client, and storytelling power. This isn't easy, but the fun of it lies in the ongoing process. In addition, having equipment that's as quick and varied as your imagination is almost as important as imagination itself.

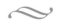

Storyteller Weddings

What is photographic storytelling? A wedding storyteller may work in any of the six styles but will take one of only two approaches: iconic or sequenced.

Iconic, single-image storytelling is best described by Henri Cartier-Bresson, who coined the term The Decisive Moment. He referred to both the process of photographing and the meaningful result on film. The photographer must size up a situation by watching and guessing how the action and expression will unfold. He or she waits and waits, holding the camera ready for the exact moment when action, reaction, gesture, and facial features are optimal. The exposure records a brief moment of recognition, discovery, and feeling, yet with precise arrangement of forms and artistic composition. It is a spontaneous and intuitive, yet refined and highly disciplined method. The storytelling impact of such an image is instantaneous and can easily take on metaphoric proportions as a modern-day, alternative icon.

The religious icon is a painting, carving, or work in any other medium that symbolizes all the venerable qualities and deeds of

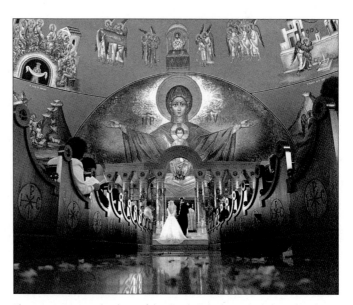

The awesome art in the dome of this Greek Orthodox cathedral is a literal icon above the iconic image of the ceremony in progress. Use of a wide-angle lens and a low camera angle add to the feeling of awe; the circular themes within the composition double the visual meaning of the image. Exposure with a tripod-mounted camera was 1/15 sec. at f/5.6 with ISO 400 film.

the particular saint or holy figure represented. It is an ideal, a perfect example, a paragon, or a model. I refer to iconic or metaphoric images as "the ultimate dressing picture" or "the ultimate cake picture." Compare this concept to the slice-of-life image that captures some minuscule, almost incidental part of the event, such as the close-up detail of the back of the dress or a fleeting grasp of hands between the new couple whose faces are not shown.

The goal of iconic wedding photography is to produce—irregardless of the amount of film exposed—just a few final images, each so complete and strong that its visual meaning becomes a metaphor for one specific, very traditional facet of the event.

Sequencing images, on the other hand, is like storytelling in the manner of a novel or the melodies of a classical symphony. A sequence will contain emotional crescendos; soft, introspective parts; and fast, step-by-step series. Some parts will state the theme, others will explain and support it.

Whether in music, words, or photographs, artists all want to have the success of Scheherazade, whose storytelling ability changed her life and that of those around her. We crave accolades for the clever way in which we weave action, detail, emotion, and suspense together with riveting style. We don't just take pictures; it's our job to make dreams happen. Storytelling style is that elusive but very recognizable something that makes the viewer say, Ah! I know that's a Sara Frances wedding album. We recognize, compare, define, and form opinions about everything in our lives based on stylistic difference. You must create something memorable and different, otherwise your product is just a commodity in a saturated market, and all you have to sell is your service. I prefer to be called a photographic artist.

Your own photographic style and approach are only half of the storytelling responsibility you shoulder for your client. You must apply what you do to *their* expectations. If you don't meld their style with yours, you won't get your fair share of future recommendations. You must do everything you can to ensure that each wedding album produced remains on prominent display within that family's home. The real difference between Scheherazade and her unfortunate predecessors was the total presentation, not just the genius of her stories.

The prominent, affluent photographer provides attentive customer service, but I think the real secret lies in the imaginative post-production and presentation—how fine photographs are made completely ready for enjoyment when they leave the studio. Assure that clients keep using your images to tell their wedding story long after the pictured event has passed by preserving and protecting those images in an accessible presentation for repeated viewing. Good art can easily get jumbled with the artistically irrelevant if you don't give sufficient attention to this last creative step. Enjoyment over time achieves long-term return on client investment.

JUST ONE IMAGE

The bride probably desires one photograph that she will later call her Wedding Picture. She wants a single, iconic image to symbolize the entire event for her, and from it she will order enlargements, maybe even a wall portrait. If she's creative, she'll order handcoloring, a giclée print, a float frame (matting in which the image is mounted so as to appear to float above the mat), or some other exciting presentation. Don't be too discouraged if she picks a stand-up altar photograph with all its traditional and historical baggage. However, if you can suggest a more natural, emotional, and creative image, client satisfaction over time will be greater, as will business referrals.

Undeterred by cold, this couple gleefully played in the snow while the camera recorded an extensive series of private fun. The single image that stood out as the strongest memory was printed in sepia tone and presented in a Victorian antique gilded frame. Automatic metering could have easily underexposed the image by reading the snow; an incident reading at subject position was compared with spot reading on the faces and a reflected reading on the concrete. As expected, I chose the incident reading, which was greater than the other two by about one *f*stop.

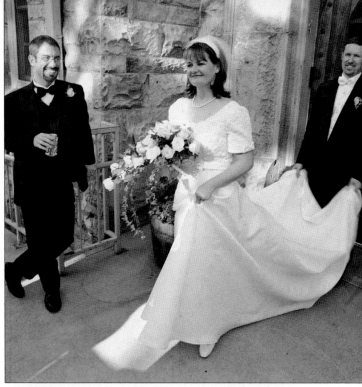

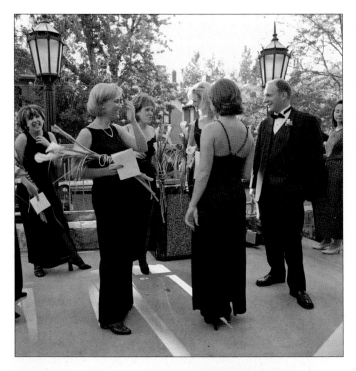

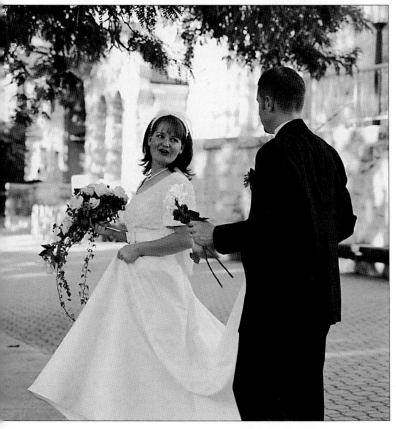

At close range with a 50mm wide-angle lens, these four frames came one right after another, and any one can stand by itself. Together, however, they tell a powerful story that says, We did it! With ISO 400 film at 1/125 sec. at f/8, I set the lens for hyperfocal distance and made no attempt to manually focus. Under the trees, I estimated that light had changed about one f-stop and, without metering, used a setting of f/5.6.

Wedding Photojournalism in Depth

What is this very attractive myth called wedding photojournalism? Actually, brides don't really know what photojournalism means; they just want something a bit different. Their opinions are very much driven by fashion, advertising, and Hollywood. They'd like their veils to blow in the wind as pictured in magazines but will usually run like scared rabbits at the first puff of a breeze.

Logically, wedding photojournalism a misnomer if there ever was one. Photojournalism is defined by the eternal style of *National Geographic* magazine, with its universal appeal of both people and natural subjects, and for its internationally relevant point of view. Wedding photography is the paid personal record for a client of a time-honored, traditional event for which the scenario and outcome are a given.

A photojournalist hears about a potential story, ferrets out facts and details over time, then edits images for a cohesive and understandable report. Photojournalists usually go to strange places with little or no prearranging or introduction and then must find their own way. It's necessary to gain the confidence of the major players in the story or to work surreptitiously, perhaps at great personal risk. Photojournalists look for shocking juxtapositions as well as for visual appeal of color and design, and record both positive and negative acts and feelings.

In contrast, every wedding participant knows who the photographer is and the purpose of the pictures. In some cultures, Japan for example, people pose so well for pictures, it seems they were taught how. Smiling into the camera is by far the most desired photo content from the client's point of view. It's acceptable to record only positive actions and emotions; the bride crying tears of joy may be a borderline subject. By my informal survey, 95 percent of all wedding photography remains stiff and staid. Most people need quite a bit of coaching from the photographer before they will get physically close enough to each other that the body language of emotion will record dramatically on camera.

So, the term "wedding photojournalism" is really an oxymoron. Wedding photojournalism is really a glamorous name for camera angles and compositions that are fresh and free, that express a real life/real time approach to images that are less symbolic and formulaic, more individualistic. It's a combination of

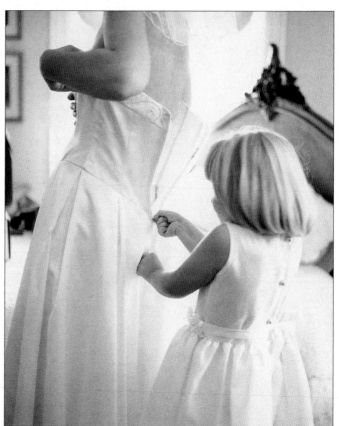

This littlest maid was proudly determined to play her part and make sure her new mom was carefully dressed. The camera, as unseen observer, captured the whole procedure with ISO 3200 film illuminated only by diffuse light from the curtained windows and wall sconces. Don't risk posing, or even subject rearrangement, which could easily break the mood in such a circumstance!

 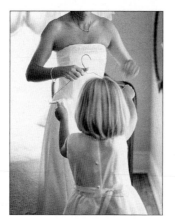

AXIOMS OF THE WEDDING PHOTOJOURNALIST

YOU *AREN'T* PAID TO . . .

❖ bring back unused film.

❖ bring back duplicates and redundant images.

❖ sit down on the job—except when you also climb, crawl, and run while looking up, down, over, and under.

❖ pretend you're a guest, socialize, dine, and drink.

❖ ignore ways you can fix small problems for your client.

❖ let accidents or lateness rattle you, or let your nervousness or disapproval show.

❖ provide a class in posing for point-and-shoot cameras.

YOU *ARE* PAID TO . . .

❖ anticipate action and previsualize results so that you'll be in the right place at the right time with the right equipment.

❖ observe subjects intently through the camera and wait for the decisive moment before pressing the shutter.

❖ know when to be instantly available, and the rest of the time do your job invisibly.

❖ take chances with composition, image, motion, expression, and even exposure.

❖ ensure client satisfaction with some measure of "safe," traditional imaging.

❖ keep working a given scenario, such as cake-cutting, long enough to create a dynamic series, rather than stopping after a few frames.

❖ "make nice" with family and guests to promote smooth cooperation and a feeling of assuredness in front of the camera.

❖ blend in with proper clothing, mannerisms, and words.

❖ give subjects reassurance that you are there to help them over the rough spots and make them look their best.

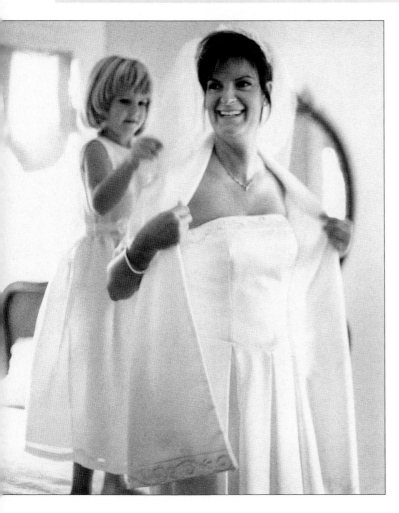

styles meant to capture real emotions through series of events, in a manner resembling a stop-action video. It implies a fashion- and art-conscious design that would be at home on a gallery wall. It means a more interesting, artistic presentation. And, it's much harder work. Speed of perception and camera operation by a photographer who always has the equipment in hand are the key ingredients. Think of wedding photojournalism as a chance to exercise your own creativity both behind the camera and in post-production, to have fun at weddings, and to be able to charge more for what you do. The most current trend may well be turning again to more classic posing, but wedding photojournalism is now a must in every photographer's repertoire. In the mind of the client, this style is often synonymous with black and white.

~ A NOTE ABOUT PHOTOJOURNALISM ~

For most black-and-white newspaper photojournalism, one image is chosen to run with a story. For a feature, as well as for a longer magazine story, several photos will be printed, but often these will illustrate different aspects of the text, rather than create an action series without words. A monograph is the pinnacle of photojournalistic art: A whole book is devoted to a dramatic and emotional photo series or progression about one story. Fine-art photographers often work many years to complete a book about a single subject, yet this is what the wedding photojournalist must do in just a few hours!

Achieving Artistic Unity

The main goal of the advanced photographer is stylistic continuity, which results in a total album impact that's far greater than that of the individual images. Experience brings no universal formula to follow, because very few weddings can be photographed exclusively in one style; the heavily symbolic event itself precludes a single approach. The participants have varied, or even mutually exclusive, opinions and expectations of the day as a whole, not just of the photography. It's no wonder many photographers simply give up, artistically. They continue to record weddings unimaginatively in a cookie-cutter fashion, because they don't want to offend anyone.

Regional tastes in the United States have been generally defined as more traditional in the Midwest, more candid on the West Coast, more formal on the East Coast, and more emotional and dramatic in the South. However, many couples naively tell me they "want it all"—a mix of all the different styles. Style-mixing is easy in color, because color itself is the chief unifying theme; the only concerns are believable color continuity and density-matching start to finish. The overall artistic statement of a black-and-white wedding will suffer greatly from stylistic disunity.

Plan the approach carefully. A larger number of black-and-white images must be made in order to be able to be more selective later. It's overly simplistic to conclude that wedding photojournalism is tailor-made to solve the problem of artistic unity. This style is on the tip of everyone's tongue, but in practice the name is widely misused excuse for out-of-focus, crooked images, incomplete coverage, and disorderly presentation at high price. Let the buyer

An out-of-focus background can sometimes create visual value. Here, it emphasizes the crystalline fragility of the candle holders in a dramatic still life.

THE BEST LAID PLANS . . .

Even nice, artistically knowledgeable clients can throw you some curves about style and posing. A charming older bride, who had already purchased a fine-art photograph of mine, spoke for months prior to her event about spontaneity, photojournalism, and casual posing. The day before her wedding at the grand old Phipps Mansion in Denver, she stopped by the studio unannounced with a list of no less than seventy-six set groupings she wanted photographed in addition to everything else we had previously discussed. She specified who was to be in each group, where it was to be posed around the house and grounds, whether it was to be close up or full length, looking into the camera or not, black and white or color. I was dumbfounded! What I should have done was add the cost of another photographer to her bill, but because of the late notice, I just tried to do it all myself. In the end, she picked well from the previews, and wanted and paid for a large order. I was lucky and very tired.

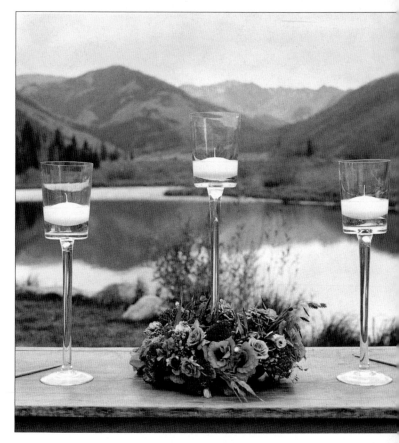

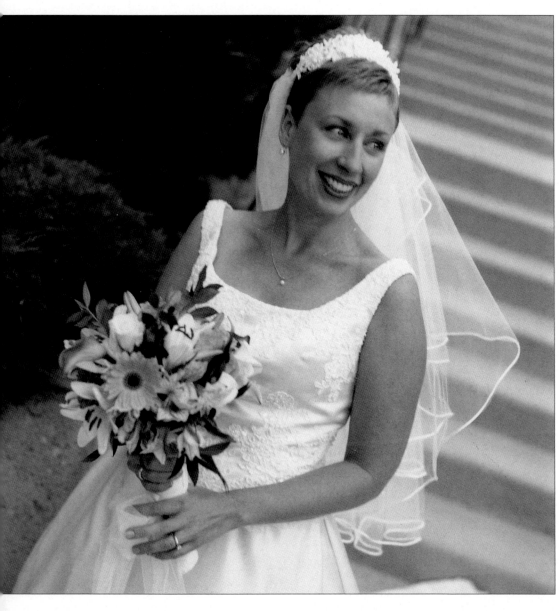

A photographic mannerism such as tipping the image can work in your favor.

beware! Start-up equipment and beginning posing technique may seem easy, but wedding photojournalism is, without doubt, the most difficult style to perfect. Nor is it the right choice for the majority of clients. I've often presented a set of gloriously artistic proofs and enjoyed great client approval, yet the final print order has favored a large percentage of traditional family groups. Become familiar with your clients and their coming event so that you can realistically limit the stylistic scope of the coverage and yet satisfy every request.

The wedding couple will have experience with flowers and food simply because everyone has ordered floral arrangements and given parties. However, they rarely know how to decide what type of photography is right for them, or how to select and interview studios with potential. Fine photography is purchased so infrequently that everyone asks, How much is an 8 x 10? Clients perceive photography as a commodity, rather than an art, and therefore simply don't realize there *is* anything else to ask.

Encourage the bride to talk about every little detail, other than photography: the colors, the decorations, her dress, the people from near and far, the honeymoon, her work, his work, how they met. (These are the things she really wants to talk about to anyone who will listen.) Other vendors will gladly tell you what they have designed and how they think the schedule should flow. (*Note:* I never call on other vendors on Friday afternoons when they themselves are preparing for weekend events.) While I'm adding more pieces to the stylistic puzzle, I'm also getting to be one of the family, and no one ever buys a $5,000 wedding album from a stranger.

What Amount of Black and White Is Right?

Public demand for black-and-white photography is historically cyclical. When I started working in the early '70s, "natural color" weddings were touted, but a temporary resurgence of black and white followed the sometimes catastrophic fading of color prints. Color soon improved, and black and white cycled out of favor. Since the mid-'90s, black and white has vaulted again into prominence, the demand driven by voguish advertising of such companies as Calvin Klein, the Gap, and DKNY. Movies such as *Schindler's List* add to the public's interest.

The audience for black and white isn't linked to an age, profession, social level, or lifestyle, but comes from a broad cross section of the population. And, people who appreciate art photography often become very faithful in their buying preferences.

As recently as ten years ago, few photographers offered black-and-white images as an artistic accent to regular color wedding packages. Complete black-and-white coverage was, and still is, limited to a handful of unconventional clients and an even smaller number of dedicated photographic artists. Monochrome portraiture was somewhat more common, partially due to the ubiquitous business glossy. The current resurgence of black and white can be ascribed to the tastes of the baby boomers. This generation is now buying fewer things, and instead spending more on family and memories. And while digital photography is claiming the technical spotlight, a significant percentage of clients is actually choosing traditionally produced photographic artwork instead.

It's easy to become fascinated with the look—crisp detail that renders deep but discernible shadows, as well as subtle white on white. Experts from Eastman Kodak have been pointing to all types of black-and-white portrait and wedding subjects as a niche market with staying power for the future. Images digitally desaturated to black and white are most successful if manipulated with plug-in programs that simulate specific black-and-white films and their appropriate filters. Color cast problems appear when black-and-white digital files are printed on color papers and also on some inkjets. Epson inkjet printers—particularly the 2200, 7600, and 9600 models—are zeroing in on neutral black and white, but I still don't feel that they will replace the three-dimensional look and feel of conventional photographic materials.

Since it's still the rare wedding that is photographed entirely without color, try to determine first what part of the event the individual client wants in black and white. Most brides and

An imaginative and effective idea was recently suggested to me by a groom, himself a talented amateur photographer: a striking color panorama view of the dance floor filled with merrymakers collaged with small close-ups of friends and family in black and white.

grooms are ambiguous; they need professional help to organize their artistic thoughts. Sometimes, other family members just won't accept anything but color. The easiest option is obviously to photograph in color and then print black and white by request afterward, even though it's hard to visualize tone translation. It may be impossible to predict how much black and white is right until you design the final presentation.

It's a challenge to mold a couple's choices into a presentation that uniquely reflects their personalities. If a series of images is split between black and white and color, I usually translate the entire group, or at least facing pages, into black and white. Beware of splicing a single black-and-white photograph into a color spread of six images or more; the effect can be jarring. A multitonal option is to screen a background scene so that it prints in pastel grays, like a ghost image, and then inset one or more small photos reproduced in full tonal range.

A NOTE ABOUT PRICING

I charge a premium for black and white—whether it's from black-and-white or color negatives—because of the high handling and custom printing costs. I price photo package collections based on machine color plus extensive print enhancement. Currently, I am trying a flat fee for a set number of black-and-white prints as an add-on option.

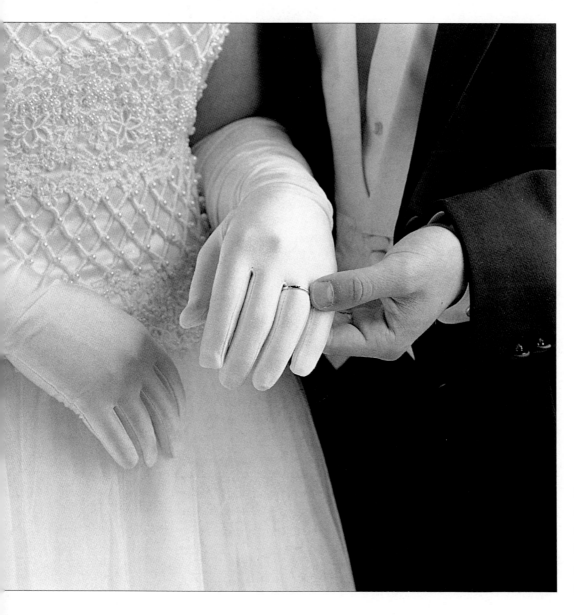

Editorial appeal lies in implied action and emotion. The impact of minute, white-on-white details is much greater in black and white than in color. Incident meter readings ensure accurate rendition of both ends of the tonal scale.

HOW TO USE BLACK AND WHITE

A very high percentage of clients expresses strong interest in black and white, but they can rarely define just what they'd actually like photographed in black and white, and frequently give in to the temptations of color. Here are nine suggestions for black-and-white accent photos, ideas to help get your clients thinking along the right track.

1. One or two rolls of portraits of the couple: close-up, full length, all formal or all casual, or both. This method is, in my current experience, the most popular.

2. Black and white before the wedding starts, color thereafter.

3. Black and white for all posed and group photos, color for all candids (or vice versa).

4. For the ceremony only.

5. Pre-wedding-day casual/formal portrait and/or bridal sittings—perhaps using TCN hybrid black and white, printed on color paper to a soft, sepia tint of choice.

6. For a smattering of dramatic-impact fashion or glamour poses.

7. For party candids only.

8. Four seasons of love portrait series. This can be done only if the couple plans a long engagement of a year or more so that they can be photographed in all four seasons, preferably at different locations. This is one of my favorite ideas, and it's as effective in color as it is in black and white!

9. "Lead" image in black and white or handcolored for each section or part of the event, followed by the "explanatory" photos in color. Each section becomes a mini photo story, a subset, or chapter of the whole wedding album.

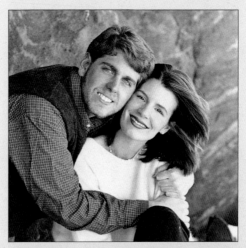

A private little "photo safari" never fails to be a fun experience, bringing out people's best feelings and expressions. For these images, I used one reflector as a gobo overhead to limit downlight and another at a bit less than 90 degrees from the camera to lower contrast and lighten the eyes.

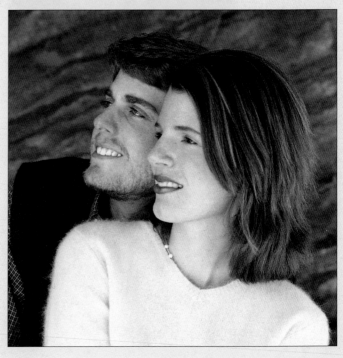

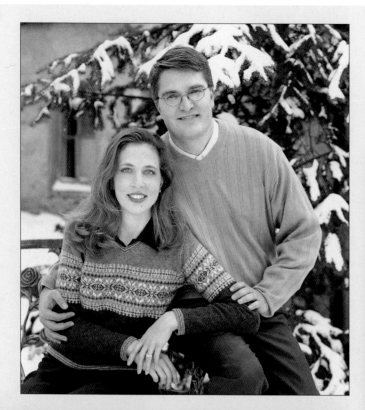

The Four Seasons is a universally understood theme that appears often in art and music. After four sittings, this very formal couple joked that they "knew all the right poses" and just played with the camera. Full-length and $^3/_4$ poses were also captured.

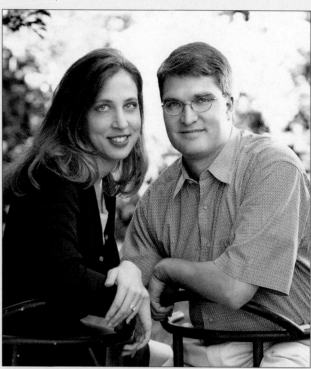

The Idea of the Series: Fluid Memories

The first studio I worked for as a beginner gave me fifty frames of film to cover an entire wedding. Without instructions, I was required to produce forty-eight salable images, including about twenty-five unspoken "must haves". It was tacitly expected I could capture images of iconic quality in one try, without margin for accidents, malfunctions, errors in judgement, planning, or technique. I was too inexperienced to know how dangerous this approach was, but I learned event planning and precision. Once, I accomplished a whole wedding in twenty frames!

What a foreign concept this is to the way I work now. My only limiting factors are time and circumstances, never amount of film. My intent is to produce a wealth of material, without many duplicates. Three to five almost identical views of the same subject

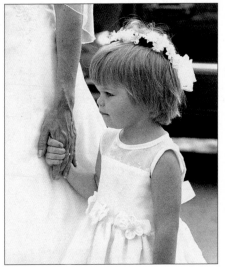

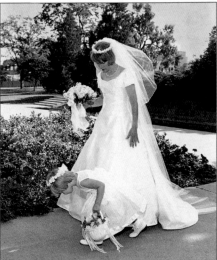

Children who are shy or stressed by new circumstances and surroundings may be completely unaware they are being photographed if the camera is at a little greater distance with a 150mm lens. Personality and precious features can often be revealed better by the unseen camera than by posing and big smiles.

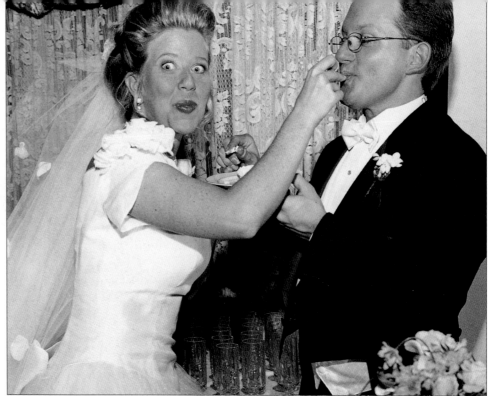

During the cake-cutting ceremony, try to achieve an extensive freeze-frame series of playing with the knife, cutting, lifting out a piece, teasing, feeding, wiping, kissing, guests cheering. Be sure your strobe can recycle in about one second in order not to miss any nuances of expression.

do not please my economical film upbringing. However, since action is scrutinized more closely in black and white than in color, the idea of the series takes on great importance and excitement. (Additionally, series photography allows you to benefit from serendipity and deal with last minute changes.) Many photographers I've hired take some convincing that I want them to produce two to three dozen images during this time.

The progression of meaning in a sequence of photos becomes a memory so strong that it should be possible to "hear" again the music of the band and the words of the toast, to "smell" the flowers, to "taste" the banquet, and to "feel" the satiny dresses.

Different styles of photography have different tempos, just as music does. The natural action of the event is where tempos are formed; an easy example is the stately, measured march of the processional. Most of us enjoy soundtracks from movies; all talk and no music would make a very odd film. We have grown to think of theatrical productions—and especially romantic action—as unfolding to beautiful music. In black-and-white series photography especially, the photographer has the chance to imply melody and rhythm through the sensitive rendition of tonal range and the speed of the action.

My clients consistently buy this lyrical, series-based imagery. Many couples, not just newlyweds, tell me they leave their album out on display most of the time and that they and their friends enjoy looking at it again and again. That comment is the reward I like best!

Series Posing for Speed and Variety

If your goal is simply to make a record of the main elements of a wedding, you can do it easily in twenty staged photos, but think about how every storyteller since Homer has recounted the flavor and flow of action. Details are of the utmost importance. So, for the wedding storyteller, the most important concept to put into practice is that of series photography: posed series, action series, and candid-expression series.

Plan ahead to imply personality and movement when arranging the coached-portraiture and posed-group series desired by most clients. Discover in advance the bride's tastes, suggest the right location, and make all these important photographs quickly and efficiently. Speed must be duly balanced by technical requirements. Your choice of background, quantity of images, level of formality, and physical arrangement of bodies and heads will create imagery that differs substantially from photography that makes no effort at a storytelling sequence. Use the elements at hand to imply emotion and lifestyle, rather than just recording faces in rows. Posed groups can justifiably be considered the most difficult to photograph as a meaningful series.

Every bridal couple wants certain group photographs organized. The photographer who thinks the story can be told without these images is simply missing the boat. To determine the correct style and approach ask your clients if they prefer their groupings traditionally posed or loosely drawn together. The response to this question sets the tone for the entire job. Great group photos drive sales, especially sales of larger prints. The group photo that also expresses emotion will become a treasured heirloom. Friends and family getting together to lend support to the newly wedded couple are what it's all about! Here are sevens key aspects that imply emotion and lifestyle in portrait and group poses.

～ HANDS ～

Have subjects hold hands in a natural manner or link elbows to imply closeness. Non-uniform placement of hands implies individualism, while everyone with ultraformal crossed hands will look military or regal. Hands near the face imply relaxation and comfort.

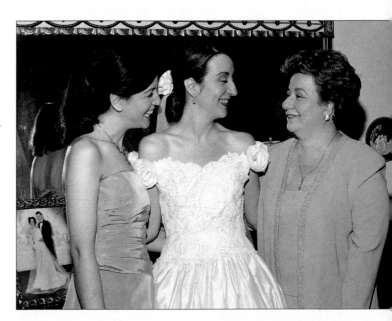

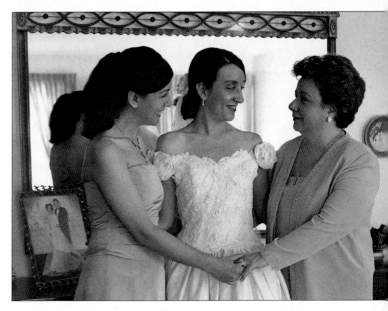

The top image is a classic grouping of mother and daughters in the dressing room, but it is somewhat lacking in the action and emotion contemporary brides prefer. The bottom image exudes reality, excitement, and fun just by the inclusion of hands and, of course, by the use of natural light, which allowed the subjects to forget the camera and concentrate on one another.

∼ DISTANCE ∼

Full-length views become increasingly personal the more they approximate three-quarter and head-and-shoulder poses. Normal to slightly telephoto lenses will usually be needed for groups, but a wide-angle lens will cover a larger number of people and add visual excitement. Photographing a group from a ladder or a stage affords a new angle and shows faces in an interesting perspective.

∼ BODY LANGUAGE ∼

Turn subjects toward one another and tip heads to imply closeness. Outward turns or awkward posture can photograph negatively. A widespread, flat-footed stance by the groom conveys his personal strength and pride, though such a position is not necessarily graceful or in keeping with traditional rules of good posing. One person leaning out from behind another can convey fun and good humor. Hugs always express excellent emotion. In a casual group, eyes closed, mouths open, and heads turned the wrong way can give the feeling of a hilarious party. Beware that some clients may find the recording of such body language to be a disjointed and unacceptable style.

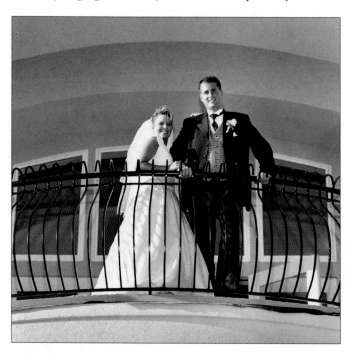

Broad shoulders express relaxed, masculine power. The groom stood naturally in this pose without coaching. It's desirable—but not always possible—to see, react to, and photograph storytelling body language fast enough. I'm unwilling to let an image slip away in disappointment; if I anticipate a subject might move suddenly when seeing the camera pointed in his or her direction, I say something like, Oh, do stay just as you are; you look fabulous! This simple interaction will, most often, net you the image you want and will have also reinforced the client's confidence in his or her appearance. It may not be real photojournalism, but it looks like it.

The first image, below, was made with a normal 80mm lens at eye level and is very satisfactory. The second, bottom right, was made from a two-step ladder with a wide-angle lens and captures the wedding gazebo and beautiful afternoon backlight from a more interesting angle.

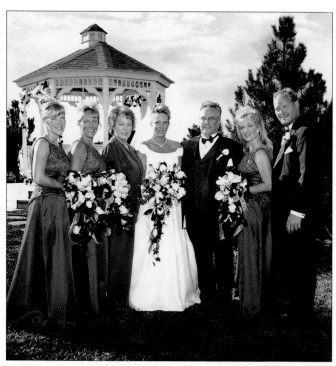

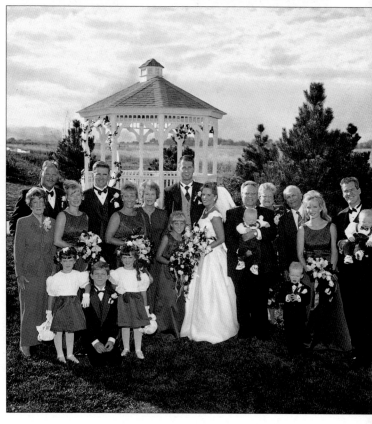

Lack of banquet hall decor forced consideration of a hotel corridor as the background for the wedding party and family groups. A chair pulled from the hall seating made the arrangement of heads at different heights possible; the hall itself provides a feeling of depth, and diffuse light from the atrium above bounces everywhere, so no strobe was necessary. (*Note:* A very low-powered wink light would have opened the eye sockets more.)

~ BACKGROUNDS AND POSING DEVICES ~

Background and angle variations imply movement and have the added advantage of showing off different aspects of a church or hall. Any angle, rather than straight on to the background, seems more lifelike. If you place subjects beside the background and parallel to it, you'll easily achieve a feeling of depth with foreground, middle ground, and background.

Posing on priests' chairs or pews allows people to gather closer with a more spontaneous feel. When some subjects are standing and others seated, faces will not only be more distinct but will also start to show personality and relationships.

~ CONTINUITY ~

Pick an artistic background and lighting situation, place the bride or groom, and then "drop in" the attendants and perhaps family members, one at a time. Actual pose can be formal, casual, individual, cuddly, or clowning. Group-posing series ideas are "literal": both straightforward and linear, meaning similar or even identical in subject placement, lighting, and direction from the photographer. They differ only in body language and expression. A handcut collage or mat with multiple small openings will add to the feeling of series.

Subject matter certainly is the basis for continuity of this wedding attendant series, while the background and angle add ambience, uniformity, and classic tradition. Take time with the first pose to make the composition and lighting perfect, and then you can make the rest of the series in just a few seconds. Overlapping the images on the album pages compresses the composition so that the uneven number of necessary images doesn't become awkward or boring.

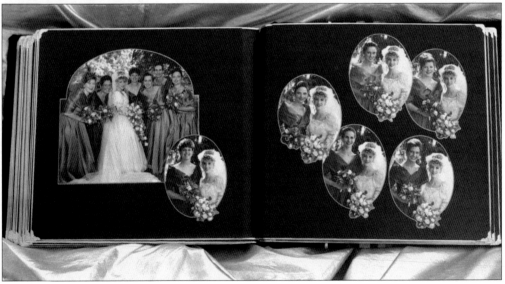

∽ ACTION AND CANDID-EMOTION SERIES ∽

A hands-off action-series approach better suits the artistic purposes of the black-and-white photographer bent on telling a personal story. Here's how to delve beneath the surface, past the literal into the "unseen observer" stance of the photojournalist.

Imagine the toasting scenario. The best man, embarrassed, pulls notes out of his pocket and raises his glass; bride and groom raise theirs back to him, as do the guests. After the toast, everyone may laugh or cry or hug, then the best man shakes the groom's hand and kisses the bride. This unposed, dream photo opportunity can result in a good series of fifteen to twenty images. There may be several other toasts, from the maid of honor, fathers, or friends. Each speaker must be photographed in turn. The right photos will bring to the bridal couple's minds the exact words spoken.

It's easy to capture effectively both an action series and a candid-emotion series when they're acted out slowly and unconcernedly in front of the camera. The storyteller need only be ready, willing, and able. A candid-emotion series is often tied to some action in progress. It's not hard to be ready and in position to photograph, because the main events of the wedding will be preceded by some fanfare or announcement, and each event generally proceeds slowly.

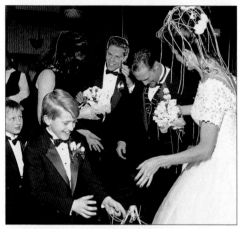

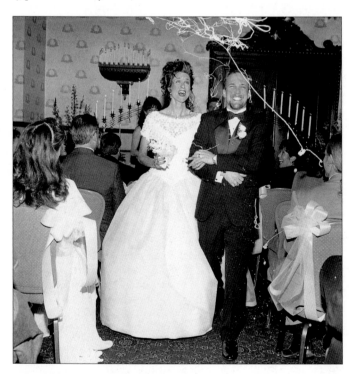

The surprise greeting of guests who showered the new couple with Silly String radiated energy and, therefore, deserved a stop-action series. Be ready to move quickly into position, change that position, and fire more frames than you think you could possibly use.

TOASTING

People sometimes raise their glasses too high and end up covering their own faces or those of the people next to them. A good tip is to take a lower angle on the speaker from a straighter front vantage point; no arms will cross the faces, and the raised glasses will be dramatically emphasized. A zoom lens, such as the new Hasselblad 60-120mm, can be extremely useful. Without standing right on top of the speaker, you can use a wider angle to show the main participants together. Zoom in for close-ups, still without blocking the view of the guests.

These images are the best of a series that recalls the exact words and emotions of the toasts. Be prepared with extra film close at hand and a fast-recycling strobe. Note the different angles and the reaction of listeners.

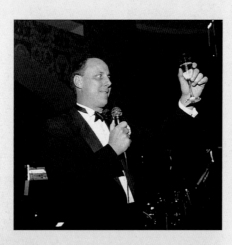

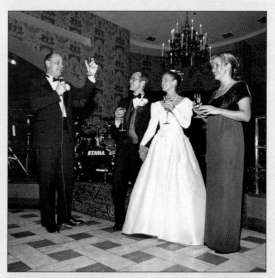

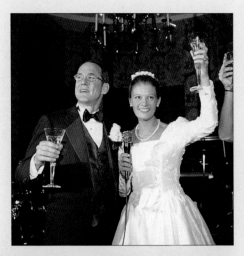

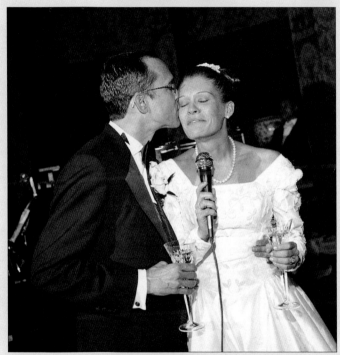

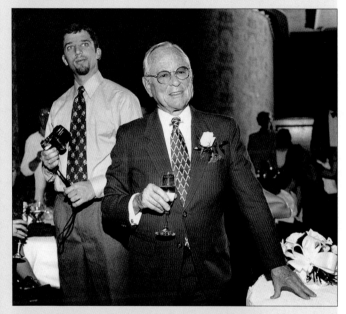

~ UNGUARDED MOMENTS AND NO-POSE POSING ~

In contrast to events like toasting, an unguarded moment between father and daughter, for example, will be truly sweet and will express volumes with one look or gesture. It will also pass fleetingly in a quiet corner. The bride wants to remember such a moment, but she also wants her privacy.

The unseen observer bent on capturing highly charged emotional moments must be constantly alert and with camera in hand. You simply can't relax. You must anticipate, be unobtrusively present, and record the scene without spoiling it for her. It's a really grueling task to be constantly prepared throughout the six, seven, eight, or more hours of the whole wedding. The worst of it is that not all couples and families open up to each other, even in a fleeting moment. Some weddings are just plain stiff. In such a case, you must realize that the story you are going to tell is simply a more formal one. Don't get annoyed with clients who do not show emotion in the way you think will create the most effective images. While my advice is to go with the flow, there are some moments when even a very stilted wedding party may unbend a bit:

* The mother or father seeing the bride for the first time fully dressed in the wedding regalia.
* The mother presenting the bouquet to the bride.
* The fastening of buttons on the dress, the putting on of a necklace, or the fixing of a tie.
* The groom meeting his groomsmen coming into the church.
* Anyone meeting a grandparent.
* Putting finishing touches on a child's attire.
* Heading out of the dressing room toward the sanctuary.
* The procession waiting for the cue to begin.
* The congratulations right after the ceremony.
* The announcement of wedding party members entering the reception.
* Toasting.
* The bouquet throwing and the garter toss.
* Dancing of all types: formal, ethnic, fast, slow.

My idea of "no-pose posing" developed from the discovery that if I can work fast with minimal equipment, people feel more at ease and will, with little coaching, automatically produce natural expressions. This is just the situation I want to create for my art-oriented black-and-white photography clients. I design the set—meaning I find a background and modify the light—insert the clients with minimal posing instruction, and let them be as they are. I actually suggest a situation of action or emotion much

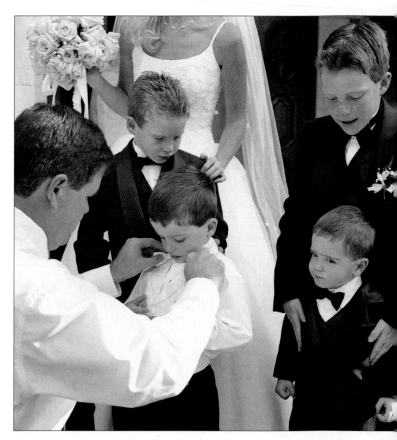

Children's gestures and expressions always steal the show. Come in close; look both for individual faces and completely uncoached groups that show a variety of "little kid things" happening.

like a movie director coaches actors. Action that generates spontaneous expression can never be equaled; black and white begs for this unusual approach with people. Interpretive no-pose series of the bride and groom will result in wonderful, natural portraits. Color or black and white, this series is fun and efficient for photographer and couple alike. Fifteen or more very different photographs can be made in as little as five minutes.

Most of these portraits will be ¾ poses or very close-up. Use any prop at hand—large arm chairs, stools, park benches, steps, hills, rocks, anything—that will enable the subjects' heads to be at different levels. I position the groom, then move the bride around him, changing juxtaposition of bodies and faces; then, I switch their positions. My secret is to play Hollywood director: After physically setting the "scene," I verbally direct the "actors" in such a way that they relax into "roles." Once I've set the scene in motion, I try to let my actors go, allowing them to show real emotions with both facial expressions and, more importantly, body language—even though they are very aware that they are on camera. I make it acceptable for people to act out how they really feel about each other.

WHAT BRIDES WANT

Brides want three things: the telling of the couple's personal story, great posed groups, and some spectacular images alone with their groom. For many photographers, this third must-have will mean making the bride and groom look like they've stepped out of a fairytale or Hallmark card.

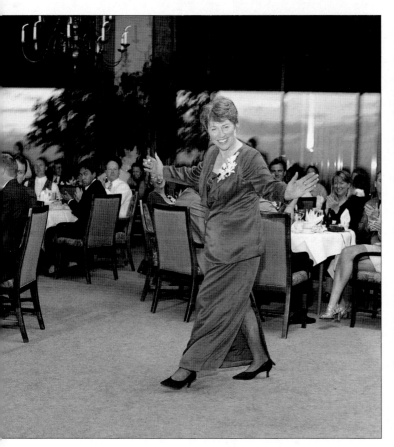

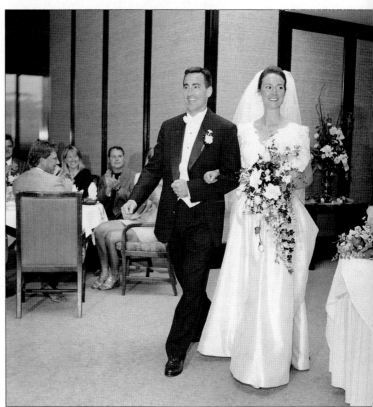

Upon being announced to the assembled reception guests, most people will make some "newsworthy" gesture because they know they're in the spotlight. The lighting here was mixed strobe, hall light, and window light with slight shutter drag of 1/30 sec. to pull in more of the background of people seated at the tables.

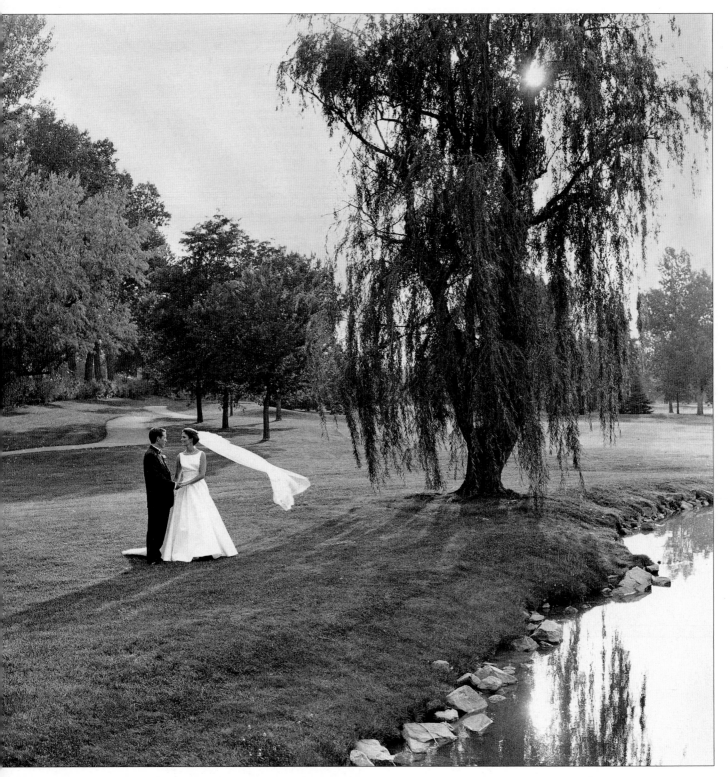

A storybook country club setting conveys timeless, universally felt emotions. The natural-seeming action of the wind was added by an assistant hidden right behind the bride. The exposure was taken by spot meter off the sunny grass. I structured the composition with a strong diagonal and off-center subject placement with the intent of printing the image as a panorama.

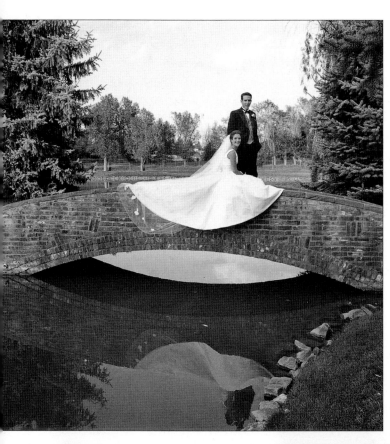

The couple must relax and have fun—allowing unposed, unscripted emotions and gestures to show—while the photographer moves in and out, changes angles and lenses, and creates variety. It's critical to pick a sequestered spot for some privacy from the bridal party and guests.

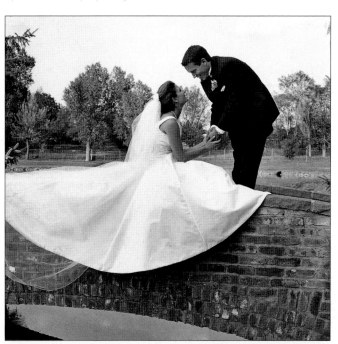

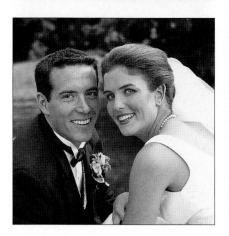

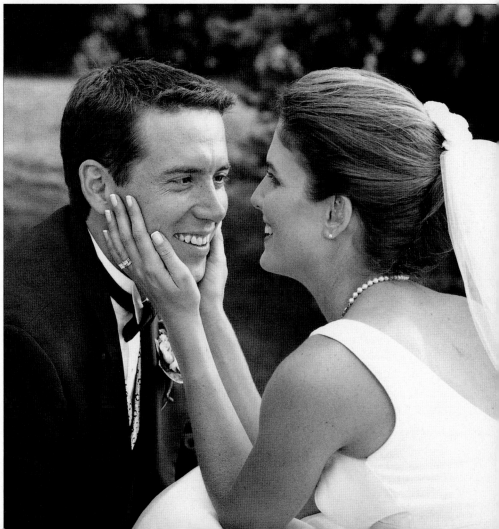

Engagement and Bridal Portrait Series

Almost every couple wants an engagement portrait taken in casual clothing at a fun location. They're looking for a spectacular image that shows both faces and feelings without either the stiffness or tradition of wedding day attire. They want a little fashion, a little glamour, a little sex, a little fun. I treat the important portraiture that precedes the wedding day coverage like a miniseries. It will be an intimate glimpse into their personalities, a story they want to tell about themselves. I call this a personal-imagination portrait.

Classic seamless-paper studio backgrounds are popular, but we sell more location sittings. My inner-city studio is situated on two city lots of mature garden and orchard. For an urban warehouse look, we walk out the back door and down the alley. Sometimes the couple wants a location special to them, or to feature an activity they do together. I've gone by snowmobile to the top of the Continental Divide for a ski instructor, to Denver's warehouse district for a rock singer, and to Coors Field for baseball fans! Many times, I'll give away a Four Seasons of Love portrait series just to have the fun of doing it. The favorite image will become gifts, an enlarged wall portrait, or a "guest book" with a wide mat for signatures. Other options are a multiopening mat holding several images or a portfolio box.

People always need our help to overcome concerns of appearance. I build confidence by making this session lots of fun and showing the couple how well they look on film. The engagement portrait or portrait series may be the first chance to meet the groom and make him comfortable with me and the entire proceedings. Once the groom is reassured I'm on his side, he'll do anything I ask.

Don't assume that older brides and grooms in their forties, fifties, and sixties are uninterested in a fine portrait. They may decide to go to more trouble and expense over a special sitting, and

Gay '90s costumes, plus a background of Victorian houses, showcase this couple's love of old fashioned style as well as the groom's prized antique bicycle. Exposure on ISO 400 film was for the background at f/11 at 1/250 sec., augmented by strobe also at f/11 output.

Colorado's pristine Echo Lake was chosen as the personal-imagination series setting by a couple who enjoyed hiking. A wide variety of lenses and angles, backlight with strobe fill, and open shade with reflector assist complemented an equally wide variety of poses and subject-to-camera distances. I allow about two hours for this kind of series.

then choose candid snapshots for the wedding ceremony. Use light carefully on older faces to soften and complement them. Selective negative and print retouching will be necessary, but I've found that most couples prefer to "show their personality," rather than have all the wrinkles removed. Digital retouching can easily make older faces lose structure and become round and puffy. They must not look like plastic dolls! While doing digital retouching, magnify the faces greatly so that you can see very small details while working, and then reduce to final-print size to gauge the believability of the result before printing. A very large screen monitor will help.

Expect to sell mostly small desk-size prints, or perhaps a little art book or portfolio box to show the whole series. I often try grouping a number of images, each about 3 x 3 inches on a side, mounted as a unit or grid and then framed in art-gallery style. I also like a mat with multiple openings cut at angles.

The formal bridal portrait is a time-honored studio tradition, but I prefer to create it on location. The resulting series must include full length, ¾, bust, and very close-up views, and must

Another delightful possibility is a secret portrait session purchased by the bride as a surprise gift for her groom. The client who really wants to collaborate on an artistic sitting will go to great lengths with props, costume, and makeup. To recreate a '50s-style movie star series for her husband, this bride got books of famous imagery from the library, and I carefully set the scene and lights to match.

Simple clothing, excellent makeup, a distressed building for the background, no-pose posing, and an overcast day all contributed to creating a dramatically Southwestern "Santa Fe" look. "Prop" rocks are featherlight and, even if kept outside, are more comfortable and warm for seating. The sky was lightly overcast and the snow naturally reflective.

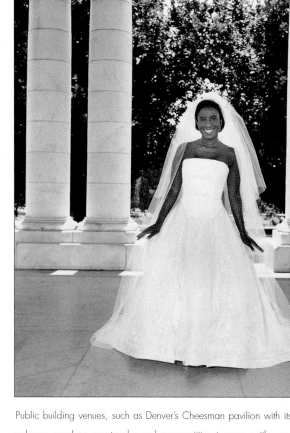

Public building venues, such as Denver's Cheesman pavilion with its Greek-style columns, produce spectacular and nonrepetitive images, with opportunities for both directional and omnidirectional lighting. Above, the bride's fashion pose dances between sparkling white columns with the help of fill strobe. Left, the groom's ³/₄ portrait, at an angle to take advantage of the visual depth of the receding columns and lit only with natural light, is handsomely introspective.

show all aspects of the wedding regalia and the locale, not just the exquisite face and expression. We arrange for everything, from sheets to protect the gown to a real bouquet. Our team fusses and primps. On the practical side, a formal portrait gives the bride a chance to try out her hairstyle and makeup, and see how long it takes to dress. The bride's mother or friends are always invited to share the fun. And, the tradition of the formal portrait pleases mothers, particularly if the wedding day coverage will be primarily candid.

We often use a small, densely planted flower garden as a setting. Private homes, historic mansions, and elaborate building lobbies are some other great alternatives. We take the time to go on location for background ambience for the same reason that catalog companies do it—to enhance the visual appeal to the buying public.

Coverage of Pre- and Post-Wedding Events

Pre- and post-wedding events coverage will probably need explanation to most clients. Think of all the months of memories from the first time the engagement ring is slipped on, to the trying on of dresses, to the rehearsal dinner and bridesmaids' luncheon, to the casual Sunday brunch. A honeymoon series would be nice if I could get it!

Right from the first consultation, I suggest everything from individual and engagement portraits to bride's formal portrait to family reunion images to personal-imagination portraits for covering the events planned for the guests. Various portrait- and peripheral-event possibilities serve to create completeness of coverage.

Often a couple marrying in the winter will choose to have a special sitting with flowers and green trees the following summer. If timing and customer requirements permit, I confine the actual wedding day as much as possible to photojournalistic, or reportage, style photography; the other photo opportunities will provide two things: (1) unhurried natural situations for posing and looking into the camera; and (2) a wealth of moment-by-moment vignettes.

WEEK-LONG WEDDING CELEBRATION

My larger-coverage packages now automatically provide multiday service to include a rehearsal dinner and an out-of-towners brunch. Several years ago, I expanded coverage for a couple creating a wonderful Rocky Mountain-experience for their guests. I covered a welcome party, jeep trips, a historic-house tour, white-water rafting, trail rides, western barbecue with line dancing, golf, ladies' luncheon, and brunch at the top of Aspen mountain. I also photographed the couple in Aspen's outrageously beautiful landscapes. I made an extensive family series, with breakout groups, at the Elk Mountain Lodge, along with images of the bride alone in her gown on her family's hillside flower garden. Amid all this, the wedding ceremony took place, followed by a huge dinner party. Such coverage is time and labor intensive. You must capture a series of images from each part of an event that will report the overall scene, people, and details.

There should also be lots of paparazzi-style images, which lend themselves well to a collaged album page of miniatures. A more conservative approach would be to select just one single photo to represent the couples' involvement in each activity. This is ideal for a coffee table portfolio box presentation. The Aspen couple had a double album: one for the week's activities, the other for the actual wedding day. In addition to parents' gift albums, they ordered 130 guest albums, which contained fun photos pertinent to each recipient, as well as favorites of the couple and the overall event.

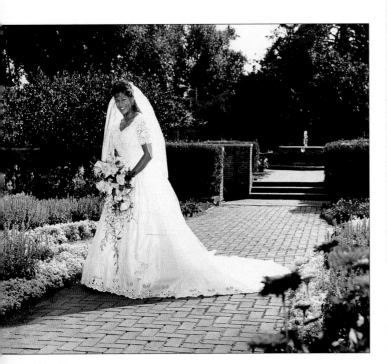

Lushness of location and season were composed in an unusual horizontal format to achieve a pictorial heirloom portrait. Note the use of out-of-focus flowers in the foreground to imply three-dimensionality. I set exposure for the background with the addition of fill strobe and natural reflection from the brick sidewalk.

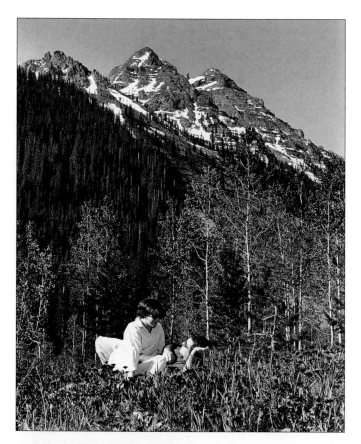

The relaxed, unposed couple is almost anonymous amidst the riot of nature, even though they are physically placed in a compositionally strong center of interest. (See pages 56–62 for information on composition.) A 50mm wide-angle lens and the low vantage point add to the sense that the camera is the unseen observer. The original in color was brilliant, with the field of yellow dandelions in full sun. The black-and-white version is rich with visual details and is a good candidate for selective handcoloring. (See pages 142–145 for information on handcoloring).

This pre- and post-wedding coverage is my interpretation of the photographic portrait styles of Asia, where there is generally no reportage-style coverage of the actual wedding event. Bride and groom select western wedding dress, Las Vegas glitz, and antique costumes to be photographed in mansions, in lush gardens, and at public monuments.

When my brother married a charming lady from Japan, we collaborated on a personal history book of their American lifestyle that alluded to Japanese artistic tradition. Individual portraits in various outfits led to a coat-and-tie formal portrait, followed by photos showing their new home inside and out, their pets, their cars, and their hobbies. Then, they brought in vacation snapshots for a double-page spread. As theirs was a civil ceremony with no

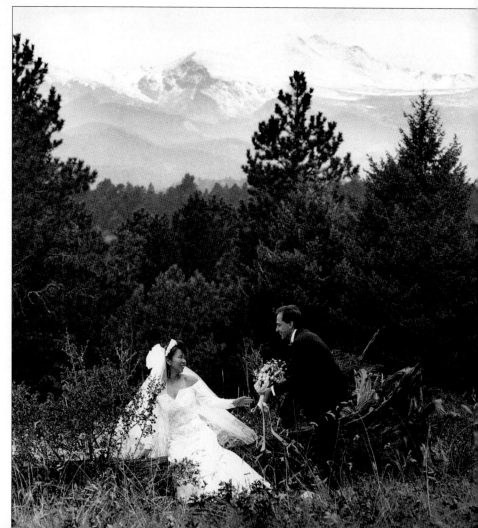

Photo-aerobics is what I call the unusual pose juxtaposition needed for the king-and-queen-of-hearts playing card-style portrait above. I used fairly flat-on studio strobes with a very high camera position, an 80mm normal-angle lens, and an edge vignetter. The mountain setting, right, needed fill strobe to combat both contrasty conditions and flat downlight (direct overhead lighting). Both mountains and sky required extra burning in to reproduce pleasing details. Black and white typically reproduces deep green tones with little of the variation seen by the eye.

guests or reception, we made a glamour-style wedding dress portrait in the studio, at a church, and in the mountains. They both had such fun with the "dress up" that they ended the book with a "picnic" of champagne served on the train of the wedding gown!

There's a limit to how many photographs showing wedding attire a couple will purchase. The more facets to the photographic coverage over a longer period of time, the more possible sales. You have to be willing to go out many different times on short notice for just a few images. Casual clothing and specialty locations, as well as the inclusion of other family members and events, vastly expand the client's perception of value and, thus, the price you can charge. Specialty sessions also prime the new couple to purchase professional photographs often in the future to record the progression of family history. Once couples see the samples and have fun being photographed, they'll be clients for life.

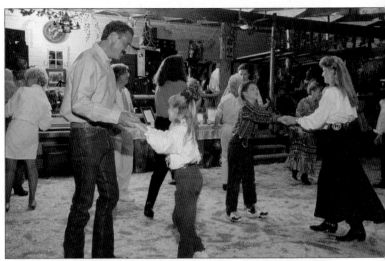

The Midwestern custom of a barn party for the rehearsal dinner/dance affords so much fun for all participants that I can't imagine missing the candid possibilities. Most often, 35mm is my choice for party snaps. Hall lighting and shutter drag add to the lively feel.

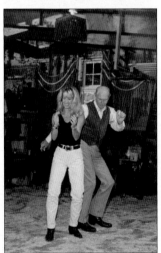

Group Photography Is Not Dead!

It can be justifiably argued that wedding photography is all about groups. Translation: Group photographs demonstrate the relationships between people at a special time. For every wedding—repeat, for *every* wedding—there will be portraits with one or two people in them, events coverage, still life, spontaneous candids, and groups. The only difference is how these photos are made: formal and traditional, or unposed and loose. With all the emphasis placed on candid and photojournalistic style, it may seem that professional opinion has determined that the contemporary bride is no longer much interested in group photography. Don't be fooled! It's surprising just how many people feel they look their best when carefully posed. Clients buy images of groups and formal poses because the professional is the only one who can pose them well—witness the friends and relations who relentlessly snap over the wedding photographer's shoulder when he or she is arranging groups.

Group posing is sometimes used for scenes usually categorized as spontaneous candids. In the Latin American culture and community prevalent in the Miami area, the presentation of gifts and flowers during the ceremony, the first dance, and the cake presentation and cutting are all intricately staged for the camera (not allowed to unfold as they actually happen during the wed-

Moments before forming a receiving line this interesting grouping presented itself spontaneously, and I captured it with a 50mm wide-angle lens from a high vantage point.

ding and ceremony) and show carefully grouped family members. Often, minimal attention is paid photographically to these events while they are actually in progress. This approach results in very symbolic imagery that's also potentially perfect and dramatically elegant, even if it repeats from client to client.

It's inappropriate to assume that the black-and-white photography client automatically wants photojournalism and nothing more. Don't prejudge the style, much less the purse, of any client; you have to be willing and able to ask the right questions that will

reveal cultural diversity and buying motivation. For instance, you'll achieve extra sales if you make receiving line photos of every guest who asks to be posed with the couple (who is often unabashedly treated as royalty, as in the custom of some evangelical churches). By accepting commissioned work, you must balance your own artistic style with the individual desires that make each couple different. Your artistic ability and style are paramount, but your ego must not unduly impose your own bias on your client's personality. While you may choose to specialize in just one style of wedding photography, be aware that such specialization will typecast you. Style specialization is good in that it's recognizable, unified, complete, and artistic; it's bad in that you're seriously limiting your market and that clients in this funny wedding industry of ours may pass you by as inflexible.

Why is group photography so necessary? Almost invariably, clients tell me right off they don't want to spend much time posing for pictures. They want to save time and avoid a stiff look. I

A background this extraordinary is like the ultimate travel picture; people simply want to pose in front of a great scene. It's up to the photographer not to let the creativity end with the view, but to arrange subjects in an interesting composition.

realize that this informal, independent stance is a regional difference, at least partly characteristic of the Rocky Mountain-area. It's easy to equate "no posing" with "no groups." Logically, you might conclude that if your clients don't want to hold still for organized posing, they are primarily interested in candids and photojournalistic style. However, the most serious client complaint is that a certain group was not taken, or that someone was missing, or that all the individuals in the group did not look their best. I well remember with chagrin a bride and her mother who wanted to pose all groups before the ceremony but also did not want the bride and groom to see each other. Later, the complaint was that groom was not included in the bride's family picture, nor she in his!

I use this crazy, funny bunch of friends as a litmus test of style. In this image, people's eyes are going every which way, and everyone is doing something different. If a bride doesn't react positively to this photograph, I know she will not accept unposed groups.

Weddings are a landmark time when it's actually possible to bring distant family members together without too much trouble or argument about buying clothing to match for a portrait. Sometimes the new spouse-to-be is included, sometimes not— but always, the ultimate sale from this sitting alone will be excellent. Posing in this example was casually traditional; exposure was for the background with equal strobe assist.

Some years ago, my staff and I had an epiphany about groups during a nine-hour event. We all noticed how strangely the photography evolved and came to the same conclusions separately, later sharing our newfound understanding. The couple had asked to pose as little as possible, listed no special family groups on their request list, wanted to spend uninterrupted time with guests, and declared they preferred candids. The groom said a number of times how he really hated to pose, because he felt like his face was set in cement. Naturally, I prepared to play the role of the unseen photographer, silently recording without intervening. I was simply astonished when not only the bride and groom but even family members started openly asking for lots of groupings not previously discussed! This was how we finally figured out that everyone, regardless of stylistic preferences, wants groups.

It was a religious experience to come to this understanding. We've gotten too busy with the more photographically sexy techniques of photojournalism, still life, and dramatic action. It should be our first and foremost public relations job to find out just how many groups are wanted, along with the how and the when. To the client, the need for groups is axiomatic. It's a ritual within a ritual to pose for group photos. Photographers aren't recognizing the need, nor the contemporary subtleties, of how groups should be photographed to meld with the overall coverage style.

In the end, you need to be absolutely sure of the answers to two essential questions: How extensive is the coverage of groups to be, and most importantly, Are the groups to be traditionally posed or casually drawn together? I always hope I'm not asked to photograph needlessly redundant combinations of people, for example, person A plus B; A plus C; A, B, and C; B and D; A, C, and D, and so forth. Speed is always a concern, so you may be forced to picture a great number of changing faces against a boringly identical background. The knowledgeable client knows redundancy to be an artistic waste, but will nevertheless require images of immediate and extended families, and almost certainly breakout groups. Show samples of a various levels of formality and background types so that your clients can point directly to the styles they like best.

Casual, of course, doesn't mean careless, either in posing or photographic technique. Once a group is in place, scan all heads and shoulders to see whether each person looks good as an individual. Even in an ultracasual arrangement, if each face can't be seen plainly, the group is a failure. Most people actually prefer to be arranged and coached, because that's when they think they look their best. Above all other considerations, how well you handle the groups will determine the level of customer satisfaction and the ultimate sale.

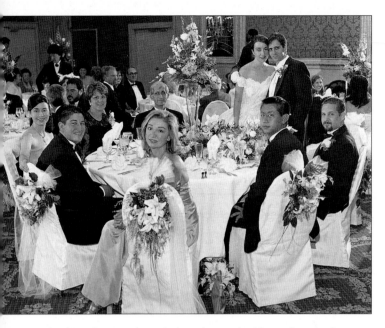

An elevated position from which to photograph tables, such as standing on a metal equipment case, affords better perspective, focus, and depth of light. One assistant tells people to look at me, and then I wave to them so that they see me easily and are subtly influenced that this is fun. Another assistant holds a hand strobe to create rim or background light, or else we light the room as a whole. Shutter drag at 1/15 sec. is standard in a dark banquet hall. Be sure not to impede the service of the wait staff as you move from table to table.

THE MOTHER WHO WANTED IT ALL

Don't suppose that a separate portrait will always eliminate the need for duplicate groups on the actual wedding day. I got a lesson in reading client motivations through my experience with a very family-oriented mother from Texas. She loved the separate-portrait idea and got the groom's family to participate. Both families later purchased strongly from the relaxed, but traditionally posed session. On the wedding day I felt I could be quite a bit more casual by pulling together groups that were actually doing something rather than camera watching. I didn't give much effort to posed groups, excepting the extended families and the wedding party. Imagine my shock when the mother bought every grouping and would have selected more had I made more! While she was open to the artistic style of the charming, spontaneous photograph, she did voice disappointment that not everyone was tack sharp (I had handheld the camera in available light at ISO 1000). I offered to personally sharpen features with dye retouching, because, as she noted, some images were the only such groupings she had.

Given the premise that group photographs often drive extra print sales, I'm always trying new ways to make them easier to take, more memorable for the client, and more carefully crafted to be worthy of a wall print. The wedding clothes themselves, ordinary standing poses, and religious backgrounds all seem to limit the long-term display and enjoyment potential of a family group image. Nobody wants to put a 20 x 24-inch "altar return print" (an image made when the wedding party returns to the altar for photographs after the ceremony) over the mantle. Uncoordinated clothing styles, even if all formal, are as distracting in a wedding group as they are in any portrait. And they're too "wedding-y." I, therefore, started offering a family sitting as a package option. This session is slated for a different day and designed for casual, real-life, nonritualistic attire. The location can be the same as the wedding or quite different. Ideal times are just before the rehearsal dinner or at brunch the day after. This extra service always nets a good add-on sale.

At the wedding itself, most clients want the VIP guest tables photographed as groups. Many want every table—always a logistical nightmare, and worse if the couple joins each table. It's dark, tables are very close, and there may be thirty or more tables. We may get in the way of the wait staff serving dinner. People get up and leave their tables anytime. I make a list of all table numbers and check them off as I go, trying to start before the food is served. I pass by tables with empty chairs, which requires remembering to come back again. I prefer not to make half the guests at a table get up and stand behind the others, but I always ask my clients which look they prefer. In any case, someone always has to slide out from behind the flower arrangement. Medium-speed ISO 400 film is a good choice for sufficient depth of field at an approximately fifteen-foot distance, considering the width of tables and low-light focus problems. Since there's no movement, I drag the shutter at least 1/15 sec. to better capture ambient light as well as any strobes we may have placed to bounce light into the hall ceiling.

More No-Pose Posing Tips

I call my personal style of arranging people no-pose posing; what I really do is place people attractively in a matter of moments by using elements of the random environment and found objects at hand. I never know just what I'll find to work with, and whatever I do, I must do it in a very short period of time. Here are some more tips both about how I get the cooperation I need and also make up my mind about posing at the last moment.

∼ BODY LANGUAGE ∼

This is key; it follows through with a theme or feeling to make expression real, believable, and personal. Body language is where the "story" part of photographic storytelling happens. Observe what people do naturally and build poses on these stances and gestures. Subjects become more cooperative if you are enthusiastic. Make quick corrections to hands, head/hair, shoulders, and feet before the pose becomes stiff and lifeless.

Slouching, relaxing of the shoulders, and elongation of the torso all have their place in no-pose posing; it just depends on the look you're going for. Careful attention to torso posture—not just straight, but stretched as tall as possible and leaning forward—can dramatically improve a portrait.

Be bold, and play the director by sizing up your subjects and deciding how you will bring out their personalities in the portrait. Very simple props are often the best to aid in inducing good expressions. Knowledge of conventional body positioning only provides you with a foundation of ideas on which to build; in practice, you must think of letting form follow function, which means that body language is dictated by the action or emotion portrayed.

It is said the French have a very advanced sense of style. This bride could have stepped from the pages of French *Vogue* with no coaching from me. Her unusual backwards pose was at once exotic, charming, and uniquely her.

Men particularly like to be pictured comfortably, with relaxed body language. I captured this elegant, moody expression unawares in between formal poses.

~ CLOTHES ~

A clothing consultation, even if only by phone, is critical in order to previsualize the level of formality and the look for which your subjects are aiming. Show clients plenty of samples of different locations, times of year, and types of outfits so that they get ideas about how they'll look on film. Homogeneity of clothing style, sometimes identical clothing, can be the difference between a nice image and a competition winner. Beware the bride for whom casual means a little black dress but for whose fiancé it means just a polo shirt.

~ REASSURANCE AND INTERACTION ~

Reassure your clients continuously of how well they're doing during the photography. Talk about feelings with words and gestures, and feel free to laugh a lot. Touching is very much okay. In cultures or situations in which touching by a male photographer would be wrong, I've watched the female posing assistant do this job while the photographer "fine-tunes" for artistic effect with his eloquent hand gestures. We always rearrange clothing in small ways even if no correction is truly needed. Wedding guests tell me my enthusiasm makes it obvious I'm having fun along with my clients.

~ FASHION MAGAZINES ~

Take inspiration from high fashion magazines, and know when to arrange the dress and hair precisely and when to keep hands off. If you rearrange a client's natural pose too much, or if you take too long with your equipment, you'll probably lose the effect. Conversely, most people don't want to look so casual for a wedding that their appearance implies the event was of little importance.

A personal-imagination sitting must tell a couple's unique story. Above, the first couple's clothing takes a sexy, devil-may-care attitude and says, We're free to be ourselves. The right image—with carefully coordinated country club tailoring—says, Now we're a family.

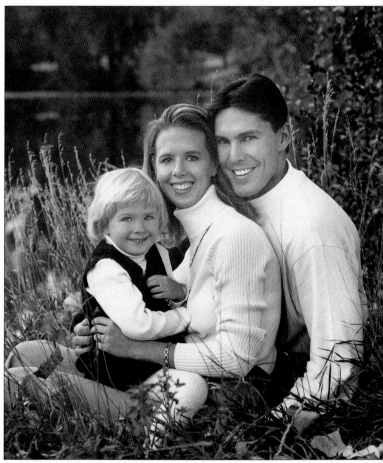

~ SCOUTING ~

Site visits, by the wedding photographer, to scout the right backgrounds are a must. Know the layout of each event venue and all the rules imposed by the management. Scout for useful backgrounds in public places that nevertheless afford some degree of privacy. Note the best lighting and angles at different times of day. We have a list of interesting locales, which helps clients to start thinking about how great their own engagement or family portrait could look.

~ EQUIPMENT ~

Equipment determines what's possible, assuming you have that equipment with you. Exotic glass, meaning unusual focal length lenses, will help you make extraordinary images. Experimentation will teach you how to make a basic lens set of normal, wide, and moderate telephoto lenses perform to the maximum by changing camera-to-subject distances and angles. Learn to operate all your equipment with speed and accuracy, as if it were an extension of your hands and eyes.

~ FILM VARIETY ~

Having a large quantity of a variety of films at every job will let you perform to the same exacting creative standards as a commercial photographer. This is especially true if you are both philosophically willing and technically sophisticated enough to allow a wedding to dictate its own style. Using only one type of film seriously limits your effectiveness. Know your location and circumstances, and choose films accordingly. Then, you need only take advantage of the opportunities as they present themselves. Modular film backs make multiple films instantly available, otherwise you'll need multiple cameras.

~ LIGHT ~

Use available light whenever possible to get the most seamless, natural look, because it will imply that the camera has been the unseen observer. Before the sitting begins, I meter several times for minor exposure variations in a specific room or outdoor area due to angle or shade. As I work, I mentally calculate and readjust settings as I move around the subjects. For automatic cameras, be sure to point the meter dot so that it will read only faces. Remember to set your ISO for this scenario at one stop more exposure than normal (i.e. ISO 80 rather than ISO 160), because faces are generally a Zone VI and your meter reads Zone V. (See page 96 for the explanation of Zones.)

Helpful techniques are to use faster films, use just a wink light to add eye sparkle, drop your shutter speed to record more ambient light, or raise the overall room illumination with hidden strobes that create bounce light. There are so many speeds of quality film available now that push or pull processing should be used only in cases of operator error in overall exposure, rather than as a stylistic choice.

~ BACKGROUND AWARENESS ~

This means being constantly aware of what's in the background, what the exposure value of the background is in relation to the subject, and where features of the background are in relation to heads. Your eye focus must shift back and forth, from subject to background and back again, dwelling on the background only long enough to make camera angle adjustments that will eliminate power poles, avoid chandeliers coming out of heads, and fix twisted hangers on a rack. It's a sort of subliminal awareness that will elevate your design and compositional ability.

~ PHOTOGRAPHER APPEARANCE ~

Usually, dark colored clothing will make it possible for you to magically blend with the scene of the wedding. It's extra hard to get clients comfortable in front of the camera when you yourself stick out from the crowd. While the conventional "uniform" of tuxedos or business suits may be right for your region, I prefer my staff attired as a sleekly sophisticated Hollywood film crew. We're coordinated but not identical. Armani designs and Hugo Boss set a great tone; Patagonia brand is similar and a bit less costly.

You'll probably get more candid opportunities if your camera gear seems less intrusive by being more compact and having fewer cords and accessories hanging all over it. I try hard to think physically small and inconspicuous, especially during toasting and cake-cutting. I hate to hear guests complaining that the photographer and videographer stood right in front the whole time and obscured everyone's view of the proceedings.

~ BASE OF OPERATIONS ~

An operations base for your equipment and film is a necessity on location. Most hotel and hall managers don't seem to understand this requirement yet are annoyed if you pile 150 pounds of gear in the corner. Find a place, preferably not on the floor, which is accessible but protected from guests and wait staff. I want security for the gear in an inconspicuous place where I can set out the materials needed and grab things quickly.

～ USE OF ASSISTANTS ～

Strangely, I've never met anyone who finds this intrusive. Instead, brides either openly or secretly delight in personal attention. Use of assistants is glamorous, efficient, speedy, and has the added benefit of distracting the clients so that they begin to relax and enjoy the experience, thus allowing the photographer to see and capture more of their real personalities. A location affording some degree of privacy is appropriate, even if it's in a public park.

Work with an assistant in the manner of commercial photographers. An assistant is different from a second camera person, because he or she handles the equipment and perhaps also arranges some details of the subjects, allowing you the freedom to think and create. This person's sole function is to deal with the technical concerns of the job and to make sure you have what you need when you need it. I carry some $30,000 worth of gear to every job, often to quite public locations. A second pair of eyes and hands will more than double security for the equipment. Another technical function is to smooth the way for the client with both words and actions. Tiny attentions to details, simple suggestions, a bag full of "necessaries" such as pins and scissors, explanations of what to do in front of the camera, and a big smile are all invaluable equipment.

～ ANTICIPATING ACTION ～

Anticipate the action and emotions of the event, and demand the same ability from your assistants. This takes experience and concentration, but mostly you just have to be willing to keep working and not sit down on the job. It has always seemed obvious to me that other photographers' biggest problem is mobility; they seem to plant their feet and not move off that spot. Be flexible enough to move in closer, to back off, and to turn around to perceive, frame, and capture the important fleeting moments before they are lost forever.

～ CAMERA ANGLES ～

Use of two camera angles at certain times pays huge storytelling dividends. In a large church, for instance, views from the balcony will be complemented by simultaneous photography from the side or main aisle. The grand exit is well covered from both inside and outside the church door, or across the street. Sometimes it's possible to do two angles yourself by running around or being prepared to switch lenses or cameras quickly. A second cameraperson could be the ideal solution, as long as you preplan who will do what and when.

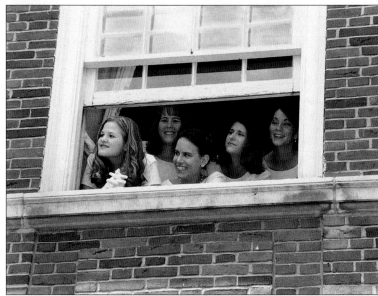

While beginning personal portraiture in front of the Phipps Mansion for the bride and groom alone (top), I spied a bridesmaid taking a peek from the upstairs dressing room window. I was ready with a second camera and got a single image when, for a moment, all the bridesmaids appeared together to admire their friends (bottom). Natural light was metered on skin tone and adjusted plus one *f*-stop.

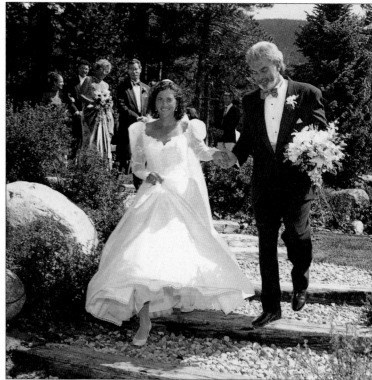

Multiple views of the recessional in the manner of stop-action video are a must. The unusual rear angle of the couple starting their exit walk provides a "bride's-eye" view, capturing as emotional a memory as the charming candid taken after the couple has passed through all the guests.

∼ IN-BETWEEN MOMENTS ∼

Interludes between traditional wedding events provide the action and emotions of most interest to the photojournalist. When most photographers put their cameras down, you need to be prepared to capture, quietly, the best expressions of the day. Ever notice how grandma kisses the groom right after the camera clicks on her stiff, formal look? Be ready during the dressing, meeting and greeting, fixing-up of flowers, anticipating, congratulating, pouring, serving, toasting, dancing, and walking away to name a few excellent photo opportunities.

I've discovered that it's actually easy, given the happy wedding scenario and the ebullient spirits that go along with it, to induce people to "act out" the feelings they already have for one another. If I tell subjects they look good and are having fun, all of a sudden they realize it's true. Then they relax and begin to really enjoy their own event. The expressions, therefore, just keep getting better and better.

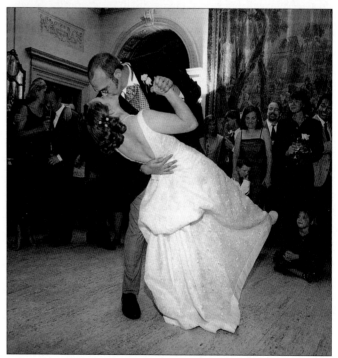

Unless a couple has practiced a routine, the first dance is more about feelings than action. I knew I had a good series but stayed ready. My patience was rewarded when the groom dipped his bride at the very end of their song. Film and exposure were ISO 160 with f/8 at 1/60 sec.; the ceiling was bounce-lit with a 400-watt-per-second studio light synchronized to on-camera strobe.

Composition without Clutter

~

In color photography, a busy background can be burned in during printing, or darkened with various retouching techniques. In black-and-white photography, the disunifying effect of clutter will often remain in spite of enhancements, or the enhancement will look false. The viewer's eye gets confused with unwanted elements and roams the image, dissatisfied by unclear meaning.

Black-and-white photography cannot be other than a graphic medium, and as such, its impact is intensified by simple lines and uncluttered composition. When the extraneous is left out, good design will practically impose itself automatically on your composition.

The first and best advice is to move in on your subjects; often, you'll need to close in tighter in black and white than in color for greatest impact. Crop out everything unattractive. Client after client tells me she loves how my photographs are close and sharp on the people, without so much empty space around them. The approach I prefer is based on spatial composition favored by many modern painters. If surrounded and isolated by dead space, a subject will recede; close cropping, whether in-camera or during printing, visually projects the meaning.

The difference is a matter of millimeters. The simplified explanation is this: Old-fashioned composition, especially still lifes, isolated the subject dead center. Arguably the most famous portrait of all time, Leonardo da Vinci's *Mona Lisa* (1500–1504), is centered, but remember that she is famous primarily for her expression. Modern composition—à la Matisse, Picasso, Bonnard, and de Kooning—pushed elements of the subject matter to the edge of the composition and beyond, out of the image. Part of a chair, or only half of a person may be visible. Unconventional use of empty space can visually make action come alive and will put the viewer right in the midst of it. For many black-and-white photography clients, it will be acceptable to use extreme off-centering, tipped horizon lines, blurred movement, and even show the backs of heads.

However, softer styles of classic composition—for instance, framing the subject with existing backgrounds (such as an archway, tree branches, or a window)—never cease to be visually intriguing. The jury is still out as to whether some of today's very loose, untraditional styles will remain viable as art after passage of time. The more usual client in the greater scheme of the eternally traditional world of weddings is probably not quite as interested in the fashion/rock/video look.

Layers of focus or layers of light and darkness provide meaning and emotion in the story. Look for oblique angles in which naturally occurring depth, from foreground to middle ground to background of a scene, will inevitably throw some elements out of focus. Depth and dimensionality can also be built with creative use of lenses and multiple lights. It should go without saying that you must clear away unwanted clutter, for instance bags and curling irons and jeans in the dressing room. (A photograph with stuff all over the place may, however, provide material for a valid photojournalist image.)

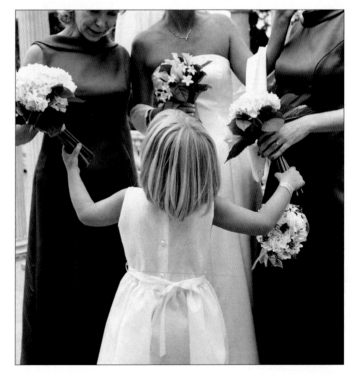

With faces hardly visible at all, the child's gesture speaks volumes of feeling. The subject matter is concentrated in the upper half of the image, leaving the lower half visually bare. While conventional rules of composition would place "heavy" elements toward the bottom of the photograph, cropping this one just below the elbows would be an artistic mistake. An alternative would have been to elevate the camera position, place the little girl's head at the extreme image bottom, and allow contrasting heights of the subjects to tell the story.

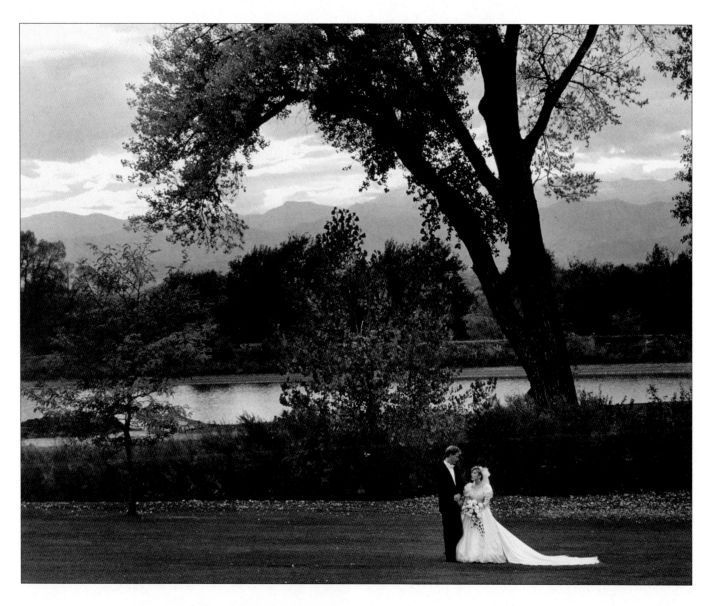

Black-and-white photography can easily take on a stiff, old-fashioned feel. Of course, there are circumstances under which such formality could be entirely appropriate. Group poses are historically significant anyway. When viewing an older family album, someone always remarks, Look how weddings were done in Grandma's day! In order for the timeless quality of black and white to be really successful, I believe that images must be posed to perfection or totally candid. Since line and form take compositional precedence in the absence of color, the viewer more quickly perceives how awkward or ridiculous an inept arrangement of people and clothing appears. A bonus is that black and white *does* mask the fashion sins of the past; burnt orange bridesmaids' gowns from twenty years ago will mercifully not continue to haunt the bride today.

Dramatic scenes with small figures and lots of "empty" space may win professional awards—in this case a Kodak Gallery award—and client accolades alike.

Big, heavy shadows caused by flash placement that's too low or to the side, or when the background is too close, are another kind of clutter to be avoided. Highly regrettable in color, shadows become looming black holes or ugly dead space in black and white. The eye gravitates naturally toward the tonal extreme. The general rule is to lower contrast for color portrait work. However, in black and white, flat light usually drops dead. Only in a few specialized circumstances, for instance a snow scene or very soft light, will exclusively middle-range tones work artistically. Contrast and shadow created by *competent* directional lighting generate a dynamic feeling that's almost a necessity in black-and-white photography.

An oblique angle permits the unusual venue to be an important part of the meaning of this rather formal group. They look like they've stepped from the pages of a British period novel. Careful placement of the subjects assures that the decor doesn't interfere with or overpower the faces. The antique decanters in the foreground add to the sense of three-dimensionality. The exposure was made with available light at 1/60 sec. at f/8 with ISO 400 film.

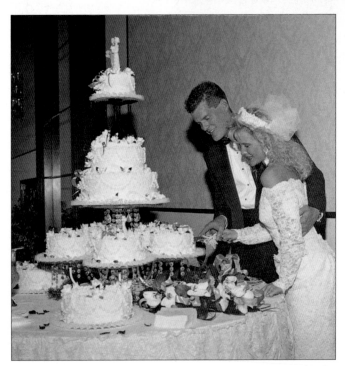 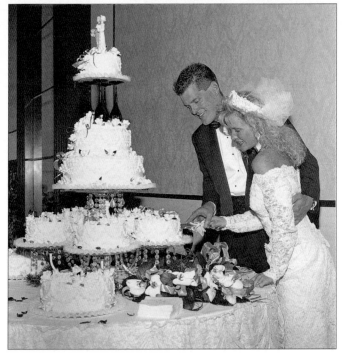

Placed on a narrow, four-step dais, this couple was forced to stand almost against the wall to cut the cake. The only available camera angle resulted in a shadow too unprofessional for me to permit in the bridal album (left). Digital recreation saved the image (right).

The Architecture of Meaning

Elements of photographic composition fit together like building blocks of architectural design that bring forth the genius of artistic inspiration to achieve a meaningful and beautiful whole. Artistic composition is related to our understanding and enjoyment of the spaces in which we live; we call this structure, framework, skeleton, pattern, form, or foundation. The architectural style or period of a great edifice is incidental, because it is timeless. Some examples are the Acropolis, the Taj Mahal, Frank Lloyd Wright's Falling Water house, and Frank Gehry's Guggenheim Museum in Bilbao. All have impact and imaginative fire. They are so memorable that they fire our imagination, as well.

~ FOCAL POINT ~

Artists and mathematicians have devised many systems for placing the main subject in just the right spot for emphasis as the focal point of a composition. Three of the most useful are the Rule of Thirds, Bakker's Saddle, and the Golden Section, all grid systems

This Victorian church provided an ideal setting, offering both highly directional lighting and an unconventional angle that pictorially bridges the present to the past. Though it might seem distracting, the checkerboard floor adds to the historical aura. I determined the exposure by taking a spot reading on the shadow side of the faces, with the wall to the right providing sufficient fill.

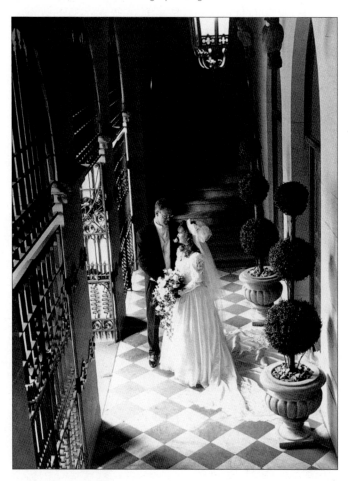

of lines that are superimposed over any composition. Doing this, the artist then places the subject at one of the points of intersection of the grid lines for greatest impact.

The three grids at right are the Golden Section, Rule of Thirds, and Bakker's Saddle systems. By visualizing these grids over a composition, the photographer can find the most successful compositions often by placing the image's focal point on one of the points of intersection of the grid lines.

∼ VISION PATH ∼

The vision path is the traffic pattern the viewer's eye will take on its way to find the focal point and, eventually, the meaning of the image. Letter shapes such as C, S, L, or V are prevalent vision paths, as are triangle, circle, or cruciform shapes. Repetition of a shape, color, or light/dark tone helps to mark the visual pathway. It is said that the eye subconsciously detects a pattern after two repetitions, and that a third confirms meaning.

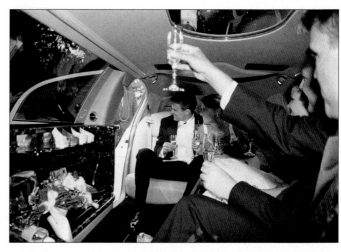

The groomsman's hands in the foreground (right) create a backward C-shape that encloses, but does not confine, the focal point of the bride and groom looking out the open door of the limousine.

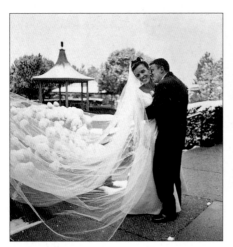
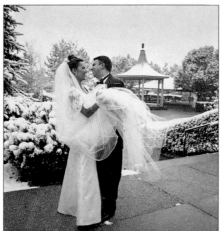
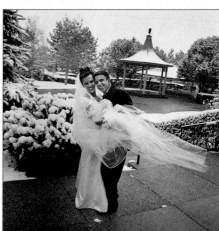

For the series above, I tried several arrangements, each of which has a different emotional dynamic. The flowing form of the veil creates a varying S-curve in each composition. I used a 50mm wide-angle lens held at eye level for the first two images and then turned the camera upside down and held it over my head for the third.

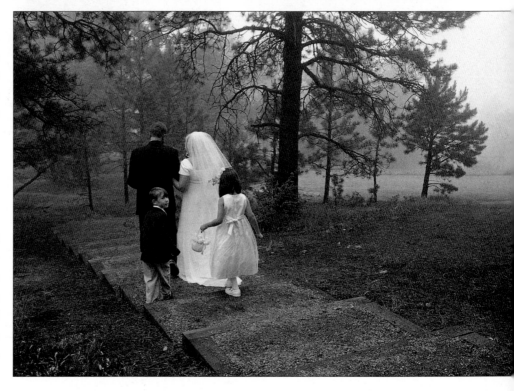

Atmospheric conditions provided a beautiful vignetting of mist as the couple walked past me after the ceremony. I waited until their vertical shapes formed a perfect L-shape with the path. The children add bonus interest. Note the unconventional focal point placement to the left of the composition, and the implied action continuing outside the frame (the idea that they will eventually walk out of the image).

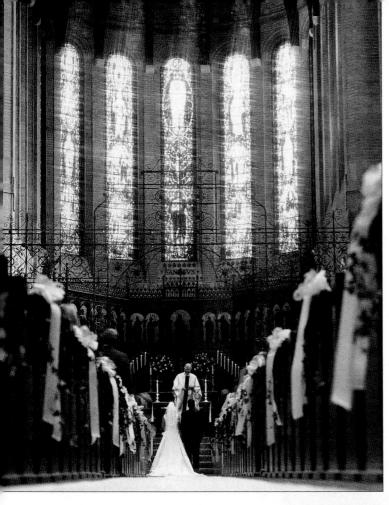

Lines of the building, staggered posing of the wedding party, and the advantageous placement of the couple on the balcony all add to the A-shape, triangular composition. Natural sidelight was augmented by on-camera strobe to even out the contrast on faces.

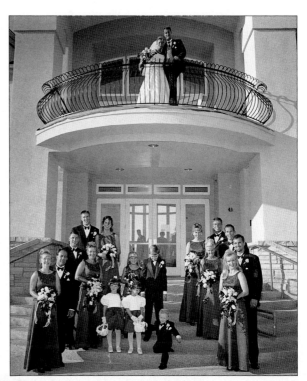

The simple expedience of photographing from the floor takes advantage of the receding pews to record a powerful V-shape, with the center of interest balancing on the point of the V. The windows (and their height) make the composition more effective by their intrinsic architectural interest and because they necessitate the focal point being low in the frame.

The two young girls with their backs to the camera complete the O-shape circle of action and keep the viewer's eye revolving within the frame. The subjects are involved in themselves, and it's almost possible to hear the excited chatter of last minute preparations.

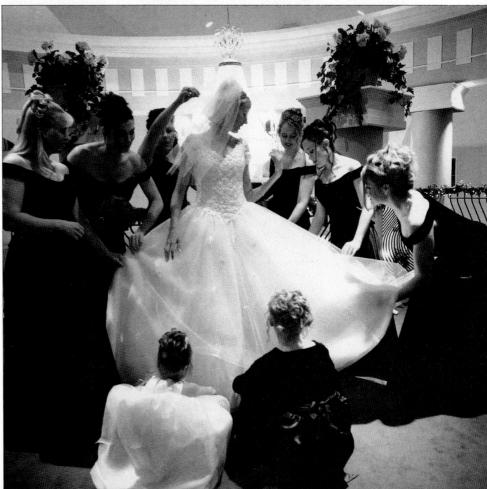

~ DOMINANT STYLE ~

Dominant style refers to all the supportive elements that reinforce meaning and finish the whole. These are the photographer's choices of technique or format, of cool or warm tones, of size, of presentation, and of decorative elements. Style addresses both usefulness and visual appeal of the compositional "traffic pattern" in an image.

The uncommon cruciform arrangement calls for two compositional lines to bisect each other. In this case, it's the receding aisle forming a vertical line that intersects with the horizontal formed by the groom and his groomsmen. Usually, the subjects' heads wouldn't be placed side by side at the exact same level, but by breaking the rule, this image gains a powerfully stable and regal feeling. By happy accident, the period chandeliers echo the same shape.

Image space is divided by strong diagonals created by the foreground shade and tree trunk silhouettes. The focal point is then "placed" for both maximum impact and implied action that is at once directed and enclosed by the V-shape.

Additional Elements of a Picture

~ FRAMING ~

Framing a subject allows the viewer to remain the unseen observer of real, unaffected action and emotion. We all love looking in or out of a window or door, because the scene appears contained in an ornamental border. Framing with leaves overhead or arch-ways are two classic examples of what may be the most powerful compositional device.

Note that space that's merely left over will add nothing visually and will probably give a feeling that's negative and uncomfortable, vague and amorphous. Hotel hallways are a good example of lonely, segregated space. The most effective positive space is space that's shaped, definite, and only partly encloses the focal point. We're not comfortable in small, confining rooms with closed doors. A sense of balance and freedom must be felt.

Preplanning for success, I posed this bride to achieve natural sidelighting in her veil and a halo silhouette from the church's arched walkway. Once completely camera-ready, I told the little boy to go hold his aunt's hand. She was coached to talk to him so that I could capture the fleetingly real moment before he remembered his mother has told him to smile for the camera.

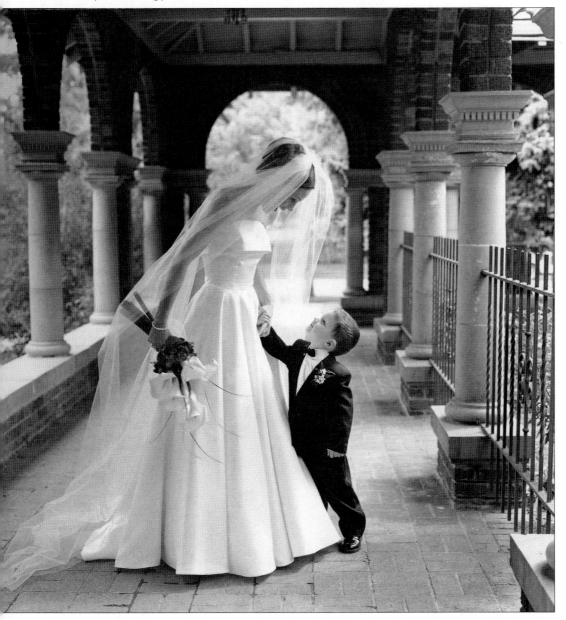

I used a 50mm wide-angle lens appropriate to architectural magazine photography to show this couple's new home as the background for their new life. Tall windows acted like a large soft box, illuminating the subjects from the front right. Accent light from patio doors in the rear created dimensionality in the room and on the subjects themselves.

~ GROUPS ~

Two and three people are more interesting than bigger groups; there's no need to be perfectly neat or symmetrical in arrangement of this type of candid composition. Definitely allow plates and food to be seen; other than dancing, the wedding banquet exhibits a spirit of togetherness, just as the family community revolves around dinner time.

Emotional energy and personal connections will begin to appear in a group portrait if people are posed at angles to one another, because this position is natural for encouraging eye contact and conversation. Round tables also promote conversation, while most formal side-by-side seating arrangements are sterile, and people avoid them because nothing ever happens there. Avoid posing in a flat row with heads all at the same height, all directly above one another, or all facing straight on to the camera.

Guests relax at tables, so it's relatively easy to capture a spirited response to the camera. By approaching people from the back, they must turn toward the camera and lean in close to one another. The body language, subtly influenced, implies action, fun, and feelings.

Steps, furniture, or other natural objects make it possible to arrange faces at different levels. Posture should be leaning in or turned slightly inward; include hands and touching to achieve better meaning.

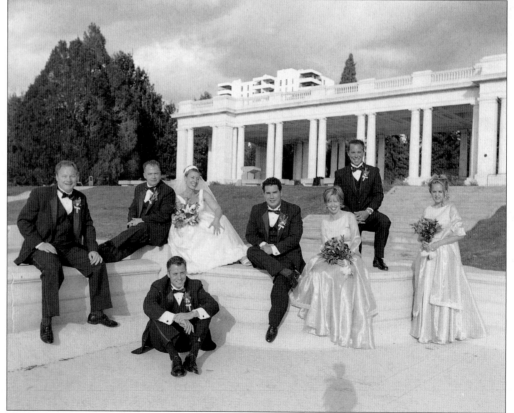

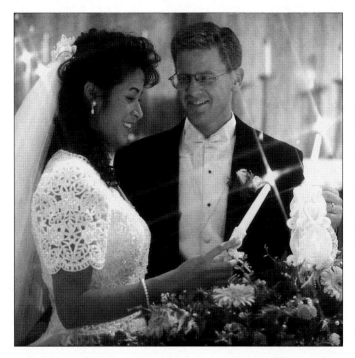

Ambient church illumination plus candlelight and a reflector (held horizontally to lessen shadows under the chin) create a texture that is at once soft and full of crisp detail. Incandescent light and candlelight will both exaggerate the tendency of black-and-white film to record skin tones darker then normal. For this image, ISO 400 film was exposed at f/5.6 for 1/4 sec.

One of the simplest and most effective compositions is easily created by seating people on old-fashioned park benches or front porch steps—places where everyone feels comfortable naturally. The ambient light that occurred under the tree branches was augmented by a reflection from a sidewalk and also the use of a reflector, for sparkle.

∼ LIGHT ∼

Lamp shades and indirect lighting soften interiors and lessen harsh shadows, making details easier to see. In the studio, we use soft boxes, diffusers, and reflectors for the same purpose. Another interesting effect is window light filtered through leaves or tracery. "Cookies" project patterned light onto a background to get this same effect. Golden Age Hollywood films used this technique extensively to create a compositional device on empty backgrounds.

A room lit from only one side often remains unused and empty. Photographic devices such as harsh glare, contrasty silhouettes, and impenetrable shadows definitely exhibit mood or ambience, but tend to defeat the impact of individual expression. Accent light, fill light, catch light, or a second light of any kind will enhance meaning, create depth of character, and will feel bright and lively.

∼ POSING ∼

People are most comfortable sitting or standing with their backs to a wall or tree, and are uncomfortable isolated in open space. Full-length posing without props is difficult both for subject and photographer. Natural activity forms around the edges of spaces, for instance shoppers pausing to look in stores fronting on a public square. By observing interaction of people at the edges of spaces, we get many clues as to how to pose subjects, what sort of furnishings work best as props, and how to orient subjects in relation to those props.

∼ ENVIRONMENT AND VISUAL PATH ∼

Without visually linking the subjects to their environment, the composition has as little physical context as rear projection. Most often, photographers settle for middle ground only—that is, the prop or stool the subject is touching. Foreground framing is more unusual, and immediately creates additional depth both in physical dimension and meaning. It can be achieved using out-of-focus leaves or flowers in a lower corner of the image, or perhaps an item on a table in front of a portrait subject. The background must repeat the same colors/tones and motifs, and relate to the tones of the clothing to create the best visual path.

An eye-catching visual path in artistic composition is very similar to a path that's comfortable for walking. We tend to walk straight toward a goal or destination, but we are also scanning the

The emotional message of this image is so special it would come through in any environment. Three-dimensional framing is achieved with just a few little vine leaves in the right foreground and with the similar, but completely out of focus, trees in the background.

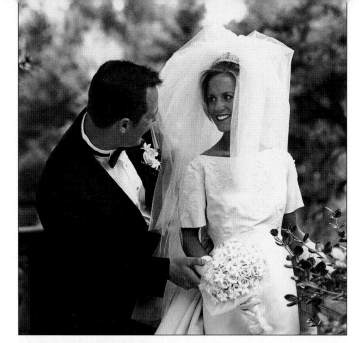

NONCONFORMITY

Conformity to photo-processing sizes is the main way we photographers allow ourselves to be locked into stereotypical presentations. Preoccupation with systems and means of production often bring nothing but rigidity of composition, just as perfectly aligned grids and the angles of ultramodern architecture actually have little sense in human terms. The same is true of photographs mounted artificially off-center to conform to focal point placement according to the Rule of Thirds. Try not to let standardized photo systems dictate artistic choices.

landscape for focal points of interest along the way, particularly around corners or through unexpected openings. Perspective that leads the eye is always the foundation of a powerful composition.

Office workers complain that rooms without a view can feel like prisons. In photographic composition, I substitute "background reference" for "view." This is how the photographer makes the story clear and readable—with background reference. About 25 percent of an image area should generally be devoted to background reference, which will visually place people and events into context of time, location, weather, season, and ambience. In special circumstances, the amount of background reference may be 50 percent or more.

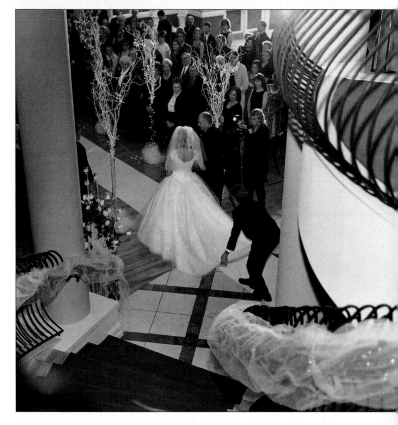

This image leads the viewer down the bride's own visual path. We can feel her anticipation and excitement just as she turns the corner. On-camera strobe synchronized with a studio light on the far side of the guests both raised the illumination of the salon as a whole and created accent light from the side.

Creative Lensing

Perspective and the relationship of objects within the frame can be effectively changed only with lensing. Camera-to-subject distance and angle of view add interest, but don't alter the relative sizes in the same way that changing from a wide to telephoto lens will expand or compress the field of view.

I recommend lensing that is slanted toward photojournalistic style and black-and-white art, but my suggestions can certainly improve traditional color work, as well. (For convenience, lens focal length is expressed for 120mm 6 x 6, except where noted.) The photographer must make artistic decisions to step closer or back off to change the camera-to-subject distance. Cropping the negative should be mainly for simplifying, intensifying impact, and modifying compositional dynamics. I know a number of photographers who use just one lens. I find this concept impossible to imagine, although I do advocate consistent use of the "normal" 80mm lens for 120 format.

Many clients tell me they want to see things as they really happened, and optically, you can do that only with a normal-length lens. Therefore, with normal lenses, your artistic flexibility must rely on where you put the camera—your angle, your closeness, what you include in the frame.

Other advantages of the normal lens are weight, size, and a lower *f*-stop. With ISO 800 to ISO 3200 film, I can handhold under a wide variety of lighting circumstances without a big, on-camera flash rig to slow me down and make me more conspicuous. This method of exposure, unassisted by strobe or with just a tiny wink-light flash to open eye socket shadows, greatly augments the feeling of reality—a critically important concern for both the photojournalist approach and for black-and-white work in general. My Hasselblad used this way simulates the speed, portability, and flexibility of 35mm.

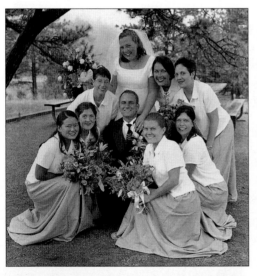

At first glance these two images seem to have been photographed identically, but the group of women was made with an 80mm lens and the men with a 50mm wide-angle lens. The latter characteristically includes more background, and the subjects in the back row appear smaller than those in front.

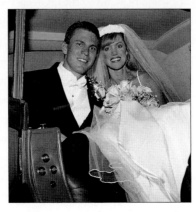

A simple variation of distance and a lower angle, as well as body language, make this pair of images equally salable and highly effective together.

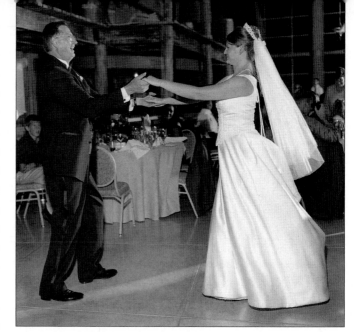

Undesirable light falloff is demonstrated on a close-up when hall lights did not fire, though the expression makes the image a success. A little greater camera-to-subject distance would help to gather a more even illumination, because the subject would be proportionally closer to the background.

Good images are waiting to be captured from every direction—including from above and below. One of my main complaints about photographers I've hired is unwillingness to move around to different positions. Many photographers never seem to think of the reaction of spectators. Spectator action, reception panoramas, and little kids doing little-kid things are great reasons to switch to wide-angle lenses. Expressions can be plucked unawares out of a crowd by moderate telephoto lenses. It's also good to look for naturally occurring depth in a scene—that means, planes or layers of focus, light, and meaning. Don't place people parallel to a background but at an oblique angle to scenic elements that automatically will provide fore-, middle-, and background features.

My standard lens kit is the ubiquitous 80mm, the 150mm, and my favorite 50mm (equivalent to 50mm, 90mm, and 35mm lenses in 35mm format). There are no secrets here. The solo photographer can easily carry these few items in a waist pouch or small bag, but I find it just plain fun to work with a personal assistant.

Some photographers use a slightly wide-angle 60mm lens as their "normal" lens. They like the ability to get in the midst of crowds and in tighter corners, and also the inherently wider depth of field. To me, this is a compromise lens, which leads to imprecision because it tries to do too many jobs at once. Since you must move in closer, you may disrupt the action, rather than let it unfold as if the camera weren't there. You risk excess background or extraneous material in the frame that will have to be cropped out later. Due to wide-angle perspective, closer people will appear significantly larger than those just behind them. Strobe covers wider-angle lenses less well at close range because the light source doesn't have enough camera-to-subject distance in which to spread illumination evenly corner to corner. Bottom vignetting, where the exposure turns very dark in the lower part of the frame, can indicate misaligned equipment or simply the wrong choice of lens for the subject and distance at hand.

It's never desirable to have a pitch-black background behind the wedding party posed on the altar, or behind guests on the dance floor. Wide-angle lenses afford the greater depth of field you need when moving closer toward your subject, but they're actually harder to focus critically sharp. Close range combined with a higher f-stop, like f/11 or f/16, makes it very challenging to record details in the background of a dimly lit altar or ballroom. It's much wiser to step back so that you are less conspicuous, and lighting will naturally have spread out more evenly. Use a slightly telephoto lens, drop the f-stop as low as you dare, say to f/5.6 or f/8, and also drop the shutter speed to record much more of the

ambient lighting. Note that exposing for ambient light helps to minimize the harsh, specular light put out by strobes used without umbrellas at some distance from the subjects.

A zoom lens is of real benefit to me for a hora, or any ethnic dancing, during which my goal is to grab forty to fifty varying images. Arrange in advance so that those who are carrying the couple's chairs know where you'll be and will turn toward you. You can't afford to get situated and then have everyone turn their backs to you! Position the lead camera on the bandstand or a small ladder, with a second cameraperson weaving in and out among the dancers to get another dozen or so frames from quite a different angle. Generally, the camera-to-subject distance will be about twenty feet; ISO 400 film combined with extra radio slave lighting in the hall help to create overall brightness and a reasonable f-stop for good depth of field. If you use several different lenses for dancing photos, you have to disconnect and replace the strobe sync for each change; this is when it's really handy to have an assistant pass lenses and film up to me. The cameraperson on the dance floor will use just one lens, probably a 50mm.

Even in the studio on a tripod, f/11 is generally needed to achieve sharpness of a whole face at about seven to ten feet. Camera shake, subject movement, and aerial haze—all of which are exacerbated by telephoto lenses—can easily result in unusable

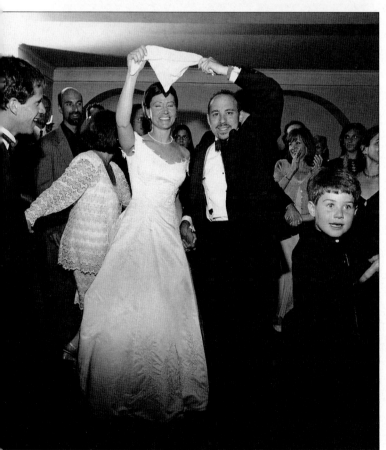

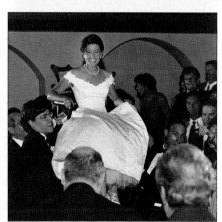

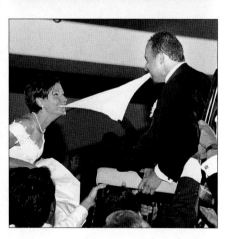

The small ballroom of a historic mansion made it possible for me to photograph the hora both from the bandstand and amid the dancers. The first image was made with a 40mm lens from a higher elevation, the second with an 80mm on the floor, the third with a 50mm and extra low angle on the floor, the fourth with an 80mm from the stage, and the fifth with a 150mm also from the stage. Additional illumination to the on-camera strobe was provided by a studio strobe in the background.

images. Sports photographers work with extremely long focal length lenses under high illumination, very high shutter speed, and autofocus, among other tools, to ensure their success. Beware the use of a 250mm or 350mm lens for portraiture under lower light and low shutter speed and *f*-stop. Antivibration-technology lenses could be a real lifesaver, giving the stability of two *f*-stops more speed than the actual camera settings.

I never want to be forced to do without one of my three main "tools," so I carry three 80mm and two each of the 50mm and 150mm lenses. The 30mm fish-eye, 40mm, 250mm, and 350mm are brought out only to create the trademark special effects that are sprinkled throughout my albums. Even when not relegated to the rear of the sanctuary, use your full complement of lens lengths to tell the complete story. Since weddings have many distinct small ceremonies within the ceremony, it also makes good sense to take multiple angles.

Unimaginative ceremony photos, all made from one spot with a normal lens, are inexcusable. If you don't own a telephoto lens, rent one suitable to the physical size of the location. A close-up memory of the exact moment the ring goes on is why the bride is going to all this trouble in the first place. You have to be in different places using different equipment to capture guests watching as the procession starts, the procession itself, mom crying, dad kissing bride, groom admiring, the hand-off, the readings, listening to scripture, children fidgeting, vows, presenting and blessing rings, ring exchange, preparation for communion, kneeling, nuptial blessing, breaking the glass, kiss, pronouncement, guests clapping, coming down chancel steps, hugging parents, the recessional, and greeting relatives at the back of the church. There are a myriad of special customs in Muslim and Jewish ceremonies, plus colorful ethnic and regional differences from around the world. This "short list" is the real stuff of dreams that makes up contemporary wedding photography.

Sometimes it's impossible to get a clear view at all of the important action, for instance when twenty or more people are crowding under and around the chuppah. If it is not permitted to photograph during some parts of the event even without flash,

A fish-eye view of an elegant garden reception taken from on top of a fifteen-foot wall recently netted me a double-page editorial spread in *Colorado Homes and Lifestyles* magazine.

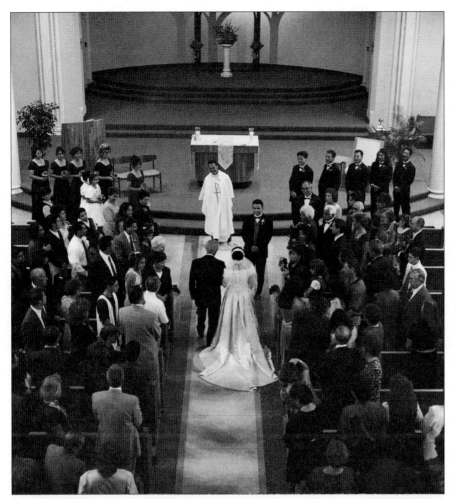

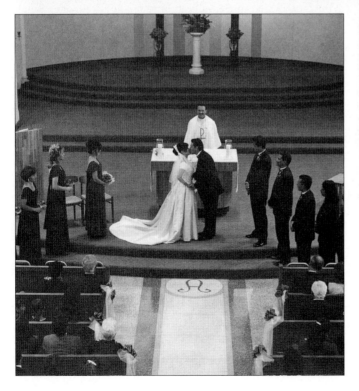

Old-world ambience always makes for intrinsically interesting images. The first image was made with a 150mm lens as the bride approached the altar with her father, the second with a 30mm fish-eye, the third with a 50mm from the side to emphasize the architecture, the fourth with a 350mm to bring the action up close, and the fifth with a 250mm to include the wedding party.

The Jewish ritual of acceptance and signing of the ketubah involves the officiants and the men of the religious community, as well as friends of the groom. Taken with the Widelux, this grouping has the artistic feeling and "political" weight of the famous painting of the signing of the Declaration of Independence.

recreation is your only hope. The rituals director of the church or synagogue should be able to help you. Call him or her in advance to discuss what you require. If necessary, do a site visit and show samples of just what you wish to achieve. Generally, directors are impressed with the attention you give them and their facility. Sometimes, a rehearsal in full wedding regalia when you *are* permitted to come in close will precede the seating of the guests; more often reenactment takes place after the ceremony.

You can use any lens, not just a wide angle, to make a panorama, so long as the proportion of the final image, horizontal or vertical, will crop to approximately 2:1. This popular design feature is 10 x 5 inches, or fits a double-page album spread of 24 x 11.5 inches. Typical panoramic composition in 6 x 6 format with a pastoral scene of just the couple, or a large group, will show a great deal of wasted foreground and sky before cropping. Take care not to miscompose in camera; subjects must not be too big or too small in the frame, or placed dead center, right where the fold (gutter) of the album will come.

Another option is to use a real panorama camera, like the Widelux, which has a revolving lens that covers 140 degrees. The perspective recorded is very different from that of regular lenses or contemporary so-called panoramic cameras. The Widelux is a challenge to expose, because it has only three shutter speeds and an f-stop range from $f/2.8$ to $f/11$ without click stops. The best thing is to have film of several ISOs available to meet varying site conditions. The viewfinder shows less than appears on the film; keep your fingers completely away from the front of the camera or they will be in the view!

Panorama subject matter is unlimited, and so are distance and lens choices. The image directly below was made with a normal lens from a small hill, taking in the entire wedding scene. The couple was so far away in the bottom image that a 150mm lens was required. I photographed the toasting bridesmaids in the top right image with a wide angle while sitting on the ground.

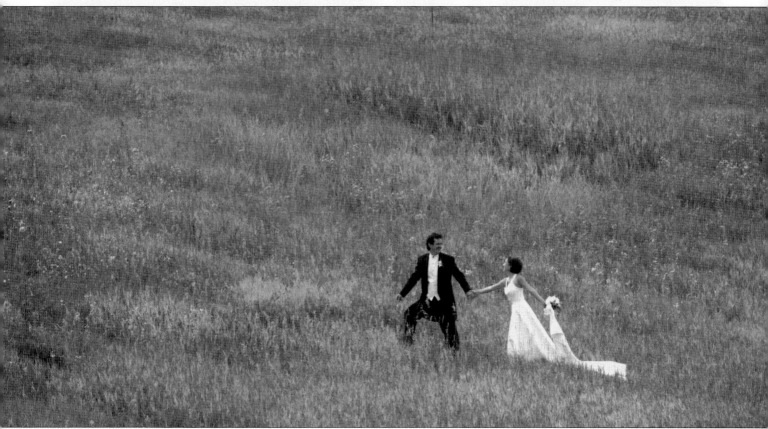

Chapter 2

FORMAT, FILM
& EQUIPMENT

The Debate over Format

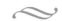

Over thirty years has provided me ample opportunity to work with all four popular wedding camera formats.

My early wedding work was in 6 x 7 rangefinder format. The first studio with which I was associated preferred 6 x 7 SLR (single-lens-reflex), due to larger head size for negative retouching. I shifted to square format when I found out how to take advantage of a Hasselblad's speed of operation, lightness, and modularity by mounting it on a Stroboframe. I bought the full range of exotic glass to be able to produce artistic angles and compositions. A flock of film backs means I can be extremely fast and use a variety of films at once. Since then, I've introduced 6 x 6 to many photographers. In all the important postproduction phases of cropping and album design, 6 x 6 format allows maximum options both for problem correction and artistic enhancement.

Photolabs I've informally surveyed report that they process 35mm, 6.45 cm, and 6 x 6 cm film for clients who offer black and white, but process very little 6 x 7 cm, a format which seems more popular in color. The 6 x 7 format may become more common due to the advent of Mamiya rangefinder cameras.

Both 6 x 6 and 6 x 7 negatives produce the best quality, but the cameras are obviously heavier, slower, more expensive, and harder to work with. The 6 x 6 format's secret is its potential for allowing highly varied compositional effects through cropping after the fact. The 6.45 cameras are currently a popular option that many photographers feel levels the format playing field. I've found that this hybrid is practical in traditional portrait situations and lowers the initial equipment investment cost. Although the film size is noticeably larger than 35mm, image quality never seems to approach that of 6 x 6, and the format proportion offers fewer options for artistic composition. In the work of intermediate photographers, this format exacerbates imprecise composition and posing. Time and again I've observed that the square format of a Hasselblad will improve ability dramatically almost overnight.

Beginners are looking for easy handling and less expense to start. However, unless you plan to do all your own darkroom work, printing costs will rise prohibitively with 35mm film because only a mini-lab, with its concomitant quality problems, can machine-crop the format. Most mini-labs don't print black and white at all, so you'll always be paying custom prices.

By its very nature, 35mm invites exposure of more film; 120 format makes any photographer more careful, more willing to *wait* for the exact right moment, rather than pressing the shutter with abandon and *hoping* the right moment occurred somewhere during that time and was captured by default. Quantity can easily be just that—more pictures, *not* necessarily more visual value. Reckless technique most often results in a meaningless jumble of uncoordinated photographic mannerisms—fuzzy, crooked, unattractive expressions; too loose or too tight cropping—that can never be considered styles in and of themselves. This is what I call "snap-shoddy."

Digital photographers, myself included, report a veritable mushrooming of image quantity. This is due partially to environmental difficulties of autoexposure and focusing. Reusable memory cards, CD archiving, and proofing on the Internet make images so easy to get that no one cares if there are a thousand or more pictures from one event.

It's not entirely fair or correct to criticize "trigger happy" photojournalists, because we all must take every opportunity to capture unusual, fast, and different images. I have, however, viewed the work of professional photojournalists who also do weddings, and while all these practitioners do have *some* decent single images to show, I have yet to examine the work of more than a very few photojournalists that had the depth and strength to tell a story.

This is not surprising, because the newspaper photographer's job is to look for a single illustration to express the content of the text. Only on rare occasions does the photojournalist strive for a series of images. Style calls for a purpose behind the technique. Consistent use of devices in a uniform, recognizable fashion is what we want to achieve, because style will hold a story together properly. We simply cannot take indiscriminate shooting as our main philosophy, regardless of the format chosen.

No one camera system can be perfect for all purposes, so think about how *your* end result will be best achieved. To leverage your money, buy equipment with a high resale value; buy used, buy to suit *your* hands, *your* eye, and the way *you* work. Buy for wide availability of accessories, for cost-efficient local repair service, and for any automatic features that help you. Keep in mind that autoexposure and autofocus can fail you in difficult circumstances and may be nothing more than cumbersome crutches. Take time to learn traditional lighting, exposure, and focusing techniques. Ability with completely manual equipment is making it possible for me to handle digital cameras much more competently than my experience with them would suggest.

Multiple Films, Multiple Formats

Choice of format, or whether to use multiple formats, is driven by knowledge of your materials, client, ability, and style.

In many countries, many couples opt for black-and-white wedding photography for economic reasons; both color films and quality color printing, as well as medium-format equipment and materials, are extremely expensive or simply unavailable. In Central and South America, the ubiquitous mini-lab cannot produce what the American bride knows as professional quality.

Multiple film backs make working with multiple films easy and quick, but too many variables can diminish focus on artistic composition and capturing of emotions. I find it challenging to work in multiple styles and, simultaneously, in black and white and color—in spite of the eleven film backs, four camera bodies, and eleven lenses that I carry to a wedding. It can also be frustrating for my assistants if I can't tell them what film to load next. There's nothing worse than seeing action unfold, yet not being able to jump right in because the wrong film is in the camera. I usually use three or four color films of various speeds and purposes, and black and white adds three or four more, including infrared and TCN sepia hybrid films for special effect.

If you're working in 35mm or 6.45, the only way to take advantage of multiple films is to use multiple cameras. The big advantage of digital is the ability to change ISO equivalents, white balance, saturation, and contrast in-camera. I've talked to some photographers who use as many as ten or more 35mm cameras, each loaded with a different film type and mounted with a specific lens so that changes are unnecessary. The photographer simply grabs a different camera for each application and distance. It's hard for me to imagine just where this huge amount of equipment would be located during the event, much less how to differentiate what camera was loaded with what film. I *can* imagine tripping over cameras, forgetting them, and never having the right one at hand. I feel this way of working would make me conspicuous and damage the equipment (when the cameras knock into one another).

I prefer to keep the equipment much simpler, to rely on my intuition to sense action as it develops, and to previsualize where I need to be and what equipment I'll need.

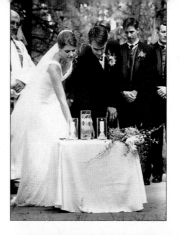

Note that 35mm (left) appears less sharp, more contrasty, and grainier. Most clients, if shown graphic examples of this difference, will favor the larger format 120mm (below). However, the emotion captured in an image still nets more sales, by far, than image quality alone.

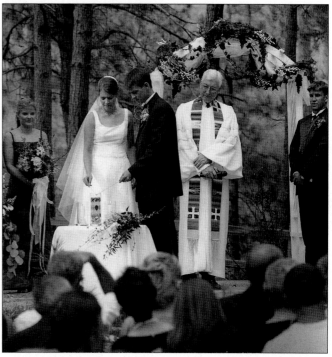

While lab statistics confirm that medium format is still the most popular choice, all the major manufacturers agree that small-format equipment and films now record such fine detail that 35mm is a viable option. The downside of 35mm is that the photographer must be far more accurate in framing, focus, and especially exposure, because the physical negative area has less room to correct faults than 120mm film. A remedy for both format and color problems is to split camera responsibilities: One team member makes color, the other black and white; or, one uses 120mm, the other 35mm. Another option: 120 for groups and portraits, digital for photojournalism and the reception.

Note that the otherwise excellent idea of using 120mm for portraiture and 35mm for candids can have a disunifying effect, because prints from the two formats have distinctively different appearances and, therefore, may show poorly side by side. Digital "grain" and pixel noise can also look quite different than film.

My Equipment

~

Everyone asks about my complete wedding equipment kit. Originally, as a young photographer, I was happily introduced to the Koni-Omega 6 x 7 rangefinder system. What a gem that was for accurate focus and quick, easy handling. It's hard to believe I started out blithely with one camera, one lens, one strobe, and one ten-frame film back! However, this scenario taught me precision, film management, and preplanning. I didn't consciously set out to practice and perfect these fundamental lessons, I just didn't know any different. Needless to say, I look back in some alarm!

Your standard gear should evolve over time, changing to meet new abilities and styles. I soon had extra lenses, bodies, film backs, and, most importantly, a new Hasselblad. Reputation made me believe I ought to have one, but I really couldn't figure out how to use it effectively. It seemed slow and cumbersome in comparison to the "photojournalist's model" Koni. So, the Hasselblad sat on a tripod getting limited use until the day someone put a Stroboframe in my hands. The Stroboframe model R66B let me perfectly balance the weight of the Hasselblad with strobe and radio sender for long hours at a stretch. Many Saturdays I'll work twelve to fifteen hours with little time to sit down—and then do it again the next day. Post-Stroboframe, I've never looked seriously at another camera system other than the Hasselblad, especially since I've refined my technique so that I use these cameras with close to the same speed and flexibility as 35mm.

One of the first things I noticed a long time ago is how well a Hasselblad is shaped and the controls arranged to be graspable and workable in my small hands yet not clumsy or dainty for a man. The overall size, heft, and "gripability" are excellent. In addition to weddings, I also provide light commercial, portrait, and lifestyle pictorial photography. The Hasselblad PC control unit—which I use primarily in conjunction with the 40mm lens, less often with the 50mm and 80mm—lets me do almost any straightforward architectural photography job. This model and its sophisticated cousins, the FlexBody and ArcBody (which operate like mini studio-view cameras) have made me put away my Sinar P 4 x 5. If you have ever tried to get the bulk of a P with a tripod in the guest bathroom of a finished show house, you will know exactly what I mean.

The newer Hasselblad features are well considered: dual exposure setting method, which allows *f*-stop and shutter-speed operation either linked or independent; a very secure strobe sync contact; the built-in dark slide holder; automatic features; and a variety of finders that meter light, add a diopter, or change the viewing height. The modularity of the Hasselblad system is so logical and money saving that you think you designed it yourself. Old fits new and vice versa. System parts are easily bought, sold, exchanged, and updated. It's better than buying a new expanded memory chip for your computer, because previously owned Hasselblad equipment is so easy to find at reasonable pricing, and it doesn't lose its value.

If you happen to live in an area of the world where equipment is scarce and expensive, consider a "buying vacation" in the United States, where the moneyed amateur market creates an active circulation in very "low mileage" (meaning gently used) gear. I automatically assume that any used lens, film back, or body I buy needs an overhaul, if for no other reason than atrophy.

Hasselblad units, especially the older ones, are eminently repairable. Wedding photographers probably give their cameras more abuse than the photojournalist in combat. However, Hasselblads are just plain hardy workhorses. Among my equipment there is one over twenty-five-year-old body that continues to function perfectly in spite of a missing gear cover. I am careful with equipment but treat my repairman with the respect usually reserved for visiting royalty.

I use my equipment in three different camera setups for different applications: action with strobe, portraits from a tripod, and available light photojournalism. By keeping the three setups distinct and dedicated, each to its own purpose, I can often turn out results that make it seem like I was in several places at once. Have you ever been working on-tripod with a portrait and seen a great candid moment start to happen out of the corner of your eye? At a moment's notice, I just grab a different camera setup and can literally accomplish two styles at the same time. The three-setup method allows me to change my approach just by setting one system aside and picking up another. Flexibility of ready tools lets me create art that more truly reflects the spirit and the emotion going on around me.

WHAT I CURRENTLY CARRY ON THE JOB

- 4 Hasselblad CM bodies, PM-45-degree prism finders (image reversing) equipped with my diopter correction, 45-degree split-image rangefinder focusing screens with handdrawn grid, after-market dark slide holders, bellows lens shades.
- 1 Stroboframe R66B with Quantum radio sender.
- 1 Davis/Sanford BB tripod plus Manfrotto ball head on monopod for digital.
- 3 80mm T* lenses.
- 2 each 150mm and 50mm lenses.
- 1 each 40mm, 30mm fish-eye, 250mm, and 350mm lenses. (I prefer lenses in which shutter speed and f-stop are geared to function in tandem.) If there is to be second photographer coverage, I add another each of an 80mm, 50mm, 150mm, and 250mm lens, and another Davis/Sanford pod and Stroboframe.
- 10 120mm-size film backs allowing concurrent use of six to seven film types.
- 2 Visual Departures Flex Fill round collapsing reflectors, black/silver and white/gold; a second set is added for a second camera team.
- 1 Wescott 4 x 6-foot translucent collapsing panel.
- 1 Pro-Step folding ladder.
- 1 changing bag.
- 3 various width close-up extension rings.
- 1 Sekonic L-508 digital meter strobe/incident/spot with zoom capability.
- 1 Gossen F analog strobe/ambient meter (incident and reflectant).
- 1 Minolta Spotmeter F digital strobe/ambient spot meter.
- 1 each star filter, homemade soft filter, Hasselblad Softar, and B+W Soft Focus 1 (with concentric rings).
- 1 set each black-and-white Lindahl mesh vignettes, attached with Velcro to lens shades.
- 4 Rollei manual strobes with output of f/5.6 at 15-foot distance on half-power ISO 100 equipped with Quantum radio receivers.

- 2, 3, or 4 Portamaster 400-watt/second self-contained monolights with case and stand attached to the power pack, which sits on the floor with Quantum radio receivers or infrared sensors—quantity depends on the size of the hall to be lit.
- 3 rechargeable nickel metal hydride batteries that look like nicads. For lightness and speed, the new high-tech nickel metal hydride batteries are unbelievable. At half-power they recycle so fast that the ready light doesn't go out! They work strongly for about 100 flashes and lose power abruptly, rather than tapering off like nicads do, with ever lengthening recycle times. And, of course, there are no battery packs to wear or cords.
- 3 Quantum #4 batteries and inserts for the handheld strobes carried by assistants.
- 1 rolling travel case for power cords, umbrellas, and battery belts.
- 1 folding luggage cart with wheels.
- 1 case for RCA jacks, sync cords, batteries, Quantum inserts, backup light slaves, AC adapters.
- Bags: Everything is carried in smaller Lowepro and Lightware bags for speed of handling out of a car trunk.

THE DIGITAL AND 35MM SET-UPS INCLUDE:
- 3 Canon D60 cameras with battery grips, with 3 battery sets per camera.
- 14mm f/2.8, 28mm f/1.8, and 50mm f/1.4 fixed focal length "prime" lenses.
- 16–35mm f/2.8, 28–70mm f/2.8, and 70–200mm image-stabilized f/2.8 zoom lenses.
- 2 Canon 550 Speedlights.
- 1 Nikon CoolPix 5000 with 28–85mm zoom lens (my 35mm equivalent) and fish-eye adapter.
- 3 Leica M2 rangefinder cameras with small autoexposure strobe.
- 35mm, 50mm, and 90mm lenses.

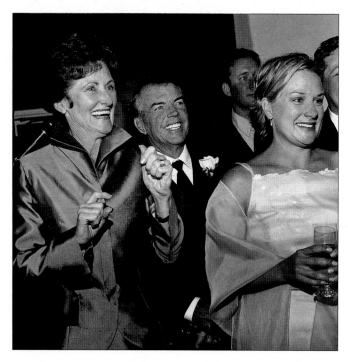

A candid this spontaneous demands the speed and crisp detail of strobe exposure. I captured this expression only because I stayed ready and engaged in the action past the end of the cake-cutting—and had the advantages of hyperfocal focusing and fast strobe recycle time.

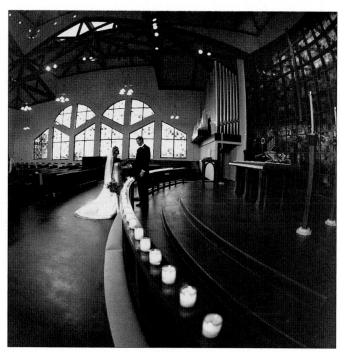

Portraiture in low ambient light requires a tripod, because the 1/15 sec. exposure used in this example is just too slow to accommodate handholding of the camera. I can refine the pose or adjust the subjects' clothing without a camera in my hands. Strobe on this subject would have destroyed the private mood entirely.

~ STROBE USE ~

So much of our work requires strobe for sharpness and stopped action, because a huge percentage of events take place in darkened halls, closed spaces, at night, or when contrast must be equalized. Everyone understands strobe on-camera, especially considering the ease and accuracy of contemporary autoexposure equipment. Sometimes, only the ceremony-in-progress photos will be made without strobe. For candid fun and dancing photos, the on-camera strobe unit works in conjunction with the multiple studio strobe heads to light the entire room—a sophisticated technique that's much easier than it sounds. My method is based on solid knowledge of manual strobe exposure. The ergonomic balance of my rig is the hardware that makes speed and endurance possible. Beware setups that are heavy, hard to grip, or that exceed the ability of your wrists and forearms to perform repetitive lifting motions over time. The main point is that I don't do any serious portraiture with this setup, other than groups, which shouldn't be considered portraiture—they're *groups*.

~ TRIPOD USE ~

I'm always amazed how few photographers carry a tripod. Of those who do, most want to be able to use just one camera for all purposes by snapping the entire strobe rig onto the tripod platform—a practice that can be awkward and top heavy, and may seriously limit your artistic flexibility, rather than simplify it. I also get far less tired if I'm not constantly supporting the weight of the camera. Portraits are mostly made with the camera on a tripod; this setup is also used for time-exposure ceremony work. Choose a tripod model you can adjust practically without looking at it; if the controls are awkward or the pod is either too light or too heavy, you won't use it. Speed is the object here. A Bogen grip-action Manfrotto ball head is a great tool that you simply squeeze to change the camera position.

~ AVAILABLE LIGHT ~

I always prefer to work with available light, or perhaps a tiny strobe as a wink light to illuminate eye sockets. Undeniably, this is my favorite setup, combined with any fast film, but particularly ISO 3200 black and white or Kodak's PMZ at ISO 1000, which can also be pushed one full *f*-stop, or the new Portra 800. I frequently also use the 50mm and the 150mm lenses, both *f*/4, which are light enough to handhold. The 50mm affords interesting perspectives and works in small spaces; the 150mm enables me to pick out individual expressions without being noticed.

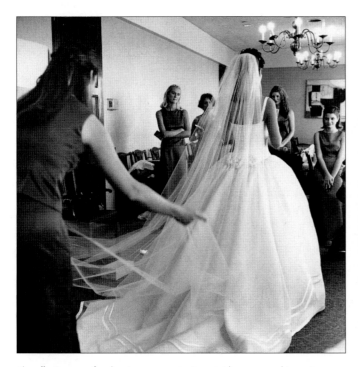

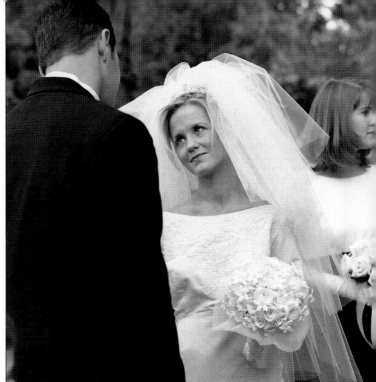

The effectiveness of a dressing room series is certainly exposure driven. As a prelude to exposing available light in a given room, I meter the space thoroughly and memorize the setting changes from lighter to darker areas, with and against the light source. A 50mm wide-angle lens captured the whole scene.

A surprising photojournalistic benefit comes from posing all group shots *before* the wedding. During this quiet time, subjects can simply enjoy one another's company and the camera can record the unguarded expressions of the families and bridal pair. My setup for my photojournalism is a completely loose camera used most frequently with an 80mm lens, because of its *f*/2.8 light-gathering ability.

The available-light setup and method are effortlessly natural, especially at the start of the day when people are getting ready and you need to build rapport with the wedding party and families who aren't yet secure with the intrusion of the camera.

In black and white, the visual value of ambient illumination is at its best, because there will be no color crossover due to mixed lighting. To try to avoid camera shake, it's best to use a shutter speed of 1/60 sec. or higher; apertures will almost always be *f*/2 to *f*/5.6. If it's necessary to raise the exposure level of the entire room, I try for low-power on-camera strobe or a strobe bounced off the ceiling for overall natural effect. The artistic mood would be fragmented if I were to change and do some of the images with straight-on strobe.

Once comfortable with the exposure questions, the photographer is free to be "glued" to the eyepiece in instantaneous and inconspicuous readiness for the story to unfold. Then, all it takes is persistence to capture amazingly real emotions.

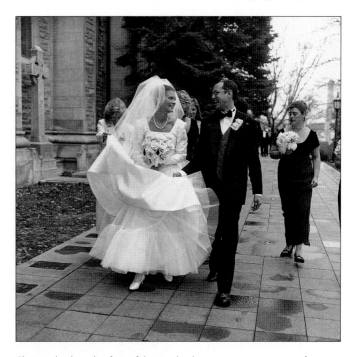

Skipping backward in front of the couple, there was no time to meter, focus, or even hold the camera very still. While it's always good advice to wait for just the right expression, a series of exposures will increase your chances for an exceptional image and may also be meaningful as a sequence.

35mm and Digital

It used to be empirically obvious that no small format, whether 35mm or digital, could compete in the same league with the precision, clarity, and visual appeal of a Hasselblad negative, not to mention the extraordinary compositional artistry of its square shape. I do *not* use 35mm just to save money, for automatic features, for lighter weight, or for speed. Nor for the outward appearance of the photojournalist—*that* cachet I have already, and it depends on my ability, not my equipment. Of course, my Leicas are light and steady because they have no SLR mirror shake, and the rangefinder is quick and accurate to focus in any light level. They, and my Canon and Nikon digitals, are so silent as to be virtually undetectable. The lenses are all supersharp. Naturally, the smaller format makes working in lower light much simpler with the combined advantages of handholding at quite slow speeds, stronger light gathering ability with smaller *f*-stops, and more maneuverability in crowds.

A few years ago, I thought that some colleagues were becoming irresponsible by using 35mm and digital as a way to quickly get through the less interesting parts of the wedding that would make less money than the posed photos. I don't like the "shotgun" quantity approach, and I was also worried about continuity of color saturation and sharpness. Now, I'll admit I am increasingly pleased with results from our Canon D60s and the tiny Nikon CoolPix 5000. While I'll always prefer fixed-length lenses, the flexibility of zooms for picking faces out of a crowd is unparalleled. Manipulation of the digital settings is getting to be as much fun as manual exposure and strobe. Mastery of capture saves postproduction time and lends itself to magical retouching and artistic presentation, as well as to efficient sorting, selecting, and archiving.

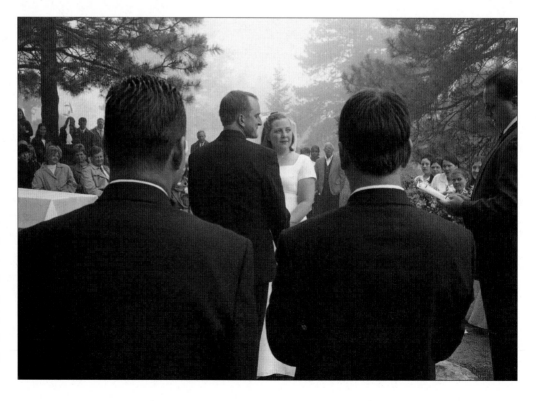

No one cared where we moved during this ceremony, partly because the Leica is so silent. With a 35mm wide-angle lens, I stood less than three feet behind the groomsmen, allowing their shoulders to frame the couple. I held the camera over my head for better perspective and waited to fire until I saw the right expression.

35MM AND DIGITAL RECONSIDERATIONS

What changed my mind about 35mm and digital as viable options has to do with the nature of the event, the agenda of the client, and the guests themselves. It turns out that the appropriateness of format, or formats, is better judged on a case by case basis, instead of being standard operating procedure. Here are several anecdotes that explain what I did and why.

BIRTHDAY LESSON During the fiftieth birthday party for a doctor, I posed a few family and colleague groups using the Hasselblad and multiple lighting. For the rest of the event, I and three other photographers all took our 35mm cameras and worked independently as paparazzi. We lit the banquet hall with three portable 400WS strobes, synched by radio. We set our camera shutters at 1/15 sec. The result was just over 600 images.

We all had a fun time, dancing and chattering with the guests—in short, blending right into the scene. That's the key word and concept that we learned: If the event is going to be a *scene,* consider using 35mm or digital.

WEDDING LESSON I was very excited to book an informal wedding to be held on the antique narrow-gauge mining-town train out of Georgetown, Colorado. Guests included several nearby town mayors and other celebrities. The special train car would just barely hold the forty guests, so I knew conditions would be crowded, warm, and bumpy. Digital allowed me to work with minimum equipment and see right away if I had missed a shot due to a sudden lurch of the car.

I traveled with the party and a Canon D60 and the Nikon CoolPix 5000. An assistant drove ahead to the ceremony to set up and be ready for the arrival. A very few group poses were taken with the Hasselblad. There was no schedule whatsoever to the day, making digital images the perfect choice, along with the telephoto zoom lenses that allowed flexibility where tables were so close we couldn't walk between them. The result was almost 850 frames! A somewhat unusual mix of guests and their loose approach are valuable clues to the right atmosphere for digital or 35mm success.

The client's own timing and personal agenda are further signs I've learned to look for when considering whether to include 35mm or digital in the proposed coverage. If the pace is fast and furious, it's far wiser to relinquish medium-format precision and take the self-contained, small-format or digital approach with several photographers buzzing around so that nothing is missed.

WEATHER LESSON On one rainy, cold June morning, 35mm was absolutely the right choice. The forested hilltop wedding site was enveloped in swirling mist, which floated like a living thing among the pine trees. I knew that backgrounds would be obscured; that my hands would freeze on the metal of the cameras and tripod; that I risked falling on the slick, rocky ground; and that moisture might very well affect the film and camera interiors. I simply refused to take the Hasselblads out, except for a few portraits, because I didn't want to risk paperbacked film or having to put down cameras somewhere in the slippery wetness. This is the first and only time I've ever worked a formal event in my motorcycle jacket and boots!

By the time of the afternoon reception, the temperature had risen to the 90s in full sun. Big cameras would have again been a real liability, because the dining room was so crowded it was impossible for us to walk between tables. Later, I found out 35mm was much more suited to the weather, and the agenda and style of the couple (who registered for gifts at REI outdoor equipment).

PACING LESSON Another couple expressed similar interests and photographic desires when they told us about their plans to wed at her grandmother's home in the charming historic mountain town of Redstone, Colorado. We immediately chose 35mm for the preponderance of the event, again saving 120mm format just for portraits and groups. Our four-person team was constantly in and out of the tiny house, on the main street, and in the big front and back gardens. Action happened as though we were on the inside of a blender. We never sat down! The dining tent was located across the road in the town park. Catering and decor were superb, as were the toasts, the swing dancing, and the bride and groom's personal presentation of specially designed, competition-grade collector Frisbees to every guest. The warm personality of the entire day resulted in a huge selection of fun imagery; 35mm helped us again—under difficult, fast, and fleeting circumstances—to capture the genuineness of the emotions we found on every face.

Practical Troubleshooting Hints

There are many things you can do to sidestep problems before they start. Here are some practical hints to help you identify and avoid problems.

∼ LENS EXERCISING ∼

Do this every couple of months on all lenses to ward off atrophy, most particularly in the exotic-glass special-purpose and backup lenses, which see little use. Work the action of each shutter speed several times. Listen very carefully for speeds that just sound wrong.

I always leave backup lenses, which remain idle over a period of time, uncocked to reduce wear through constant tension on the shutter mechanism. To turn the mechanism that makes an uncocked lens ready to mount you need a technical screwdriver, which has both a flat and Phillips end. It should also fit the tiny interior screws that recock a jammed Hasselblad lens that has fired without being fully secured to the body.

∼ KNOW YOUR EQUIPMENT ∼

Listening to and feeling your equipment function is an acquired skill that takes time and familiarity with one camera type—and particularly with your own units. Imagine the equipment as an extension of your hands, eyes, and ears. If you can hear differences in the timbre of the equipment and sense the characteristic vibrations, you'll begin to establish a "memory pattern" of how well-operating equipment should sound and feel. Often, I can hear a shutter speed anomaly just before it's going to throw a blade, and certainly, I can recognize the sound after it does. In order to preserve that personal relationship of human to inanimate object, two of my Hasselblads are set up so that only I use them. The others are for anyone in the studio to use.

∼ FILM OR MEMORY-CARD LOADING ∼

Much film looks similar and will inevitably cause loading confusion, so I preopen film and separate each type in color-coded net bags. Backup film remains in foil wrappers.

Memory cards don't have "exposed" labeling. Turn a card backward in its box to differentiate full from unused. Never format in-camera on the job site, and format in the exact camera in which you'll use that card. Cards should never be erased, even partially, during the event.

When loading film, start to wind it to the first frame with the dark slide partway pulled out to watch for positive confirmation that the film is advancing. Be sure of proper load direction and seating of memory cards.

In the dark, you can feel the movement by lightly touching the film leader itself. I verify the speed/type label on the back and review what the counter says. After an exposure is made, there's a distinct sensation you can feel through the metal when the transport mechanism is operating normally. If it feels loose and light, as if nothing is being pulled through, it's wise to check the load because the counter will advance with or without film. I remove the back from the camera and narrowly open the dark slide quickly to see the face of the film before continuing. Done carefully in lower light, this procedure will ruin only one frame—better than risking having no film in the back at all.

Unload immediately, once again verifying that the film is the same as the label on the back. Occasionally, a film is accidentally used at the wrong ISO due to failure to change the label or to a mismatched label or films that were switched through carelessness. Transfer the empty spindle immediately to the take-up side to help avoid a backward load. Recently, I pulled out a film that had paper backing that was all black with no markings or adhesive strip—an assistant had loaded the film inside out. I nullified the potential repercussions by my methodical double-checking.

Remember to power-off digital equipment before removing and replacing memory cards, or you risk either losing files entirely or damaging the card. The Canon D60 automatically shuts down the camera when the card gate is opened and restarts when it is reclosed. Downloading at an event, in order to immediately reuse a memory card, is a recipe for disastrous image loss. Don't erase anything until you have created archive copies. Even in the computer, it's unwise to delete a file entirely.

∼ LEADER TABS ∼

Leader tabs on some films have an awkward tendency to tear or slip. When inserting into the spindle slot, put a finger on the tab until the spindle revolves sufficiently to secure it with its own pressure. Fairly often, a bit of the adhesive band at the end of the roll may shred or detach entirely, so we always have a supply of small rubber bands to substitute. Don't continue to use a back if you can't find the entire adhesive tab, because that means the torn part is invisibly lodged somewhere in the mechanism and will probably leave a contact print of itself on every subsequent image. For fear that trash may accidentally drop into an open back, I never discard leader bands anywhere in my camera bags.

～ DARK SLIDE PROBLEMS ～

A dark slide that's suddenly hard to insert almost certainly indicates that a baffle has torn loose from the light trap in the film back. Discontinue use, unload the back, and remove the dark slide entirely. A thin metal foil strip will protrude into the photographic frame and would, of course, be reproducing a $\frac{1}{4}$-inch-wide bar across the film. Tiny particles get trapped in the pin holes of a memory card and cause failure. Don't open the gate in windy or dusty conditions.

～ LIGHT LEAKS ～

Light leaks indicate many varied problems. Streaks showing from the film edge probably indicate a bent dark slide, a baffle about ready to fail, a back that's not attaching tightly enough to the camera body, or a separation in the fabric of the bellows lens shade. Light streaks in the center of the film usually indicate flare due to inadequate coverage of the lens surface by the bellows shade, or a light source shining directly into the lens. Irregular, wavy light leaks right on the film margin occur when a roll hasn't been wound tightly enough on the take-up spindle. This will indicate a transport gear problem.

More obvious transport problems result in loss of part of the first or last frame, or irregular spacing between frames. Spacing may be so tight as to overlap frames, or so loose that one whole frame is off the end of the film. A finished roll that feels puffy or spongy when unloaded is a forewarning. Put such a roll immediately in a dark bag, and later unwind the leader about a foot and wind it back up tighter by hand.

～ IDENTIFICATION ～

A simple, positive identification system lets me know which of multiple film backs is the culprit when transport or flare problems occur. I've filed tiny notches in a pattern unique to each film back in the metal edge of the opening. The notches will reproduce as tiny wedges in the film margin, thus providing instant identification without harming the image, or the resale value of the back. Numbering memory cards is a good idea, if only to make them easy to inventory.

～ FOCUSING ～

One out-of-focus roll amidst other satisfactory ones points to a problem with a specific film back, probably a loose pressure plate or loose attachment of the back to the camera body. If you notch your backs, you'll know right away which one needs repair. If the plane of focus is irregular to the point that one side of the image is sharp and the other soft, the camera body is out of square.

A series in which all images are soft suggests a collimation problem with a specific lens. You'll know, for instance, that the culprit is a 150mm lens if close-up portrait views are uniformly a bit soft. On the other hand, out-of-focus $\frac{3}{4}$-length or close-up dancing photos made in a dark hall probably indicate operator failure; insufficient depth of field is the cause, either from underpowered strobe, slower film, or simply the photographer's lack of understanding of how to prejudge and set distance when precise physical focusing is impossible.

Smooth or dark objects pose autofocus problems for both SLR and digital cameras. Faces give excellent autofocus lock and also autoexposure that isn't fooled by light or dark clothing.

～ LAB LOYALTY ～

Troubleshooting is one of the reasons I preach "marriage" to a single main lab. If you have a close relationship with your lab, you may receive an immediate courtesy phone call if something that looks like an equipment failure appears on your film. It's great to have an ally to inform you of trouble before you do another job with the same gear. However, be aware that it's sometimes hard for technicians to sort out incidental operator error from equipment malfunction.

～ REDUNDANCY AND ATTENTION TO CAMERA SETTINGS ～

These are equally valid in both film and digital. Backup equipment, batteries, memory cards, a second meter, and extra sync cords are always needed to ensure against image loss. Intricate digital-camera-setting changes replace the frequent film reloads and lighting of traditional film. It's easy to forget to alter settings, as one moves so quickly and effortlessly from scene to scene.

～ PREVENTATIVE MAINTENANCE ～

Preventive maintenance and testing are excellent habits. I send all my gear, in rotation, for an annual checkup with the "doctor," my repairman, who performs the more sophisticated checks for body square and lens collimation, not just shutter speeds. Ask for a printout of the speeds so that you can decide if an overhaul is a good idea. A leaf shutter will always have difficulty maintaining its top shutter speed of 1/500 sec., so it's often expedient to ignore the problem if that one speed reads out 20 to 25 percent slow. Shutter cleaning and lubrication are always a valid request after prolonged or heavy use, and equally so after very long periods of no use.

Working Solo or with Assistants

❧

Great photographers will develop a methodology with which they are successful time and again, even when circumstances dictate variations in that method. From questioning many photographers across the country, I found that the majority work alone, mostly for economic reasons. I, therefore, preface this section with an apology to colleagues who really like to work solo, because I do believe there are as many methods of working as there are photographers.

Photographers who hate weddings may simply never have been able to solidify a personal method of working. They need a repeatable way to achieve individual creativity—without the stress of reinventing the wheel for every event. I ascribe my lack of burnout, even after close to four thousand events, to the cooperative method I have developed.

∽ THE ASSISTANT ∽

The assistant's primary role is to reduce the stress on the photographer by providing additional eyes, hands, and pockets. Secondary event responsibilities include having equipment available when needed and keeping it safe, under control, and in an accessible location. This method results in greater concentration by the photographer on composition, posing direction, and capturing the moment.

In my case, a third responsibility is to keep track of my several sets of glasses and car keys; my assistants claim they

Extraordinary real-time emotions are captured when, as a team, we can take two different simultaneous angles to record action, such as during the processional, exchange of rings, or cake-cutting. Either of these recessional images tells a great story by itself; combined with the high five that followed, they're an unbeatable memory.

also try to protect me from falling off ladders, parapets, and stairs! The division of responsibilities for tasks to be performed before, during, and after the event should be discussed and agreed on in advance, in order to function as a team. Teamwork is, in my opinion, not just the antidote but the means to prevent technical disaster and artistic stagnation. A team that works well in unison works quickly, more easily, and more creatively, and will automatically—

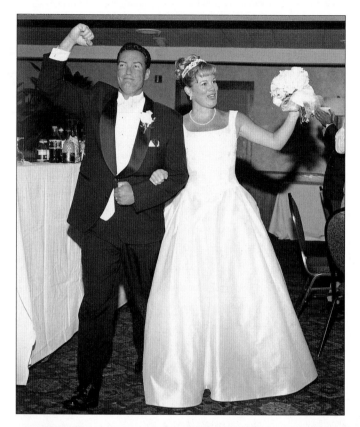

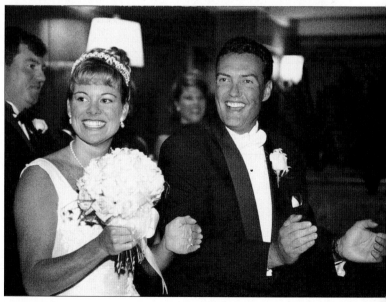

through heightened awareness and sense of common goals—troubleshoot the many pitfalls of exposing film under pressure.

My preference is for a three-person team. My personal assistant makes sure my bag containing my basic lens set, film, and multiple backs is nearby. He's a good location rigger who can work as second camera or primary support. Ideally, the team of photographer and personal assistant learns to anticipate and act in unison to meet developing action. This assistant is also responsible for film management and for communicating the need for additional equipment to the third team member. Two photographers must learn to take different lenses, angles, and attitudes so that their work complements each other's.

At a very large event, a team of five makes sense because the photographer/assistant teams can split—for instance in two completely different parts of a hotel—and yet one person remains in a central area to take care of multiple strobes, hall lighting, big equipment, and security. Digital cameras and laptop computers are high-risk items for casual theft. Wherever possible, I prefer to balance my team with both men and women, and to let individual strengths shine.

Assistants perform the expected functions as grip and equipment security, and they also interchange their tasks. As each individual progresses in experience, I make opportunities for them to photograph as second camera. If a new assistant is being trained, he or she functions with a trainer in addition to the formal team. I've heard of photographers taking observers or apprentices who want to learn, but I must say I disapprove most strongly of teaching on the client's time. While I applaud the generous motive of any masters who will allow themselves to be observed, I can't imagine jeopardizing creativity with an unofficial assistant who is an unknown element and, as such, might cause an inadvertent failure, or simply get in the way.

I've had the privilege of hiring a number of charming and flexible young photographers, most of whom are trying their skills for their first "big studio" employer. They take direction well, though they lack on-the-job training. Of course, we have challenges, but I use my personal experience and unflappability like a technical umbrella to shield them from the worst of the possible errors. I take every possible precaution to set them up for success. In between sequences, I try to quietly explain every step I take, what equipment I want, and when I want it. An assistant who has a personal agenda or who can't get the clue of how to "play well with others" after a trial period will no longer be an employee, because he or she endangers the safety, accuracy, and artistic success of the whole team. Our team method has produced unex-

THERE'S ALWAYS AN EXCEPTION TO THE RULE

I do work alone sometimes. Recently, I spent six hours and almost 300 frames in 35mm by myself at an elegant, black-tie engagement party for a politically prominent bride-to-be. There were thirty-three guests, of which I was the thirty-third. A two-person team would have overwhelmed the gathering, which was held in a spectacular private home. The large camera rig would have been overkill. Attired in a steel gray, off-the-shoulder ball gown and high heels—and with my forty-year-old Leicas—I fit right in to the scene. Most guests knew me or my face, and they just ignored what I was doing because I was one of them. The expressions captured were fantastic and so was the four-and-a-half-hour dinner!

pected and unique benefits that add perceived value to my service. While I expect my leadership to be unquestioned, assistants realize how they individually make a difference.

Assistants are not hidden away but are expected to be well dressed, and are formally introduced to the clients. They're encouraged to interact when appropriate, whether we're photographing in more arranged posing or photojournalist style. They work hard. Clients see and appreciate what they do, especially during traditional portraiture when I am giving constant direction and encouragement to both clients and assistants. Clients love the personal attention of so many people working together to assure that they look their best.

My teamwork concept grew out of my insistence that everyone checks and helps each other. We're all working for the total quality result, and that takes seamless interaction. My admittedly feminine management style turns good employees into an artistic family. Our group spirit is based on flexible but long hours, mutual help and instruction, stiff group critiques, instantaneous praise, life counseling, artistic license, and extravagant field trips. With the coalescence of any crew into a team, both on location and during postproduction, it's possible to combine personnel into different configurations to handle a greater number and variety of events concurrently. Varied jobs build priceless experience under a wide variety of circumstances and venues, equipment problems, and customer challenges without the high stakes of a wedding on the line.

WORKING WITH THE BRIDAL CONSULTANT

I've always hoped to discover a bridal consultant who was efficient, fun to work with, and a tireless team player behind the scenes. Unfortunately, I find working around most outside consultants will jeopardize the outcome of our job. Some photographers ungraciously use the label "wedding police." While a bridal consultant may be able to fit a dress, I have yet to meet one who knew how to "pose" a dress for formal photography. Constant intrusion to rearrange or primp destroys spontaneity of action and feeling. Nobody participating in a wedding likes to be told what to do; however, everyone appreciates the seeming effortlessness of consultants who don't inject their own egos into the event but work unobtrusively behind the scenes to make everything perfect.

My team must move quickly and without fuss to create the arrangements of people we need to satisfy all the photography requests. Recently, following a forty-minute receiving line, I was barely five minutes into traditional altar groups when an imperious voice announced we were twenty minutes late—and that I could have two more pictures and then had to go outside! As a younger photographer, this challenge might have been fairly hard to meet. I prevailed because of my age, the strength in numbers of my team, and my willingness to come back with the soft but definite rejoinder that this was the bride's choice and that I was going to continue. Need I mention that the same person did not bother to coordinate timing with us in advance?

∼ THE TEAM AND LIGHTING ∼

Even though we may be entirely familiar with a venue, we can rarely choose how the light falls. Therefore, on location our team literally creates light. The team approach makes it much easier for me to magically turn the random environment into movie-set quality by how we work with backgrounds and especially how we modify the lighting. Naturally, I look for extraordinary places where directional light and appropriate backgrounds already exist.

However, I demand more than this from location light, even during fast-moving events. We work to soften the harshest downlight (direct overhead light) with a 4 x 6-foot collapsible translucent flat and add catch light, wrap light, or hair light (and also subtract light) with a pair of 36-inch round reflectors. The four surfaces (white/gold and black/silver) maximize our possibilities. A convertible disk reflector that zips inside out will contain four surfaces in one single unit. In very spotty illumination, we can shade the subjects entirely and light them back to a satisfactory contrast level with straight-on strobe. Certainly, many of these applications can be accomplished by flats on stands, so long as the subjects are stationary and there's no wind. However, I feel the level of sophistication and minute adjustments I require for portraiture can be more efficiently handled by assistants. The lighting and auxiliary-equipment assistant creates dimensional lighting with reflectors or a radio-controlled handheld strobe. We also light halls with monolights synchronized by radio controls.

Other than on rare occasions when we take a portable studio background, I confine the use of our four Portamaster 400WS units to bounce lighting in the reception hall. If possible, the lighting team member sets up in advance at the reception hall so that lighting is working when the bride arrives. It's a specialized job just to set up these monolights effectively and inconspicuously, and make sure they're functioning correctly and consistently.

This method of working is excellent, and there are lots of brands of monolights in the 200 to 1,000 watt/second output range that are currently being produced. However, there are exciting new developments in the lighting industry, like the ProFoto 7 series distributed by Mamiya (there are others), which aren't plugged into the wall but use a rechargeable, lead-acid motorcycle-type battery. You can plug one or two lamps into the same battery with a total of 1200 watt/second output. Many more flashes are possible from one charge, even at this high light volume, than with competitive units. The output and automatic timing of the modeling light is very practical, not skimpy. While the initial investment is high, the value of this equipment is extraordinary.

Clients get interested and excited when they perceive how enthusiastic we are as a team on their behalf. We silently communicate our feelings, even if we're working in unobtrusive photojournalist style. The effect on subjects' attitude is cumulative and uplifting. The more they observe our sincerity and teamwork, the more they're distracted from their camera phobia and relax, so our results just get better and better. Many times, even guests notice and compliment our teamwork, because they can visualize just how great the images will be. My favorite comment came from a father we had not met before the day of the wedding. He said, "I didn't know anybody worked that hard!"

STROBE LIGHTING

Almost every strobe image I make indoors is exposed with two lights, perhaps more. The most usual applications are . . .

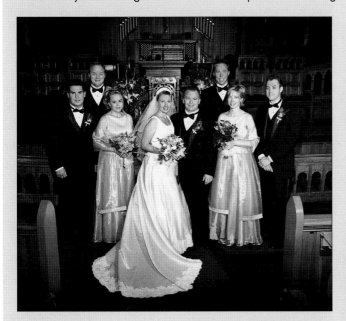

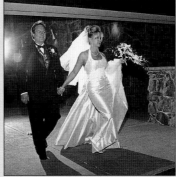

. . . to backlight subjects for separation of tones and for an extra-glamorous Hollywood effect. Backlight from a studio strobe placed to light the hall creates separation between dark clothing and background, and also gives a luminous halo to the veil.

. . . to provide main light, studio style, on groups. It's amazing how much depth and shine result from the use of a main and fill light together on groups. This image was made with handheld strobe units, not umbrellas. The combination of main light and shutter drag caused a happy perfection of facial rounding, nicely illuminated background, and subtle vignetting.

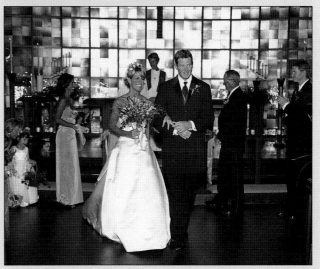

. . . to open up dark church backgrounds during the processional/recessional—or any large, dark, open space. In this venue, the entire stained glass altar panel is lit from behind with radio-controlled strobes. The result is a dramatic glow that separates the subjects from the background; without it, there would be no apparent depth to the scene and the glass would appear dull and black. An opaque background would be frontlit to achieve similar separation.

. . . to bounce off any lower ceiling to give an overall softer and more naturally lit room appearance. The resulting domelike light softened this scene, lowered contrast, and increased detail in the attractive cake table display.

. . . to provide side or rim light that gives texture, dimension, and background separation, particularly for black tuxedos. Narrow or dark churches make sidelighting of subjects on the aisle easy and effective.

The Assistant's Primer

First and foremost, I want to be ready to work the moment I arrive at the job site. My assistants understand this.

I like to have film preloaded and memory cards preformatted. I'm not personally comfortable until the assistant has assembled my tripod camera and my Stroboframe setup. I'm especially annoyed if my dark slide holders and lens shades aren't in place. The first few minutes do a lot toward establishing a positive team atmosphere for the whole day. It's very gratifying to have one's attitude adjusted by an attentive assistant.

～ SETTING THE STAGE WITH THE EQUIPMENT ～

The photographer needs a tremendous amount of gear to be able to work to his or her fullest potential—as well as to be secure with backup equipment. To a large extent, the equipment available determines the types of photographs that can be made. A spare film back or lens left at the studio does no good until someone fetches it; you must make sure everything the photographer will need is at the event. Further, you must anticipate the exact items needed and have them at the ready as action evolves. This sounds simple, but wedding photography is characterized by such flux that it's almost impossible to know precisely what will be needed when, and what unusual accessories you could take advantage of given varying lighting conditions or spontaneous moments.

～ PACKING ～

You should devise a way of packing all the equipment so that it will be both protected and easily available—and then always pack it the same way every time you work. If you do this, you'll rarely leave anything behind, and you will be able to tell what's missing just by looking in each bag. The correct reaction is, That's where the meter goes and it's not there, rather than, Do I have the meter? Imagine my annoyance and stress level one afternoon after traveling an hour to an unfamiliar location for an engagement sitting and discovering that a new assistant had neglected to pack any meter at all. He didn't ask himself either of the questions above—a total breakdown in organized thought and planning. He didn't imagine the equipment scenario that would unfold if he were doing the work himself. Major mistake!

Good working habits and years of experience enabled me to make the sitting a success. However, I was still angry that another person's inability to be a team player caused me needless stress. Capturing just the right body language and expression is challenging enough without putting technical pitfalls in your own way that jeopardize the entire result.

～ DIVIDING EQUIPMENT ～

Equipment can be divided at any given time into what the photographer carries, what the assistant has close at hand, and everything else. I've already mentioned the three camera configurations I use during any job: Hasselblad on Stroboframe, Hasselblad on tripod, and Hasselblad loose. I generally carry the camera setup for the next anticipated use, and the assistant carries a second one, plus a video-style bag with a zip-open top (not a fold-over flap) that contains my standard lens set, an array of preloaded film backs, and extra loose rolls of film.

Lenses are removed from their hard cases at the beginning of the job and kept loose in this small bag with the front elements facing up. It's a good idea to keep a back cap on lenses with rear elements that aren't recessed, in order to keep them clean and undamaged. Film choice will obviously vary with the situation at hand, so it's important to be prepared with several backs loaded for high-speed available lighting conditions, several for standard ISO 160, and at least one of an intermediate speed. Generally, I keep one back unloaded for unexpected conditions.

Labels are a must; we use color codes, not just the ISO rating or film box end as they all look alike at a fleeting glance. I switch back and forth between films many times to suit the varying lighting conditions, the appropriate style for the action, and type of film (black and white or color). By having this small bag with favorite lenses, film backs, and basic accessories, it's possible to operate at some distance from the main body of equipment for an extended period. Should the assistant need to leave me, he or she hands me this bag, or sets it near my feet.

～ STROBE LIGHTS: AN EXERCISE IN REDUNDANCY ～

Multiple units not only make multiple lighting techniques possible but also combat problems of delicate lamps, cords, contact points, "flaky" electronics, and radio interference. Since I favor more difficult lighting situations, I prefer to calculate camera exposure and strobe output manually. The exception to this scenario is 35mm paparazzi pictures, for which I usually use a tiny automatic flash or a Canon D60 digital camera with its dedicated strobe. In either

case, we carry three or four strobe heads and several connecting cords, separating each type into its own Ziploc bag.

If the electronics are misbehaving, the first thing to do is check all the connecting points and switches, and then start changing out cords, which in Colorado's dry, static-prone environment can be flaky one moment and fine the next. Hot shoe attachments eliminate cords, but that's rarely where you want your strobe located. A second light controlled by transmitter is also handled by the assistant and must be test fired. It's not working, is not a satisfactory response; you just have to make it work! And, of course the assistant must automatically, without being told, handle reflectors for optimal additive light needs.

～ CARRYING EQUIPMENT ～

How to carry equipment is an ongoing concern. If cameras are encased in heavy travel bags, they're safe but relatively inaccessible given the speed at which fleeting expressions pass at a wedding.

If you have several cameras around your neck or loose on the back seat of your car, the risk of damage is magnified. I use a combination of transport and smaller job-site bags.

We're often asked why we don't have some sort of rolling cupboard for the equipment. We have too much gear for a small cart, and a large one would be too heavy and unmaneuverable in most locations, especially on stairs. The only place where a large cart would be useful is at a hotel, and they already have large carts.

Several smaller bags are a lot easier and quicker to move than one very big one. We do use a folding dolly, which accommodates a stack of several hard cases to be moved at once. However, two people are needed to negotiate the loaded dolly on stairs and over curbs.

～ EQUIPMENT HANDLING TECHNIQUE ～

This must be developed between photographer and assistant for positive control, just like in an operating room. Either have the assistant put a lens/film back into your open hand, or pick the piece of equipment off the assistant's open hand. Try to pass equipment in the same manner each time to increase teamwork speed and lessen the risk of breakage.

Film loading must be handled consistently, as well, particularly with multiple film types. Watch the film advance before closing the dark slide. A spent film back is laid dark slide up; a full or partially finished back is laid face down or replaced in the bag. If an unconventional type of film is being used to create accent images among regular ISO film types, the assistant should mention the speeds while changing the backs and intermittently remind the photographer what film is in the active camera. In

35mm, make sure the spindles revolve, indicating a correct load. Double-check the ISO marker and the actual film at the end of each roll so that alternative processing can be ordered for the rare occasion when an error occurs.

～ SPECIAL SUPPLIES ～

My assistant will have gaffer's tape, a knife, screwdrivers, contact cleaner, electrical converters, pliers, wire cutters, lens cloths, and other useful tools in his vest or hanging from his utility belt. At a moment's notice he can assemble or fix just about anything. A little bag of simple conveniences will solve almost any wedding party crisis. Scissors and all kinds of pins are the most frequent needs. We add needles and thread for on-the-spot repairs, mints, bobby pins (both white and dark), florist's tape and wire, pens, aspirin, powder, and lip gloss.

～ ADDITIONAL RESPONSIBILITIES ～

The assistant is always responsible for stray film tabs on the work site, and for tightly sealing all rolls of film, giving extra care to torn back tabs, which frequently get stuck in the camera mechanism. Memory cards are reversed in their cases and set in a special box.

Rubber bands substitute for broken seals and can be used to label a misbehaving or obviously broken back or lens. Film types are separated into color-coded nylon mesh zippered bags: yellow for normal ISO 100 or 160; red for ISO 400 and 1000; green for anything special; and blue for instructions, maps, and exposed film.

～ ADDITIONAL "TOOLS" ～

The tools of the trade aren't limited to the hardware that you carry. Some of the most important things to have are a timetable, a list of special photo requests, a VIP list noting relationships, and a list of group photos desired. With these, you can be "clairvoyant" with participant names. When people get flustered and don't know what to do next, you can use your timetable to gently propel the event in the right direction. You'll also be able to work seamlessly with the other vendors.

An assistant cannot blindly take orders without understanding what's being done or let his or her attention wander. A flustered or inattentive assistant gets in the way. I require assistants to become fully cognitive players, anticipating action, deciding what they would do in the given circumstances, comparing that to what they feel I will do, and providing me with the equipment and film appropriate to my style and perceptions. The photographer and advanced assistant also ought to be able, for the sake of teamwork, to switch roles—to automatically move to help each other.

Working Environment Considerations

It's well documented that the psychological profile of the photographer resembles that of fighter pilots, race car drivers, and firearms experts.

Like it or not, we're all stuck with this somewhat macho mystique. I've learned to enjoy the more exotic aspects and glamour brought by the perceived show-off, take-charge stance of our profession, and yet bring my own unique sensitivity to the job. Women have long worked as assistants, holding lights, arranging dresses, touching up makeup, and affording a congenial, calming influence that will improve the quality of expressions. Across the United States, there's a growing proportion of women behind the camera—especially those with art backgrounds—because of their tenacity, detail orientation, and affinity for social events.

~ SIZE ~

Physical size is the overwhelming problem women must face as wedding photographers, so preplan alternatives to ensure success. Small size does have a big advantage when moving quickly and inconspicuously in and out of the crowd. Once I saw a 5'1" woman try to handhold a 6 x 7 SLR with a waist-level finder for candids; it wasn't pretty, nor were the results. Fortunately, contemporary medium-format equipment offers a variety of smaller cameras, Mamiya and Hasselblad brands in particular. An eye-level prism finder is a must to avoid a low camera angle that looks up into subjects' nostrils. I also use a 20-inch-high hard case as a step stool.

More than size, there's the question of overall weight to carry with the additions of strobe, bracket, and battery pack. Physical stress makes wedding photography one of the most grueling civilian professions. Without weight training and aerobics to keep me competitive, I would not be able to handle heavy gear for long hours at a stretch.

On many jobs, both wedding and commercial, I carry a Pro-Step ladder. My three-step model is the smallest available and fits easily in my car; the four-step size is hardly any heavier but requires more space to transport. The high rail makes it very unlikely you'll fall off when your hands are busy with the equipment. The ladder turns a disadvantage into an entirely fresh new angle of view that is very much in sync with my desire to include environment as a storytelling device. In a hall without a stage or platform, this ladder is now a must to get the needed perspective for Jewish dancing. I can't imagine how I got along without it; it's simply one of the best accessories I've purchased recently.

~ ATTIRE ~

Men need only don business suits or tuxedos to be correctly attired and comfortable at any venue. Women need specialized clothing. As a novice photographer thirty years ago, I worked in long dresses and high heels! Of course, the fashion of the time called more for posing and about one quarter the total images I typically make now. Most coverage lasted about three hours, versus the seven to eight of our current commissions.

I've settled on several "uniforms" that I vary with the season, level of formality of the event, and what I have to do physically. I have several men's suits in dark colors that work great because of all the pockets. I do have one tuxedo. A dark blue voile dress gets me through hot summer afternoons. Black pants and a fancy white blouse are never wrong. Since Colorado weather can

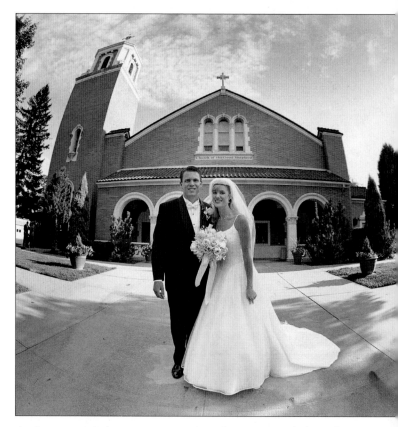

An alternative to a higher vantage point is to turn the camera completely upside down. With a 45-degree prism finder, this rock'n'roll technique will gain you about ten inches of elevation. A rise in height, plus a fish-eye lens, dramatically changes the final angle of view.

WOMEN IN THE WEDDING PHOTOGRAPHY WORLD

Women enjoy some extraordinary advantages as wedding photographers, above and beyond being welcome in the dressing room. Natural empathy for the event as a whole and appreciation for the fine points of dress arranging make clients happy right from the start. By my informal survey, the successful black-and-white pro is more likely to be a sympathetic woman, partly because it's very acceptable for women to touch their subjects on the job. I take over quite naturally with arrangement of the bride's, attendants', and other female relatives' attire.

To augment direct instructions by voice and gesture, I will gently take hold of any subject, often just briefly touching the elbows, to refine a formal pose. At first, I was amazed at how I can do the same thing with men as with women. I'll admit that age and tireless enthusiasm do help a bit. To get what I want, I say and do everything with little jokes and smiles, and try to call everyone by name. I find as a woman I can get away with a lot!

Postproduction is the other part of the total wedding service in which women will excel. In most studios, women already perform the painstaking tasks of computer enhancement, handfinishing of prints, and assembling of albums. Eternal patience is always needed when helping a couple make their selection from the previews. Instinctual storytelling flair is the skill needed for preserving memories and rekindling emotion through the photographic album.

change quickly, even in summer, I carry a blazer and a Patagonia fleece jacket with wind-stop lining if we're headed to the mountains. Now and again jeans are required. I have worn a ball gown to work only twice in the last ten years when there were no stairs to negotiate.

If your feet hurt, you work poorly. I wear bifocals, therefore I find flat shoes offer safety and comfort when I need to move quickly over uneven ground or steps. Mostly, I prefer plain white aerobics shoes, not heavy ones with distracting colors and logos. With these, and formal lace-edged socks, I can work twelve hours or more without tiring. While this somewhat eccentric footgear is not for everyone, it makes people smile, especially if my assistant explains that I need to run to make their day perfect.

Powering the strobe is another problem because of weight and awkwardness of attachment. During a very long job or consistently high-power settings, Quantum battery packs are a must with their extra wires and heavy module. This setup is no problem for assistants who have nothing more to do than walk around holding a Quantum in one hand and directing a loose strobe head with the other. However, a ladies' pants belt will not adequately support the weight of a battery and will pull clothing uncomfortably awry. If I'm wearing a dress, the additional swinging weight of a shoulder strap is an awkward burden. After years of searching for an alternative, I discovered snap-release police pistol belts. Constructed of very stiff webbing and a Velcro flap that folds to size, these two-inch-wide belts support and distribute the weight of the battery around my hips so that I barely notice it. It's a real find for a modest $10 investment; men would like it, too.

~ VOCAL AUTHORITY ~

Timbre and volume of voice can betray the woman professional and make her seem a lightweight. When I need to command attention, for instance to attract all eyes in the camera's direction for a formal group, I try to lower my voice and think in terms of projection of sound. This is a skill I learned as a private pilot. Low, distinct tones always carry better over the radio when you're talking to air traffic control and have the added advantage of making you sound extra confident.

~ ENERGY MAINTENANCE ~

Everyone needs high-energy snacks and drinks. Don't work so long that you get tired or dull from low blood sugar. Our events usually require the equivalent of a full business day of work, especially considering travel and setup time. Tempting as the catered spread may look, it's full of the wrong sorts of foods to maintain your physical standard of performance, no matter what your age. Only occasionally can we convince the caterer to provide us simple "service meals" to nibble out of sight of the guests while the bride and groom are dining.

So, we try to troubleshoot food in advance and often bring power bars, cut vegetables, maybe sandwiches or yogurt, something with protein. Water bottles are a must on location in the summer. I try to keep soda consumption to a minimum. Breaking other photographers' rules, I will sometimes take a glass of champagne at the very end of the evening, specifically to thank everyone, as well as to personally toast the wedding couple.

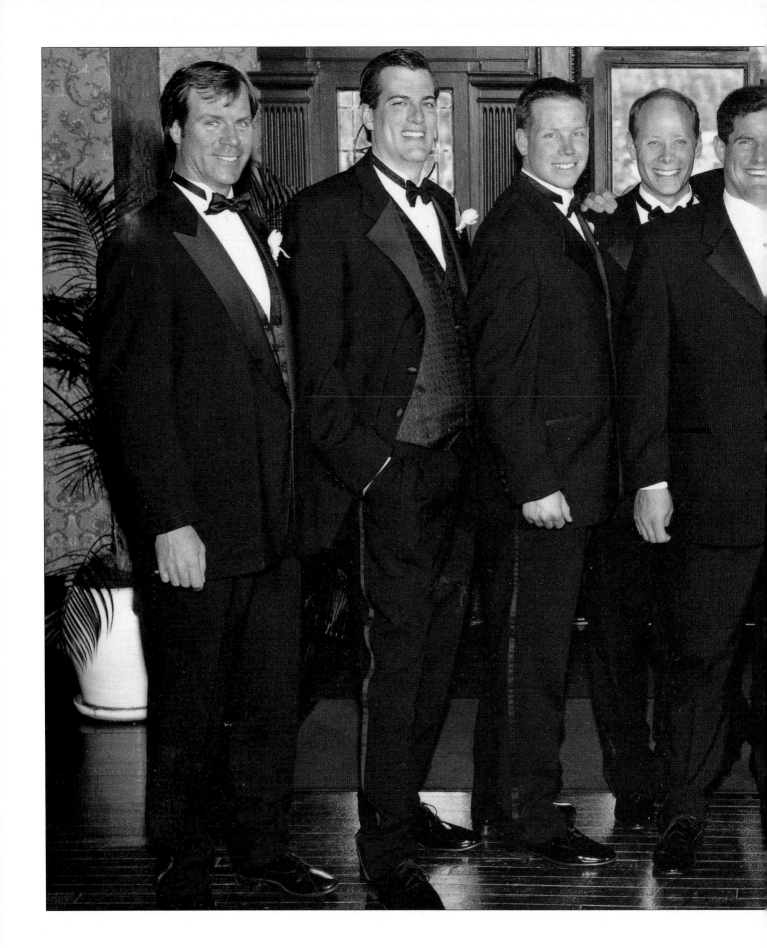

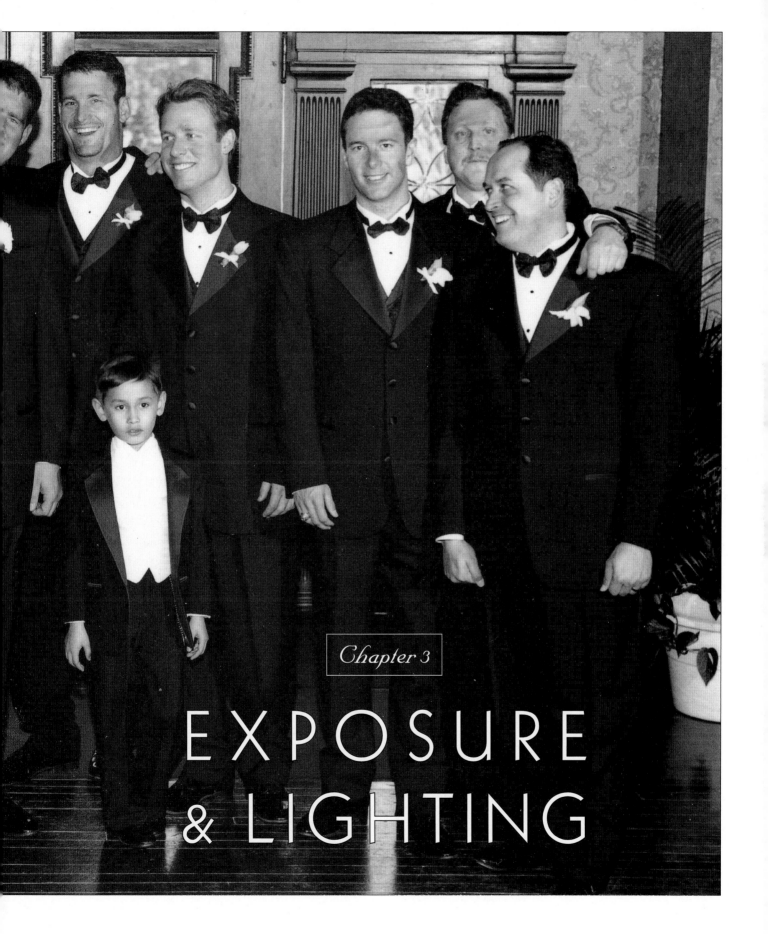

Chapter 3

EXPOSURE & LIGHTING

The Basic Concept

I've observed that photographers tend to put either too much light on their subjects, or not enough. Misunderstanding the physics of light will aggravate the admittedly difficult contrast situation of white dress and black tuxedo. In general, not enough time is spent in metering or calculating how to achieve the exposure effect desired.

Wrong exposure is just that: a negative or digital image with so little, or so much, density that it cannot be easily printed with any acceptable result. Adequate or correct exposure produces a print with pleasing and natural rendition with both blacks and whites. Creative exposure, when form follows function, renders an interpretive effect or treatment of a subject. Black-and-white photography is, of course, always an interpretation, not reality, but the majority of wedding subjects must be handled with a pleasing and natural look that's detailed and believable.

Correct exposure is never a simple matter; testing and metering are key. The best advice for the black-and-white wedding photographer, or the color wedding photographer for that matter, is to work for consistency of exposure. Full tonal range containing a long gray scale, as well as the extremes, is the most preferred look. Both highlights and shadows matter, but to a certain extent, we are willing to sacrifice detail in the deep tones of tuxedos to favor detailed rendition of the dress. The least overexposure starts to increase grain, decrease sharpness, and build contrast; underexposure is even more challenging, because blacks become gray and the whole print turns milky.

Color negatives exposed within the very forgiving sixty-point range (two *f*-stops) can usually produce a print adequate for the client, who will often overlook technical shortcomings in favor of expression. Multispeed films work because two or even three *f*-stops of overexposure are now possible without too much loss of quality—at least for the amateur market. In black and white, as well as digital capture, exposure this imprecise will require a good deal of manipulation and may often result in an unacceptable image.

Digital exposure is widely reported to be as critical as that for slide film. Even as a novice digital photographer, I found that Photoshop 7's autocolor feature and simple actions for modifying slight over- and underexposure work better than traditional laboratory color and density corrections. My conclusion is that good film exposure habits easily carry over into the new medium.

∼ THE ZONE SYSTEM ∼

Black-and-white paper and film are actually not sensitive to all visible color wavelengths. Further, objects don't reproduce in black and white in the same relationships and values as they do in color. Since skin of all ethnic groups has a fair amount of red pigmentation, faces often record darker in black and white than in color. Medium-blue sky often records very light or even blank. Greens usually lack differentiation and appear deep and muddy.

Consider the traditional Zone System gray scale that art photographers are familiar with and the color scale as related to the Zone System. This most important tool helps put the relative reflectance of colors into your memory so that you can recognize how they deviate when translated into black and white. We expect evenly illuminated green grass, medium-blue sky without clouds, light brown, magenta, and red all to "read" the same as asphalt-like middle-tone gray—the 18 percent gray defined by Zone V, which is the tone all meters register. Grass in bright sunlight, pale-blue sky, tan, pink, and orange are all one *f*-stop brighter at Zone VI. Zone VII tones are very light pastels and white. Dark evergreens, brown hair, charcoal, purple, and burgundy register in Zone IV, one *f*-stop less than middle-tone gray. Blacks and other very dark tones with not much texture fall in Zone III.

It's immediately obvious that sky reproduces lighter on black-and-white film. Medium blues generally lack punch and interest, and pale blue may record as virtually no tone at all. There are three remedies: to burn in the sky areas in the darkroom, to use a tonal wash with photographic watercolor, or to use a yellow or orange filter over the lens. Green trees, especially darker ones tend to record even darker, muddy, and with less differentiation between types of foliage than might be expected. A nature or commercial landscape photographer would probably use a green filter to lighten those tones overall, which allows different types of foliage to appear more varied. When emphasizing a wedding subject, we generally settle for whatever texture we can get in such a background, because use of a green filter would serve only to darken faces unattractively. Keep in mind how in black-and-white photography a filter lightens the tonal reproduction of its own color and darkens the opposite color. Red and magenta both will reproduce darker than we want, explaining the typical problem of the female executive photographed in a red suit that may look black.

Examine the delicate change in tone from skin to lips in a print. There will be less contrast recorded than the eye sees because orange, pink, and tan appear a bit darker, and with less differentiation between them. Paler makeup base and deeper-tone lipstick help correct this problem dramatically. A favorite technique of fashion photographers is to overexpose by one to two stops to "bleach" the skin, erase blemishes, and diminish the details and contours of the features. Beware that while eyes and lips will pop, overexposure dramatically raises contrast, which in turn induces darker hair to lose depth and white dresses to lose definition and detail.

Caucasian skin reproduces well when "placed" at Zone VI, one *f*-stop lighter than the camera exposure setting. Most other ethnic groups reproduce at Zone V to V ½, with extremely dark

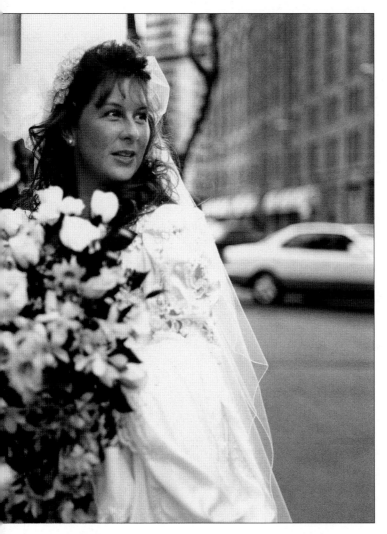

A glamour wedding candid needs three things: face, feelings, and fine details. We perversely want to portray a client so comfortable in the most formal regalia. My goal is to make every woman look this beautiful and natural.

IS THERE ANYTHING ON THE FILM?

Technical failure is the norm, not the exception. Larger labs tell me that, on a daily basis, they receive an astounding quantity of film from amateur and professional studios alike that has extremely irregular exposure, that pushes the outer limits of under- and overexposure, or that has virtually no exposure at all. Digital capture is no cure-all.

Autofocus and autoexposure features have many nuances, and are hard to learn even with an extensive knowledge of manual equipment. In-depth experience with equipment, lighting, and film is a necessity before a photographer can work effectively in the wedding photography niche market. Among all types of photography, this specialty is harder, faster, brings to bear more various photo skills, and requires constant client contact to boot. It's so easy to become distracted from technique when you must simultaneously maintain person-to-person relationships for hours on end. When in doubt about an experimental exposure, always make another with a tried-and-true setting to avoid disappointment.

skin perhaps at Zone IV ½. All black-and-white films are more sensitive to the reds in skin tones and record them from one half to one full *f*-stop, or Zone, darker than color film. This is the three-pronged central exposure problem wedding photographers face: Overall scenes must look snappy, but the characteristics of black-and-white film make it hard to reproduce faces naturally while at the same time showing intricate, bright details in the wedding dress.

Lab representatives all tell me that most professionals create additional exposure problems by overestimating the output of their strobes (even automatic ones). Automatic exposure systems, if not tested and reset for the exact situation at hand, frequently result in underexposure. In spite of the tolerances of contemporary film grain technology, you must understand and compensate for how quickly strobe light dissipates in large rooms. Men's tuxedo jackets that merge into the background are a sure indicator of this fault. (See page 107 for the challenges of the inverse square law governing light output and how to compensate for them.)

Incidence and Reflectance Go Hand in Hand

The main concept to remember is that correct exposure considers, in tandem, the amount of light falling on the subject (incident light) and the amount of light reflected off that subject (reflected light).

Contemporary automatic in-camera metering systems, it could be argued, eliminate exposure responsibilities, yet they are complex to learn and operate proficiently. Understanding and application of the physics of light will help you calculate both strobe and natural light exposures more consistently and accurately.

Most fairly experienced photographers have long passed the stage of relying exclusively on an in-camera reflectant meter. For the vast majority of portrait situations and angles, incident metering is the most accurate. If you aren't near the subject, meter from a spot where the light is similar and in the same line of sight. Spot metering on faces is also accurate. You must set the ISO one *f*-stop overexposed if the brightness range of the subject is to reproduce naturally . Metering the shadow side of the face in heavy sidelight will often accomplish the same goal. Note that the exposure correction feature of your meter or camera can be an error waiting to happen if the meter setting is not verified for each new situation.

Incident readings are made from the subject position, pointing the meter probe toward the camera to find out how much light is falling on a given scene and then observing the subject and background and judging their response to the ambient light.

Dark subjects reflect far less light than medium colors, and shiny surfaces reflect more than dull ones. In comparison to faces, black velvet dresses absorb a lot more light, and therefore, little detail of their elegant texture will be recorded unless you modify your exposure or add accent lights to the side for dimensionality. The same happens with a background of dark green trees.

The importance of reflectance is demonstrated in rooms with dark ceilings. Photographers often underexpose this type of location by 1 1/2 *f*-stops, even after cautions about the "black-hole effect" of dark decor by pointing room strobes at the ceiling. The dark ceiling surface reflects no light at all. The only solution is to point lights directly into the crowd, use lower strobe output, and drag the

TURNING A BLACK STUDIO BACKGROUND WHITE

First, determine exposure on the subjects by *incidence*. Then increase the output of the background light until, by *reflectant* reading off the background, the meter shows about two stops difference. Opinions vary as to whether to use 2 or 2 1/2 stops; the choice is certainly keyed to the contrastiness of the particular film used. You're exposing for the ambient Zone V (not the reflectant reading on the face, which is probably Zone VI) and, by choice, raising the response of the background black paper to Zone VII or VII 1/2.

shutter. I also keep people closer to the walls than would usually be appropriate, to achieve added bounce effect.

Different types of metering work in different situations. Church altars and scenes with direct-on illumination are best metered incident with the meter dome protruding, because light is coming from many directions. You'll achieve a more accurate reading of sidelight with spot metering on the shadow side of the face, or incident metering with a recessed dome or flat objective. Backgrounds are best metered reflectant or with spot on mid-tone grass or open blue sky, away from the sun. For sunsets, pick a part of the open sky to meter that's brighter than middle gray, and be prepared for dark areas of the background to lose most detail.

The accident of a wrong exposure will be less likely with an automatic camera, but at the same time, creative interpretation will be almost impossible. Since the eye is less tolerant of "blown out" highlights than featureless shadows, virtually all automatic systems are set to favor detail in lighter tones, a practice always appropriate for color slides. This bias results in underexposure extremely detrimental to black and white, which many photojournalists combat by simply resetting the ISO indicator to 1/2 or 2/3 of the manufacturer's recommended film speed.

Recently, I took time to inform myself about the new Nikon models with the help of a very knowledgeable representative. What a surprise! The longer he talked about their advances, the more overwhelming the implication was that improvements and automatic features are all about exposure. The latest and greatest Nikon F5 actually has sensors that register not just density of light (tone) but also perceive the color reflectance of objects. I predict this system may produce a real revolution in metering.

Outdoor Lighting Concerns

Clients are pleased with how they look in outdoor photographs because luminosity literally comes from all directions and penetrates darker-tone objects to create detail and depth that's much harder to render in studio situations.

Women comment in particular on how light, shiny, and full their hair looks outdoors. Black-and-white tonal rendition is a relatively easy job on location, because color shift due to time of day or reflected colors is a nonissue; in color, of course, a white shirt picks up green under the leaves of a tree, cool blue light in shade needs a warming filter, and late evening light produces a yellow bias that's difficult to print without color crossover. Technical skill in black and white must focus instead on accurate exposure, directionality of lighting for facial "rounding," and rendition of the whole tonal range. Underexposed muddiness of tone kills black and white instantly.

Lighting problems outdoors fall into three categories: downlight, splotchy backgrounds, and contrast. You don't have much control over wedding day locations. Sometimes there just isn't any cover; sometimes midday downlight can't be avoided. Look for naturally occurring directional light without too much contrast and, of course, not too busy a background. If eye sockets seem the least bit shadowed, they'll record dark and lifeless on the film.

If no natural overhang exists, use light modifiers to force the main illumination to become directional and hit the subject from

TYPES OF LIGHT

Sunlight can be categorized as direct sun, open shade, directional, sunset or sunrise, and northlight. Other defined types of light include window light, wraparound light, incandescent light, candlelight, backlight, downlight, silhouette, rim light, Rembrandt, neon signage, strobe, lightening and fireworks, fluorescent, and mixed sources. Some of these terms describe the light source itself, some the quality of light, and the rest a combination of both.

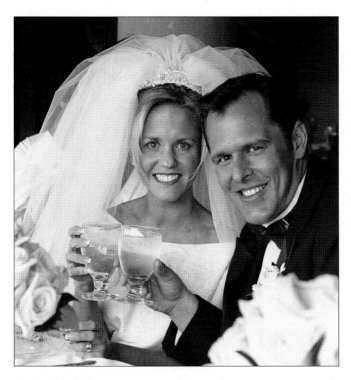

Overhead shade from a tree, eave, porch—or, in this case, an awning—easily eliminates offensive downlight. Ambient light need only be measured incident at the position of the people for pinpoint accuracy.

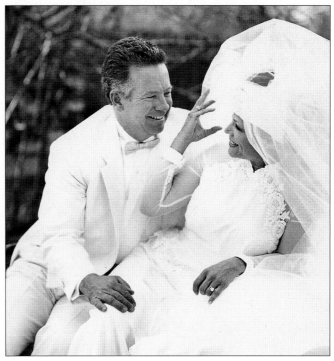

A partial tree overhang plus an overhead subtractive gobo eliminated downlight here. The white clothing and a silver reflector from camera right brought back sufficient volume of light on the faces to balance with the backlit background.

Sometimes it's hard to judge whether natural light alone or a slight amount of strobe fill will produce the most pleasing result. Faced with this dilemma, try both. The smaller image below is pleasingly soft and natural. The larger image below with strobe fill is a bit crisper, and has more background punch and eye sockets that are more open. Our prop rocks are easily transported on location to facilitate comfortable posing.

Another option is to deliberately under-expose or overexpose the background so that it appears nondescript. This example shows the relative effects of "equal" and overexposed backgrounds.

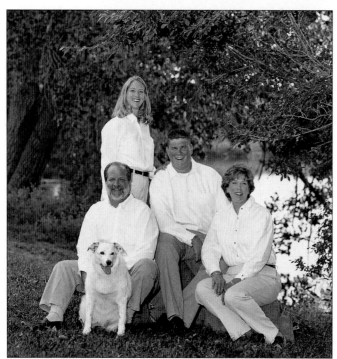

a lower angle to the side. Directional light can be built anywhere by holding a large subtractive gobo or a diffusion flat overhead, depending on whether you want to remove or diffuse downlight. Generally, I have an assistant hold the flat, but a stand will do as well. Sometimes, a fill reflector is also necessary on the shadow side. Accent or catch lights can then be enlivened with any small reflective device, which brings light in from the front on the side

of the main illumination. All of these techniques are meant to create a rounding of the features and an emphasis of mid-range tones, without elevating contrast.

The second outdoor lighting problem—splotchy light on backgrounds—may work well in color but be frightful in black and white. When outdoors for casual portraits of the bride with her parents and attendants, I make a choice based on background to work either with available light and reflector assist or with backlight and synchro-sun (see page 102). I stick with the same method for the whole series. Working speed is most important here; I take no more than ten seconds to set up and make each photograph in a semiposed series, as I want expressions to be fresh and real. Backgrounds need not be uniform, but beware that the same backlit leaves that record as an out-of-focus jewel-like sparkle in color may very well become a busy, distracting untidiness in black and white.

So few photographers look behind their subjects! Composing and lighting what is behind the subject is just as important to the location photographer as arranging the people. Overall textures, patterns, planes, or shapes that aren't too contrasty work great. An exception would be very dramatic light streaks on a black studio background, in the manner of the golden age of Hollywood glamour.

When the background is recorded sharp or semisharp, with full tonal range detail, the portrait will evoke a time and place, with people "on a set." This environmental-portrait approach is

THE ORIGINS OF REFLECTOR TECHNIQUE

The antecedents of the reflector technique described on this page are strictly Hollywood and sophisticated commercials. The catch light reflector will usually be fairly close, perhaps five to six feet—or even just under the chin if the viewfinder shows only the face and neck. Think of John Wayne's hat, the shade from which was so carefully, though unrealistically, lit in the movies as to never allow his eyes to be obscured. The hair or rim light reflector may well be fifteen to twenty feet away in order to pick up and transmit a strong, specular pool of sun. On location, I've refined the technique by using two assistants to handhold reflectors in a completely mobile fashion. The results are breathtaking!

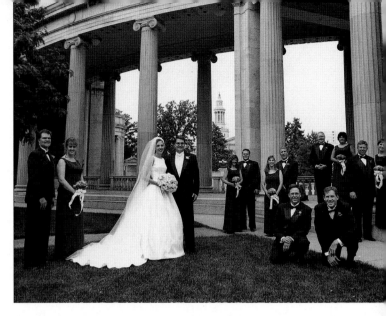

This lighting concept is equally well illustrated whether using Colorado's magnificent mountain scenery or an interesting public building. Columns and distant features are as carefully spaced in the composition as the subjects in front of them for precise results.

when the location, or "set," has perhaps not an equal, but a very important, role in the portrayal of heritage and lifestyle. This scenario is in contrast to one utilizing a nondescript, out-of-focus background designed to be artistically subservient in meaning to the faces. Take into account that the physics of digital capture produce the effect of greater depth of field; therefore, you may find it best to work at wider-than-normal apertures or backgrounds will be too sharp for portraiture.

The third outdoor lighting problem of contrast is one of tonal range and separation of tones. Muddy tones can easily result from underexposure or improper reflector technique. Punchy, blocked-up shadows and highlights with little detail in gray tones results from overexposure or lighting conditions that, left unmodified, are too contrasty for film. Both muddy and contrasty exposures are exacerbated by backgrounds, particularly dark ones, that offer no tonal separation from the subject.

The most frequent error for outdoor subjects is adding more light with a single reflector from the same direction from which the main illumination is coming. This error in reflector placement increases contrast and doesn't create the desired rounding of features, but instead tends to split light on the faces. Contrast-reducing techniques in the darkroom won't satisfactorily help.

In order to wrap the light and lower contrast of the shadow side of the face in relation to the background, I use a three-reflector setup. A large reflector opposite the light source wraps the shadow side of the face with fill illumination. A second reflector from the

When faced with dark-haired or darker-skinned subjects, choose a lighter, better illuminated, or more textured background to provide separation and a luminous quality right around the head. The first image (left) has excellent expression and body language while the second shows an improvement in separation of tones with the placement of dark hair against the light blouse.

rear quadrant adds kicker light to outline shoulders and accent the rim of the hair. Once satisfactory contrast balance has been achieved, a third additive reflector on the side that logically looks like the main source further helps to round the face, and catch lights will appear automatically in the eyes. Sometimes, that reflector has to be positioned farther away to pick up the light, or it may have to be bent if its flat surface creates harsh specularity on the subjects.

An effective and semipermanent reflector setup can be made by anchoring or weighting your flats to the ground and using the same spot over and over. A painted wall will act in the same way. With color film remember to use a 5 or 10 CC (color correcting) red filter over the lens to correct green bias caused by foliage.

Synchro-Sun Technique

Shine and brilliant tones attract clients. The synchro-sun technique lets you be a magician in many difficult lighting circumstances. The pluses of scenic backgrounds often bring with them the minuses of challenging exposure. Rarely is there time to meter and remeter while a group becomes increasingly impatient. Beautiful scenes during standard daylight hours for weddings are frequently downlit situations that usually dictate the more heavy-handed style and power of fill strobe. Intense colors and details can be reproduced with synchro-sun technique at any hour. Early or late times in the day always afford the most interesting lighting but are hard to expose. Strobe synchronized with sunlight achieves sparkling tonal range when you must combat contrast, splotchy light on subjects' faces, or any unusual light situation.

The general rule is to add enough strobe power to expose faces at a setting that makes the background equal in brightness, or just slightly overexposed. This makes the subjects darker than the background. The more you increase the strobe power illuminating the subjects to equal or to exceed the background exposure, the darker the background will appear in proportion. Background underexposure brings dramatic brilliance, and sometimes a surreal dimensionality that pops subjects right off the face of the print.

Faces must be turned away from the sun, to keep them as evenly shaded as possible, and then brilliantly strobe filled. For such a backlit situation, I read the exposure reflecting off the background. To create more depth and rounding, the strobe used in synchro-sun mode can be taken slightly off camera, but not too

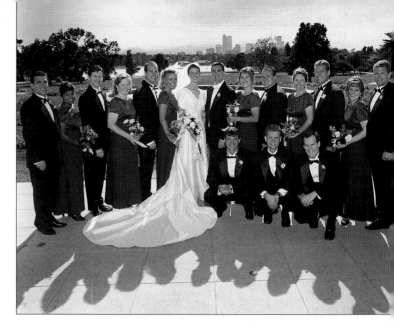

Brilliant backlight illuminating a scenic cityscape necessitates heavy strobe fill, in spite of the reflective concrete in front of the wedding party. If the estimated exposure is 1/125 sec. at f/11 with ISO 160 film, by reciprocity that will also be 1/500 sec. at f/5.6, which, with a leaf shutter synchronizing at any speed, is an achievable power output by most on-camera strobes at the distance of fifteen to twenty feet. A large lens shade is a must to avoid flare when photographing directly into the sun.

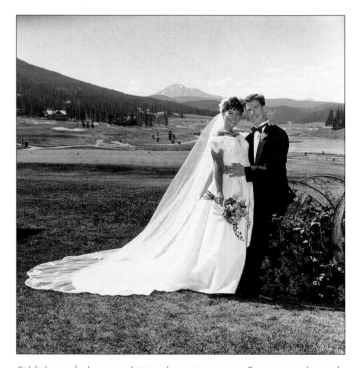

Sidelight can fool even sophisticated metering systems. Exposure can be easily metered reflectant on the grass, which is close enough to an 18 percent gray. Strobe power can then be added to be equal to or slightly less than the f-stop chosen. Even for posed subjects, a reflector will not usually be sufficient to fill the shadow side of the faces and may make subjects squint unbearably.

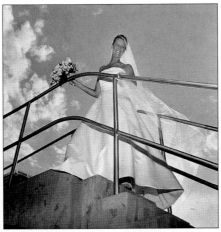

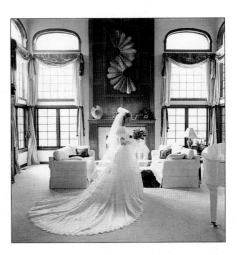

Sunset light would have easily turned this photo into a silhouette, which would have been a good alternative since the veil was flowing and translucent. I chose to add just a very small amount of strobe to gain more natural detail in the back of the dress. The low camera position avoided lens flare by placing the subject directly in the path of the sunlight.

Backlight, especially if you can position hair and veil to be touched with direct sun, creates dimensionality. Clients love the tonal brilliance and detail that this technique affords, whether images are in color or in black and white. The strong architectural diagonal and unusual angle are combined with a memorable unposed casualness.

Architectural photographers generally light the interior of a room slightly less than the ambient exterior so that the scene viewed through the windows appears realistically a bit lighter. This scene is already so visually busy that I overexposed the windows to avoid complication of meaning.

far. Don't be too dramatic about directionality of the frontlight in this situation for fear of casting awkward shadows. Bare bulb won't work well if you're outdoors or fifteen feet or more distant from the subject, since there's little or nothing off of which the light can bounce. Most often, I try to select an angle from which subjects are at least slightly back lit or rim lit.

Try to augment natural light, not overpower it. Texture and directionality of backlight should create depth and interest in the scene, and then strobe will correct, or narrow, the contrast range. Experience will get your exposure within less than half an *f*-stop, which is close enough to achieve a satisfactory negative each time. In bright sunlight, I start my mental exposure calculation with the Sunny 16 rule (see box), usually without metering, and modify it by estimating the existing conditions. I manually set the shutter speed and *f*-stop combination, which will mesh with the strobe output at the working distance. The inestimable value of a leaf shutter is that it will synchronize with strobe at any shutter speed, thereby providing the options that make this technique a success.

My method works easiest with completely manual equipment, or with a strobe that allows you to set the power output you want. Movie directors do the same thing with hot lights. Experienced photographers shouldn't cringe at this seeming oversimplification, but be aware that automatic systems tend to lead you astray in this situation. Happily, this method need not be practiced as an exact science, any more than the use of multiple strobes on location without modeling lamps.

THE SUNNY 16 RULE

The Sunny 16 rule states that the best exposure for a subject in direct, full, bright sunlight is *f*/16 with a shutter speed roughly equaling the film's ISO. For ISO 160, use 1/125 sec. at *f*/16, or perhaps *f*/11 1/2 is more realistic. It's a good idea to take a meter reading for safety to confirm your mental exposure estimate.

Recently, I had a meter malfunction without warning. I looked incredulously at the reading; it was two *f*-stops off from my estimate. The sun doesn't change; only climate conditions and time of day and year do. It was a clear midmorning and *f*/11 should have been perfect, but the meter read *f*/22! I was tempted to believe the meter; indeed, I made a few frames with that setting and then thought better of it. A second meter confirmed that the first had been stuck reading reflectant light even though it was set to read incident, thus producing the two-stop error. The moral is—get to know light and judge for yourself.

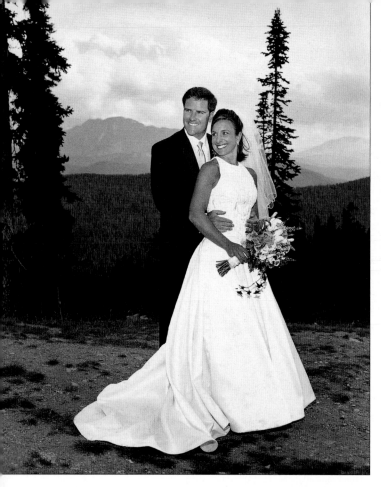

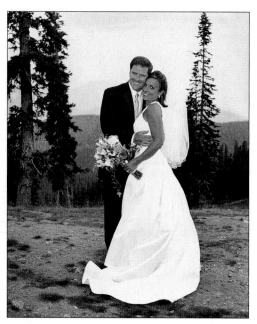

With sunset glow in the same location, a slightly different approach nets breath-taking results: In the first image (above), I tried to average the meter reading to record some tone in the trees. Exposing for the mountain peaks alone, in the second image at left, was a better choice; the deep shadows of pine trees must be ignored, because the contrast level is too great to record detail in them, and the tree silhouettes contribute sufficient meaning to compensate.

Both diffusion and fill strobe are sometimes needed to make an evenly illuminated image. My Wescott 4 x 6 flexible rim translucent flat works miracles to spread harsh illumination softly, or to eliminate spotty light. It's big enough to cover several persons full length, if the dress train isn't huge. In bright sun, highly reflective buildings are easily a Zone VII or VIII and must be slightly underexposed to render detail. The Hasselblad linked shutter speed and *f*-stop mechanism is a real boon, because it graphically displays the reciprocity scale and, therefore, what strobe power will be needed for adequate synchro-sun fill. You'll need a lot! A typical exposure of 1/125 sec. at *f*/16 with ISO 160 film becomes 1/500 sec. at *f*/8—an achievable strobe output at fifteen- to twenty-foot distance. Remember to meter not just the strobe output, but strobe added to the ambient light striking the face with diffusion panel in place.

Gray overcast and late-evening times are the most difficult situations for synchro-sun technique. Often, there's both a low volume of light and no direct light at all. Downlight from the overcast or open blank sky is effectively the only illumination, which is at once both contrasty and flat. In black and white, the sky will look featureless and eyes appear almost totally obscured in their sockets. Backgrounds look dull, dark, and featureless,

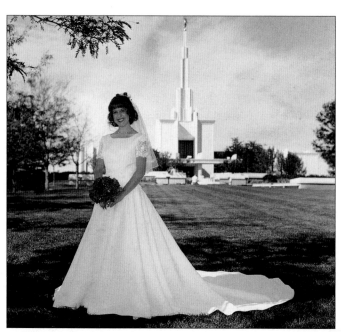

At the Denver Mormon Temple there are beautiful plantings on the mall, but in spring and early summer, the best spot for capturing the wonderful steeple in the background is plagued by spotty light coming through immature foliage. A combination of techniques that takes into account both incident and reflected light make this image succeed.

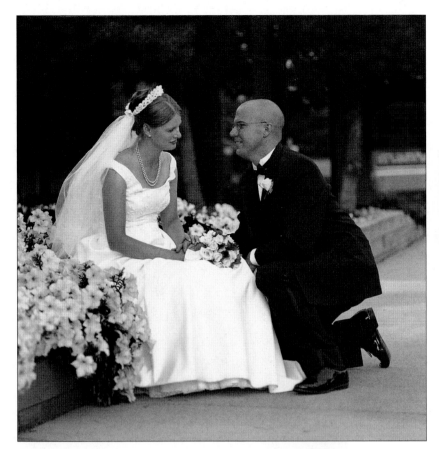

Exposure for this dusk scene was an impossible 1/8 sec. wide open. Fortunately, there remained some western directional light and the couple easily took instruction to pose perfectly still. The first image (left) easily became the favorite Wedding Picture. However, the second (below) captured all the humor and closeness of the couple in the expression and moving hand.

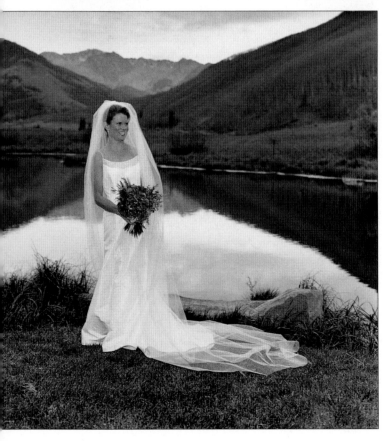

particularly if there are dense trees, bushes, or dark-colored buildings. A subtractive reflector overhead will drop exposure time and *f*-stop farther, and doesn't improve dullness or sky tone. An additive reflector won't be strong enough to illuminate eyes.

If it's impossible to modify the angle to naturally alleviate downlight and get some directional light on faces, the only solution is synchro-sun. Choose the lowest possible *f*-stop and the slowest possible shutter speed. Look for a lighter, or at least varied, background. Decide what part of the background should be reproduced similarly to faces, and spot meter there; this will be your base exposure. Add just the touch of strobe necessary to open eye sockets and bring faces to the same exposure level. Limit the amount of sky showing, and accept that it will need to be burned in in printing, or toned with watercolor wash. Limit the amount of very dark background showing, and accept that it will record much darker than it is.

Dusk had fallen when this bride was ready to be photographed alone with the extraordinary lake and mountain valley background near Aspen. It was beginning to sprinkle. With only moments to decide, I chose to meter the medium-tone grasses nearby, add in strobe to an equal *f*-stop output, and let sky and dark mountainside expose as they would.

Combating the Problems
of Strobe

~

Most wedding photographs suffer from two lighting faults: The first is extremely harsh, amateurish-looking straight-on illumination, which is often accompanied by distracting shadows falling on the background to one side of the subjects; the second is wide tonal contrast between subject and background. Misunderstanding of depth of light in relationship to depth of field results in either a "washed out" or "black hole" effect behind people.

Here's how to get rid of those harsh, unintended strobe shadows. Usually, the cause is a combination of misaligned equipment and subjects that are too close to a wall. Make sure the on-camera strobe is positioned directly above the lens by about six inches—not to the side—and have your subjects step about three to six feet away from any background. Thus, any shadow cast will fall directly behind and lower than the shoulders. Other options are to bounce strobe off the ceiling if you're in a smaller, white room, or to bounce strobe into a kicker card or into a very small soft box. I favor one low-powered strobe on-camera, synched with a higher-powered one bounced off the ceiling. All these techniques make light seem omnidirectional because faces are naturally believable, yet modeled and rounded.

Softboxes wrap light smoothly around a face but can often be too soft for the purposes of black and white, which needs a snappy, full tonal range. If wide, wrapping light is needed in a controlled situation, try putting two dishes, parabolic reflectors, or umbrellas on one side of the subject, a short distance apart, and filling with a reflector on the other side. A refinement is to place kicker lights more than 90 degrees from the camera-to-subject axis. They reward you with sparkling rim or accent lights both in black and white or color.

Assistants holding battery-powered hand strobes with radio controls function as "intelligent light stands" to accommodate my mobile picture-taking style. A lightweight stand with any smaller

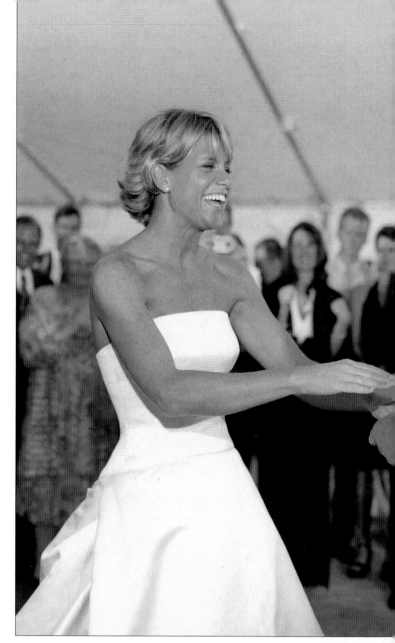

LIGHTING ON LOCATION

Portrait photographers who take infinite pains in the studio sometimes become lazy on location and use one flash on-camera, snapshot style. Establish a system to handle formal poses with the same principles used under controlled conditions. If you set up portable studio lighting either in a church sanctuary for groups or in a community room for close-up portraits, remember to allow time to do this properly. Determine in advance the availability of outlets and extension cords, and obtain permission to bring in equipment.

For this image made in close quarters, the on-camera light from which the exposure is calculated was about half the power of the strobe illuminating the dance floor from the right. The sidelight was directed upward, mostly flaring into the white tent to give a very bright and open feeling.

battery-powered strobe light is an excellent alternative for the solo photographer.

Umbrella or soft box systems inexorably tie the photographer to one background and angle. Time constraints may make studio lighting technique just too difficult logistically. I change backgounds, arrangement of people, and direction of light far too often for the studio lighting approach to be practical for me. Dimensionality rather than great precision of lighting ratio is the goal in events photography, as is the addition of side, rim and accent lights whenever possible.

In order to evenly illuminate a large posed group without widespread multiple lamp heads flat on, individuals on the outside edges must be brought forward perhaps as much as several feet into a semicircular formation. The measured distance light travels from the strobe head to the group center cannot be shorter than that to the extreme left and right, otherwise light vignetting or falloff results. Most contemporary lenses, however, are flat-field focusing; that is, focus falls in flat slices or planes perpendicular to the lens direction. Thus, greater depth of field is required to provide adequate front-to-back sharpness on a semicircular group than on a group posed in a straight line.

Another problem is natural lens distortion of faces on the outside edges of a group.

Toward the center of the image, both sides of each face are visible; at the edges the outermost sides of faces are minimized—most severely with wide-angle lenses. From the center outward people must be gradually turned more and more inward to retain natural facial proportions. A further problem is that while moderately wide-angle lenses are frequently a photographer's salvation in a tight church, persons even slightly closer to the camera are rendered quite a bit larger than those behind them.

"Black hole" backgrounds are due to the physics of light, which decreases with the inverse square of the distance. If you divide the distance to your subject in half without modifying the strobe output, four times less light will fall on the background, making it unnaturally dark. It is, therefore, unwise to put extra strobe power straight on a subject posed in the center of a large, dark open area. For a wedding party scene at the altar, cut strobe power to the smallest *f*-stop that you require in order to produce adequate depth of field to cover your group from back to front. Another refinement would be to make use of two front lights— one set like a studio main and the other like a fill light—to put detail in the shadows and determine your exposure. Add a background strobe or a kicker to throw rim light on tuxedo jackets.

THE INVERSE SQUARE LAW

This states that light decreases by the inverse square of the light-to-subject distance. If at ten feet from the subject, a strobe puts out a power of *f*/8, when the subject is moved to half that distance—or five feet away—the aperture available without changing the strobe output is *f*/16 not *f*/11. The proportion is 1:4 not 1:2. When the subject is moved farther away from the camera and therefore closer to the background, the difference between the illumination falling on the subject and the background becomes less. This situation will automatically result in a less contrasty appearance. For automatic strobes, you can help circumvent the depth of light problem by selecting a lower *f*-stop number, or wider aperture, in the first place. At close range, unfortunately, it's handy to have a high *f*-stop to give more depth of field and more margin to cover focusing errors. If you lower the strobe output in this circumstance, you will pick up more ambient light in the background, but you will lose depth of field. You can successfully lower the shutter speed as an alternative method to achieve the same end.

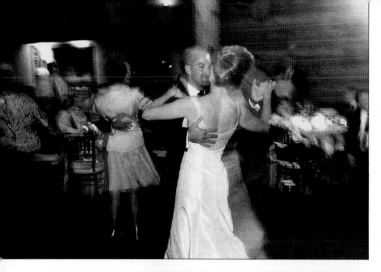

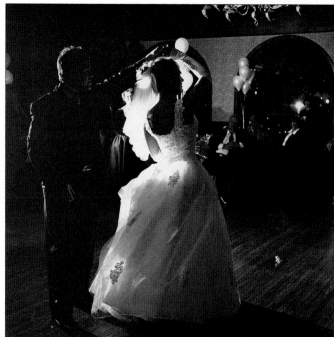

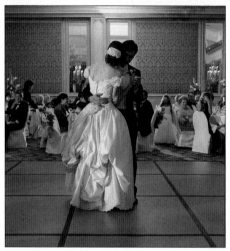

The top left image shows the excellent effect of motion that very long shutter drag accomplishes. The other two are serendipitously artistic results from strobe failure. A striking silhouette was produced, above, when the on-camera strobe didn't fire but did send a radio signal to a second light. Shutter dragging technique was not used. In the image at left, again, the on-camera strobe didn't fire but signaled three room strobes. By chance, the exposure happened to be accurate for the room as a whole at that range, and shutter dragging was used. What beautiful accidents!

Under many circumstances, three or four lights could be used to good advantage.

Amateur snapshots from cheap cameras often have better background detail than those of the pro. Underpowered, built-in flash is the reason. At ten to fifteen feet, the light puts out such a low *f*-stop that more ambient background illumination is captured by accident, though there may not really be sufficient light overall to record proper density on the people. Some of the newer models have a long-exposure flash feature, which is a mechanical way to drag the shutter. Outdoors that same flash is weak enough to fill in, but not override, sidelit or backlit conditions.

Shutter dragging is a valuable technique with any format or film, but in black and white it's extra useful because incandescent and fluorescent light record no differently than strobe, and thus look seamless. Basically, the strobe illuminates the subject and stops the action, and the shutter speed is set very slow to record ambient light in the church or any large, open, dark space. In light halls, this technique won't work because the illumination level will produce ghost images; faster film without strobe, or strobe with medium to normal shutter speed, is then the answer.

DRAGGING THE SHUTTER

Dragging the shutter with strobe exposure is done by manually setting a slower shutter speed than you would ordinarily use when handholding. This is possible because the strobe determines exposure on the subject. Choose an *f*stop according to the power and strobe duration. Then choose a speed that comes close to the metered exposure for ambient light on the background. Many automatic cameras now have a "slow speed" setting for this very purpose. Shutter priority settings work well in digital. Be aware that you may begin to pick up ghost images or motion blur, even in fairly dark banquet halls, if you use 1/8 sec. to 1 second exposures. The exact amount of ghosting will depend on the speed of the action depicted, as well as on the amount of ambient light. My preferred speeds are 1/30 and 1/15 sec. For a great many normally lit interiors, 1/15 sec. is a magic number that is an excellent guess if you have no opportunity to meter.

Creative Use of Light

The creative use of many kinds of light is a stylistic facet of complete coverage that's equally as important as capturing situations and emotions from start to finish. When a style of lighting carries uniformly throughout a given series, it is the glue that adds cohesion, and the images will have meaning as a group.

Think of the wedding photographs as a novel. There are descriptive parts, dialogue, and action. Each part will be written differently to match what is going on in the text. Different authors will have an overall style to encompass these variations. For example, think of Edith Wharton's long sentences, as involved grammatically as they are packed with image and idea. Compare them to Hemingway's clipped, terse style, more famous for what was left out than what was put in. I enjoy the work of both these authors, and suggest that the photographer involved in commissioned imagery does well to realize that many styles arise, appropriate to both artist and client, and that all can live comfortably together. Here are some of the styles of lighting I've developed that distinctively mark my work as mine. Note how the styles follow the function of different parts of the event.

Natural-light exposures in the dressing room—even if there is just barely enough illumination—will set the mood right away for the entire coverage, allowing the bridesmaids to feel free and unconcerned about the presence of the camera. Bridesmaids get the clue early on that I'm doing something unusual. Since many bridesmaids consciously or unconsciously control the behavior of the groomsmen, I try to get them on my side during this crucial get-acquainted time. Once the men know what's expected of them, they're much easier to organize. With the team approach, send the most experienced photographer to the women's dressing room, unless there's a gender issue.

I meter how the light falls in a space at different angles

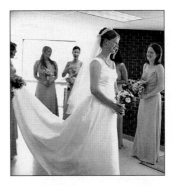

The success of images made in journalistic style with available light depends on cooperative effort. Subjects must understand that they contribute by simply being themselves, turning neither toward nor away from the camera. The photographer's job is to record an image, the value of which is measured by readable action and emotion.

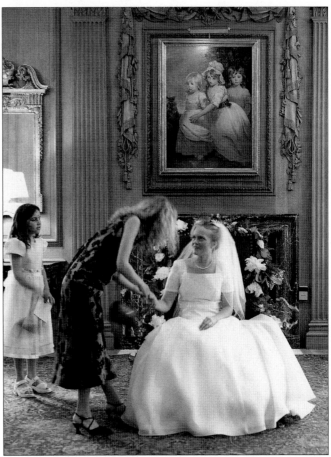

Before a traditional Jewish wedding, the bride's and the groom's receptions are going on concurrently as the precursor to the veiling ceremony. The bride is enthroned in state as women come to wish her well. Her intended is examined for his knowledge of scripture by the rabbi and party of men, with much hilarity, toasting, and ethnic music. In this situation, we run back and forth between the two receptions to make sure we cover all the centuries-old nuances of the customs.

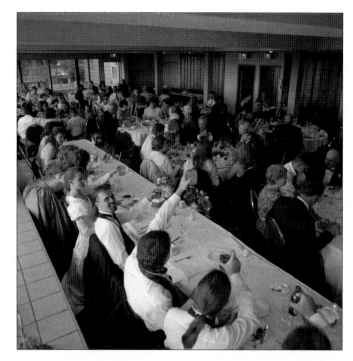

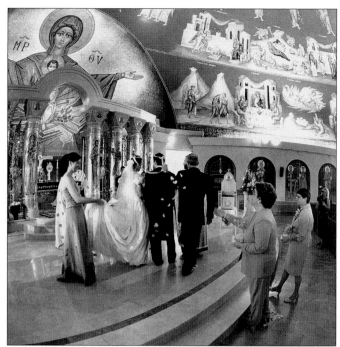

A conventional toasting picture made with strobe to synchronize with the light from the window wall behind the head table would not have been adequate. Choosing a wide-angle lens and standing on a convenient window ledge, I took advantage of the fairly bright natural illumination to capture the fun and ambience with natural light. People love to look at such an image to see what everyone was doing. The tipped angle and groom's gesture shout his enthusiasm.

Some religions customarily allow the photographer close-up access to the wedding ceremony in progress. Proximity combined with fast film and an unusual lens used wide open net imagery that gives viewers the excitement of being in the midst of the action.

and distances from the source. Once I've memorized the exposure range in the given space, I put the meter away. I adjust the setting across that range as I move around amid the developing action. I don't remeter unless the light changes drastically. This technique is far faster and more reliable than any through-the-lens metering system, except perhaps that of the Nikon 5. The manual method, however, requires you to be completely comfortable with how much the *f*-stop must be changed to coincide with your visual perception of the changes in volume of light.

This procedure isn't really as difficult as it sounds. I'm usually working in fairly controlled conditions in a smallish space. Indoors, the variation is probably not over two full *f*-stops from one part of a room to another. Outside, there may be more variation, but it's generally ascribed to backlight or shadow versus sun. A gray day or very late afternoon obviously decreases the values but narrows the potential contrast range, whereas a bright day increases the contrast problem. A touch of fill strobe may be necessary in either scenario.

All professional films can now achieve excellent color correction even in mixed-lighting situations, and isn't the interior of

every building mixed? Digital auto-white balance works fabulously in mixed lighting, and the tungsten, fluorescent, overcast and other selections have proved to be valuable refinements for me already. An incident reading made where bride and groom will stand is all you need. Unfortunately, most churches are lit with spotlights on the altar area, a contrasty condition exacerbated by brides who turn off all lights on the congregation and use candles. Expose for the illuminated portion and let the rest go, without trying to capture that level of contrast. Custom selective exposure or computer adjustment later are the best solutions.

Action images, for instance the wedding recessional, will benefit both from shutter-drag technique and multiple lighting. Use the lowest *f*-stop that provides the depth of field needed, and then drag the shutter at 1/30 sec. or 1/15 sec. Sidelight the action, preferably on the side of the men, who are usually in black and desperately need background separation. Another variation is for the second light to be in the aisle in front of the first row of seats and fired straight on the altar no matter the location of the camera.

Usually, strobe is needed indoors to stop the action of everything from the wedding procession to dancing and casual candids. A

This dramatic building itself suggested a way to use extreme contrast as part of the photograph's design. Since the bride can't imagine what her ceremony looks like, she'll be fascinated with this kind of image, as well as with different angles and close-ups of the bridal couple and wedding party in action.

1/30 or 1/15 sec. exposure is usually a safe choice, because you don't want to risk too much ghost imaging, especially if people are moving quickly. In a very dark church or hall, I've used as low as 1/2 sec. Canon image stabilization lenses used by sports photographers are a big help. Unless using autoservo focus mode, I field focus; that means I preset distances and don't attempt to manually focus at all. A handheld accent strobe is positioned about 100 to 135 degrees to camera right or left, a bit farther away than the twelve- to fifteen-foot camera-to-subject distance with a normal lens for a typical full-length image of one to three people. Power should be about the same as the on-camera strobe, but remember that the oblique angle of the second light will make it seem more brilliant and more specular, just as you may have observed in a studio situation.

Traditional-style photographers emphasize multiple lighting techniques for posed groups and are often inclined to use one strobe on-camera for action images. I've noted that while groups and portraits must be carefully posed and exposed, current client preference is for a fairly flat, even lighting style on all faces. Should the fill light in a multistrobe setup fail, the unsalable result may well be heavily sidelit faces. To the contemporary stylist, it's most important to use multiple lights to record backgrounds and details without contrast or deep shadows—more as the eye would

naturally see them. The wedding photojournalist, of course, is ready to take advantage of any and all kinds of light by using every advanced technique possible.

In halls and ballrooms with higher ceilings, I do prefer to light the room as a whole with bounce strobe. For all the reception events, this extra "ambient" light opens the backgrounds and leaves stray bits of exciting rim light on guests and decor. I drag the shutter as well. Strobes should be hung or set behind a plant or pillar, or in a corner where they won't interfere with the catering staff or guests. The reflector is turned toward the ceiling at slightly more than 45 degress. If the hall has a balcony, strobes will be placed there and pointed directly down into the crowd. In salons that have low ceilings, the studio lights are hard to position and might cause hot spots; therefore, the assistants use lower-power handheld strobes and move around at about a 90-degree angle from the camera.

An outdoors nighttime image—such as a sunset, fireworks, an illuminated mansion, or a skyline—makes a historic album ending. Exposure for illuminated buildings, holiday lighting displays, and skylines must be metered or "guestimated," and will vary widely. Color temperature at the venue dictates how it will record on daylight film; the result will be orange-biased if incandescent illumination predominates. To record background and people in the same tone, cover the face of the strobe with a warming filter to match incandescent, and then remeter the output. The

One of the great advantages of the outdoor wedding is available-light recessional photos. A series of many images can be made in quick succession that give a very "real time" effect at the very peak emotional moment of the day.

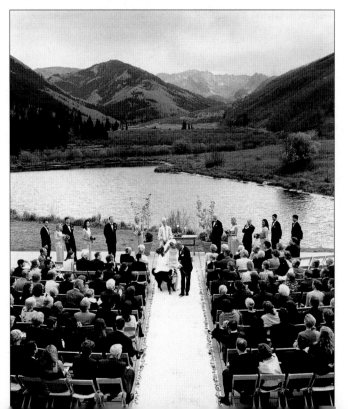

When this couple was introduced, the accent light position was at about 45 degrees to camera right, therefore effectively adding a main light. At the start of the recessional the groom impulsively kissed his mother's hand. He turned toward the direction of the accent light, making its effect more prominent. As the couple passed down the aisle, the accent strobe moved to the proper 100- to 135-degree angle to produce the desired rim lighting that reveals beautiful details in the suit and vest, which would otherwise be almost featureless.

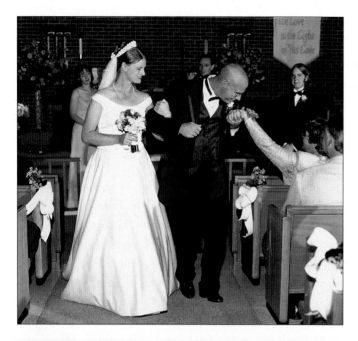

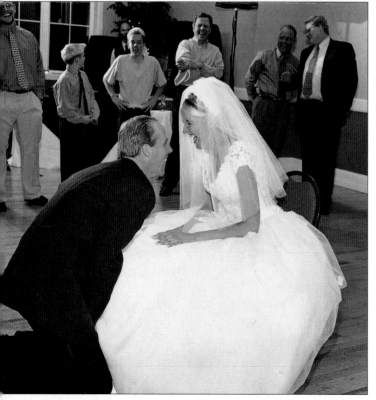

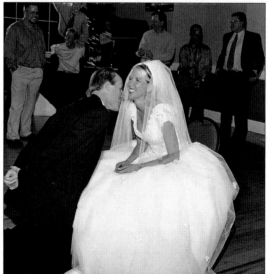

Taken moments apart, these examples show graphically the results with and without extra strobe units. The first image has all the makings of a storytelling image: foreground, background, expression, and action with depth of illumination. In the second, a second action/expression happened so quickly that the room strobes did not recycle fast enough to fire again. However, the background remains readable due to shutter drag.

resulting negative can be left all warm toned, or drastically color corrected in the darkroom. Alternatively, use tungsten index film, with strobe filtration, for a more nearly natural rendition. Of course, in black and white, the typical color crossover from incandescent or mixed light sources is immaterial, though reciprocity will remain a factor.

Unless the background is a brilliantly illuminated Las Vegas hotel, exposures generally are in the five- to thirty-second range. The sky provides a good clue for starting exposure at dusk. I do bracket, but when you're working with *seconds* rather than *fractions of a second,* exposure on negative film is not very critical in spite of reciprocity failure. Strobe dissipates quickly outdoors—and very quickly at dusk or dark. In my experience, two *f*-stops of output can easily disappear into thin air. Automatic strobes do tend to underexpose at night, especially at the more typical longer distance from strobe to subject. Many of the digital cameras have a setting specifically to blend available building illumination and strobe exposure on a person close up. Use cross-lighting with multiple strobe heads to record dimension, create depth, and counteract fall off. If you have time, meter rather than guess exposure. If you return to the same location time and again, make a test series that will tell you the best exposure at different times of night, eliminating guesswork and delays.

Sparklers, fireworks, and bonfires put out a greater volume of light than you might think. Sparklers are so bright, it may not even be necessary to drag the shutter unless you want trailing ghost images. Use a tripod, calculate the appropriate *f*-stop for strobe exposure on the subjects, and leave the shutter open during several bursts of fireworks. Subjects must remain as stationary as possible while the shutter is open if you wish to minimize ghost imaging even though expressions are recorded only at the moment when the strobe fires. Spot meter the faces lit by a bonfire to find your starting background exposure, then add strobe in the amount that gives the desired stopped-action or blurred-motion effect. The fire will always show movement; backgrounds at dusk will record a lot of detail.

This precious memory of the flower girls happily twirling their skirts required creative use of natural light alone. Knowing that the guests would remain relatively still, and therefore sharp, I bracketed several wide-angle exposures at 1/2 sec. to 1 second speeds, eventually just choosing the one with the best action since negative density was virtually identical.

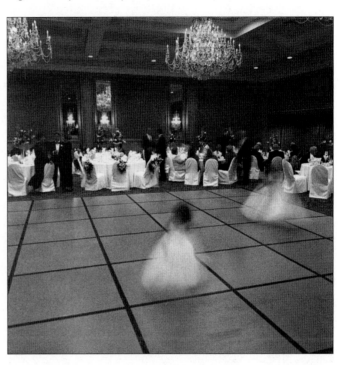

Bunches of sparklers put out a surprising amount of light. This handheld exposure was 1/30 sec. plus strobe set to *f*/5.6 output at about twenty feet. I spot metered on faces directly illuminated and increased the exposure one *f*-stop. A small amount of ghost blurring adds to the feeling of motion.

Chapter 4

CREATIVE
POSTPRODUCTION

Editing for Impact

To choose or not to choose? This is the question—whether you the artist or your client edits and sequences the photographs. If you let the client choose, she will make errors due to inexperience or the embarrassment of having too many or too few pictures of herself. But, if you don't let her choose, you'll never know her personal style and will, thus, be doing her an artistic disservice. I feel that postproduction should be as much of a cooperative effort as that of conductor and orchestra, joining together to interpret a great symphony.

There are four possible scenarios for image selection and editing. More often than not, previews or contact sheets are released, and the client chooses to build a collection of images à la carte—or else to eliminate images until a set package is reached. Sometimes, the photographer predesigns the album, allowing the client to change or eliminate pictures later. Transparency projection or scanned images displayed on a computer screen are methods of presentation in the studio, when choices are made on the spot. Video transfer or web site display allow clients to choose electronically in their own homes and across the country. A collaborative approach between photographer and client can be achieved with any of these methods.

Preview albums have been the norm for years, but after trying every delivery method imaginable, I box previews and thereby save the time and money that would be involved in packaging. Many colleagues say that loose previews, rather than a preview book, would not be tolerated by clients in their area. However, I have never met resistance to my system, especially once I've shown artistic-minded clients how easy image comparison becomes when previews can be held side by side and shuffled like big playing cards. I don't worry too much about unauthorized copying of previews either, because by the time the prints and the clients leave the studio, the entire sizable contract has been paid in full.

Many photographers rightly fear that a preview book will satisfy a client's need to hold a completed album. Since a boxed preview set makes no pretension toward finished presentation, I really am not risking a decent add-on sale. The impermanence of the boxed presentation subtly influences clients to place their order quickly, rather than showing off loose and therefore fragile previews. Through presale and samples, they're primed to see what unusual album design features we will create just for them. And, of course, *that's* the book I want them to show to their friends, because it will clearly display both my photography and my presentation.

Releasing previews, however, isn't the right method for everyone; you must use a method with which you feel comfortable. A new option that alleviates lab costs and fear of copyright theft is "magazine proof pages"; six to twelve small images are printed together on 8 x 10 or larger pages. I, personally, want to "feel the goods" when I'm deciding on an expensive purchase, and I really dislike a salesperson hovering when I'm just beginning to look at merchandise. Trust and cooperation between studio and client makes preview-release work for me. I encourage clients to take their time about making selections and showing the photos to friends and family, but caution that we guarantee prices for only ninety days after the event.

The client's incentive to return and order is to get full value, soonest, of money already paid, and also to reap the discount I offer on all extra items ordered in a month. This offer isn't exclusive to me or my market. The secret is my step-by-step presentation, service, and guarantee, which are all coordinated toward the one goal of creating an extraordinary wedding heirloom.

LESS IS MORE

It's important to note that I *do* want clients to compare and cut down the number of their final selections. As I don't limit the film used, I always end up with a large number of images. While most of our albums contain 80 to 125 prints, a smaller collection of iconic images may indeed be more effective in black and white. The client who can't narrow down the field to less than 200 images (excepting a multiple day event, in which case several albums are used) has probably picked too many to allow designerly architecture to create a coherent structure of meaning. The final album will "read" as overly "wordy."

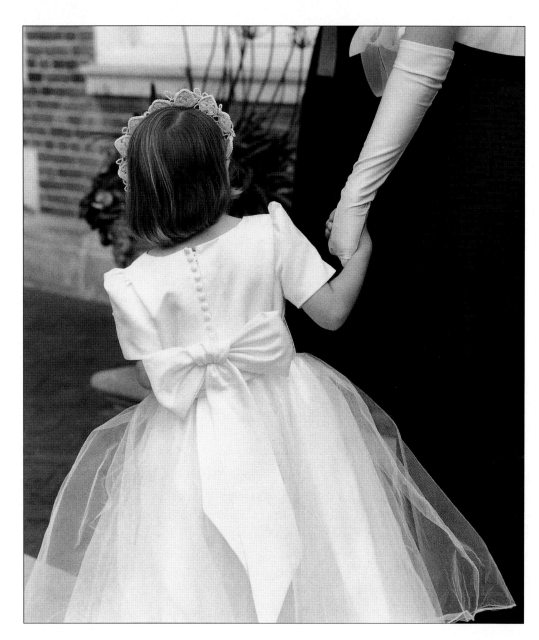

Images that capture details of the day enrich an album. Clients may not realize this, so the photographer should suggest images like this to round out the selection.

I price wedding packages so that the client perceives that I am motivated not by extra sales but by achievement of the right design. One colleague tells his clients that his initial low price makes him "try harder to make good images, because he will make money only if she buys more on a print-by-print basis." I find this argument quite denigrating to our profession; I need no incentive to work hard for each and every client. And, I certainly don't want to disguise what clients can actually expect to spend. I don't want to hurry; I want to involve clients in the experience of helping to create art they will use. To this end, again, I insist that the client make selections privately from old-fashioned paper previews. That done, I use every avant-garde postproduction technique I can to provide a superior product.

~ PRESERVING MEMORIES ~

Most clients want this golden period in their lives to last as long as possible. Once the actual event is over, the photographs have no competition for the bride's attention. While only 10 percent of the budget may have been allocated for photos, after the fact the client realizes that the album will represent 100 percent of the memories. Philosophically, I believe that the photographer is a hero, because the viewing and choice of the photos prolongs the wedding-day fun and glamour.

Many lecturing photographers advocate a very quick viewing and ordering system, first because funds dwindle after the wedding day and second because they want to spur impulse buying. While this may be true of some of the add-on sales, I don't believe that

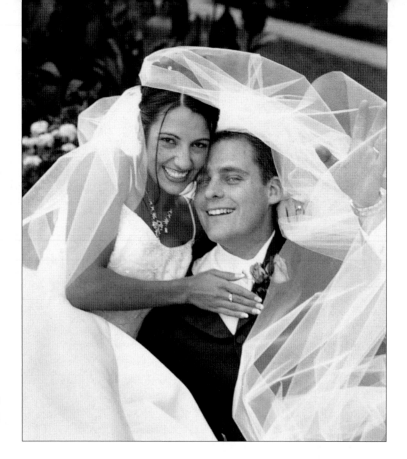

Candids enhance albums. Try to avoid letting clients choose only formal images for their albums.

fine-art photography—either for the main album or for primary gifts—can be classified as an impulse purchase. A client who recently returned to place her order seven years after her wedding said, "Now we have the money and can fulfill our appreciation of what you did!"

~ UNIQUENESS ~

To me, art comes in where technique leaves off. No two weddings I photograph in a year resemble each other in final form; I want to be sure that lifestyle differences between couples, whether subtle or striking, are instantly recognizable. Knowing that the images are already "trademarked" with my style, I ask the couple to make the first cut. They eliminate the ones they really don't want in the album and also the duplicates. I don't mind taking over the decision-making process at the point when the couple is still debating some of the "maybes" or hasn't yet chosen enlargements. However, I want to have both the flexibility to design an artistic presentation that reads well front to back *and* the security of knowing that the couple—not I—selected the larger body of images to suit their personal tastes. I have not imposed my subjective choices on their book.

Many photographers select and make up the finished wedding album without any client input. They reason, Who better to ice the cake than the baker? Obviously, this method offers a huge savings in time and effort, and will therefore increase studio profit margin. But does it serve the client's interests? My opposition to photographers predesigning albums, even if clients are permitted to alter things later, is based on seeing how many studios design one album just like the last—even to the extent of putting photos of very similar subjects, with similar lighting and angles, not only in the same matting but also in the same album-page sequence.

Predesign is efficient if there are fewer images, and is also a blessing for the volume studio that offers a more set look. For a few couples who are very indecisive or uninvolved, I can understand how this standard production would work well. Another positive example would be resort photographers who can provide a more responsive product by showing work electronically and then taking all responsibility away from the client. However, I think of the musical comparison again: We criticize as lackluster musicians who don't inject enough of their own personality into a performance; on the other hand, we say that too much of the performer's personality obscures the composer's intensions.

I'm equally opposed to the photographer who offers "any combination of prints that fits in a twenty-page album." Studios imagine that this method may be a time-, product-, and responsibility-saving device, but I would hardly call it attentive personal service. The bride may very likely crowd images together regardless of the meaning or flow of the action depicted. Often, so many formal images have been selected that there isn't enough space left to tell about the fun of the party. If you package prints to conform to standard inventory rather than individual choices, you risk the entire artistic effect of the album, and this artistry is what will eventually become your best means of advertisement.

Digital collaging of multiple images and sizes is the new and visually valid way to fit about 80 to 100 images in a twenty-page storybook that's also much lighter and more manageable than a traditional matted album. In the last few years, digital books have been prohibitively expensive, but it's now cost effective to scan and design with equipment any studio can own and operate. The added bonus is that the entire album can be retouched and manipulated quickly and accurately. Printing is still more economically outsourced, but that, too, is improving rapidly.

∽ CHOOSING IN-STUDIO ∽

Having wedding clients choose images in the studio is such a grueling, and time- and space-consuming event that I don't recommend it unless you have a sales consultant ready to devote a number of undivided hours to each couple and their families. In-studio selection *does* work well for portraiture, when choices have more to do with expression and refinement of pose. I am again thinking, for instance, of our Chinese and Mexican colleagues who photograph a portrait series in each of several locations and outfits for the bridal couple. I don't mean that selection from a sitting is cut and dried, but contemporary electronic methods work very efficiently with a smaller number of views that don't require a storytelling presentation.

∽ ALBUM ASSEMBLY ∽

Some photographers now offer a discount if clients assemble their own albums. The prospect of having clients in the studio for hours on end—with the concomitant questions and general uproar—is not appealing to me. Since creative postproduction, and especially collage, is a large part of what I sell, I want to make sure my design-and-build service meets quality standards that I can guarantee. Photographers who sell their negatives and don't want the responsibility of delivering a complete album to the client give up not only extra income but any control whatsoever over their art. While these marketing trends may satisfy price concerns in a tight economy, the implication that anyone can put together the album typecasts wedding photography as a commodity. Our reputation as artists rests firmly on our ability to create a final presentation.

Snap decisions simply cannot be made about our product. The client must look more deeply into each image before finalizing choices and must work with us to design meaningful series. The avant-garde part of what we do is the groundbreaking style created new every day from our imagination. We are giving clients the license to play with art, and they love it!

The bride will ask for advice and help, but is unwilling to give up her options; if she desires black and white, she will almost certainly demand complete freedom of choice and a strong voice in the final design. Often, the bride and groom are themselves involved in creative professions. Unless they've made the first cut of the photographs themselves, the method of predesign by the studio still imposes too much of the photographer's personal bias to suit my wedding philosophy. My preference is to let the quality of the images be my silent salesperson. Naturally, I also show clients how easy and reasonably priced it is to increase the size of the contract album.

The difficult clients tell me exactly what images, sizes, shapes, and page order they want with absolutely no flexibility. This leaves the door open for all sorts of sequence and design errors—and no way to correct them. The most challenging client chooses without comment, withholding the all-important information that, for instance, she hates circles or is expecting the album to start with a specific frame. The purpose of our instruction sheet is to help avoid these problems.

The ideal client brings back four stacks of previews: rejects, possibilities, definites, and favorites. After artistic discussion, I then take over designing the structure of a fine heirloom. Since I am building on the foundation of the couple's choices, I know that the design I create will remain fresh and memorable, and the book will be prominently displayed in their home.

To achieve style, think of the finished album that you hand to your client as a doctoral thesis: The first draft simply won't do. I like to lay out preview prints on a large table or on the floor, if necessary. This way, I can see the complete wedding story all at once. A studio associate makes the preliminary design, and then I refine it. A third edit happens when we present the design to the client. Digital design is now facilitated by a variety of software that permits easy positioning of images in premade and custom page layout templates.

19 POSTPRODUCTION STEPS

Postproduction is a term borrowed from the filmmaking industry and, in photography, refers to everything that happens after the shutter is pressed. Clients everywhere will pay more for creative work. Postproduction time is as creative as the photography session; this is when the finished artwork becomes far more valuable than just fine photographs alone.

I estimate that 10 percent of my creative time is actually spent making images. Most highly qualified photographers give lengthy consideration to equipment and the technical aspects of film and lighting in the pre-exposure phase. However, I have long marveled at how the public, and a very high percentage of professionals, put their minds in neutral when the film goes to the lab. Exposure is certainly the pivotal point, but pre- and postproduction form the lion's share of the wedding photographer's creative time. Your creativity is a no-cost resource—use it! Here are my nineteen steps, from negative to happy client. Note that digital postproduction rearranges steps and can radically streamline steps 10 to 15.

1. Sort, edit, and sequence the images, either in paper-preview or computer-generated form. Remove obvious mistakes, hard-to-print poor exposures, and duplicate groups, but leave in any image with a minor fault that might have storytelling value.

2. Organize and number negatives to correspond with previews. We do this to enable positive identification later, and also to make individual images easy to find since they're in a logical order—not how they just happened to come back from the lab. Decide whether to use on-line previewing, conventional previews, or thumbnail proof sheets. Explore the custodial convenience of new software programs such as PerformerPro.

3. Package previews for presentation. I use presentation boxes with my logo stamped in silver, not proof books, leaving previews loose for easy sorting on the part of the client, who owns them all anyway. Generate client approval in advance by calling to let her know her pictures are spectacular! As I've been paid very well in full, I am happy to send out paper previews. They're so inexpensive and easy. While the bride has significant monetary incentive to return in thirty days with her order, most don't return for close to a year. Indeed, if she came back sooner, we'd be hard pressed with our heavy production schedule to serve her promptly.

4. Take the order. Generally, the studio manager personally assists with recording the huge number of details for the order. Often, it will take several hours and may require order-blank rewrites. My function is to be nearby for artistic council. For cost credibility, I try not to quote the price verbally, but present printed price sheets. I always suggest ways to buy up or maximize return on investment. We all try to find ways to give a bonus.

5. Suggest retouching and digital improvements. While taking the order, it's necessary to address technical questions, respond to any concerns, suggest specialty handwork or digital negative combination that will make a substantial difference in quality, and express personal enthusiasm for the job as a whole.

6. Suggest art presentations. Everyone loves to give gifts. It's fun to see what gifts and wall prints are ordered, and then suggest how to make them really special with our knowledge of framing or presentation products. We may go to the client's home ourselves to check sizing or framing styles, or send her home with some samples to try out herself.

7. Lay out the album design. I enjoy taking full responsibility for this stage, building album design on the individual preferences noted during the order consultation. I still lay out all photos, in order, on the floor so that I can see the entire book at once. I may well add a few prints at no charge, change the sizing, or suggest additional purchases. Most often, I'll ask for a selection of possible images, pointing out again that we have special prices for adding twenty-five or more images to the album.

8. Price the order. This part deals with the changed orders from the original contract and add-on orders. The manager will have mostly done this and have separated bills for various individual purchasers. Carefully determine pricing for custom work—there's always something custom!

9. Review the layout with the client and get an okay on the final price. Clients really enjoy getting their hands in the collaborative process. This is the time to make corrections, suggest additions, and work out any price concerns. Deposits toward additional orders are taken at this meeting.

10. Enter the wedding order in whatever computer program you use. Due to our typically nonstandard design complexity, I use our Montage software system from Art Leather as studio recordkeeping. The diagrammed thumbnail spreads of the album make a very neat, understandable map, both to help the client visualize what I've done and to guide studio personnel in the assembly phase.

I use previews in conjunction with the storyboard printout for one-on-one design consultation. Most album companies accept electronic orders, but also have sales representatives to help with nonstandard requests.

11. Place negatives on aperture cards for lab order and retouching. Digital files must be retouched, cropped, and prepared to send to the lab. While many black-and-white photographers insist on custom printing for everything, aperture cards have long been our way to get a virtually custom crop at machine pricing. Generally, carding is a two-person job. We do this work by hand, because it's far quicker and more tactile than doing it by computer—though computerization is certainly not a wrong answer. We send in to the lab only those previews that have good color and indicate that all others must be reanalyzed to match. This step may soon become entirely digital, because we're in-house capable of cropping, retouching, and enhancement. We can ship our files direct to a digital printer, or print our own on inkjet. I find that color calibration between computer and printer (inkjet or photographic) is best written as an action specific to the type of paper or for black and white conversion. Consider StoneHinge, Ilford, Epson, or other fine inkjet papers for artistic effect.

12. Verify and label completed prints returning from the lab. At this point we're really sticklers for color and tone continuity. Here's where you know if your lab will make or break you. You'll want any remakes to be turned around quickly. Total quality can be advanced by cross-checking each order part to see that you haven't made any order errors in-house.

13. Retouch/enhance all prints. Consider carefully the computer options. Once the file is altered, nothing further is required at this stage. Every eyeglass reflection, shiny nose, and exit sign disappears now, if such enhancements were not already done digitally. Primarily we use dyes for the handwork that's included in the base retail price of the prints.

14. Lacquer the prints. Black-and-white prints are not typically lacquered, but color prints are. We do this in-house with a compressor and a 30 x 40-inch spray box. A very large percent of knowledgeable studios still prefer lacquer over water-based finish. Album manufacturers generally offer an excellent roller-coated finish for both black-and-white and color album prints. Clean prints with Unseal (or other dry-cleaning fluid meant for art) to remove any finger oils, pen marks, and general dirt before lacquering. Tests are not yet conclusive on what finish, if any, is best for inkjet prints.

15. Assemble the album, and mount, mat, and frame wall prints. For longevity we secure prints directly to the album mats with archival ATG tape and back them with sheets of 100 percent rag barrier paper. Some of the framing steps are outsourced, but we do all the mounting and fitting ourselves.

16. Clean, dust, and polish the albums and frames. Any bits of adhesive and dirt are whisked away; any bit of roughness is polished. This step serves as one more color continuity and retouch check. Beautiful wall frames are always set on easels in the reception gallery to be admired by everyone until the client comes to claim them.

17. Package the order. Shopping bags with our logo and pretty tissue complete the presentation.

18. Make a final recount, and verify the billing. With the complexity of most orders, it's so easy to make small omissions or errors that annoy the client. A very effective way to cross-check is to count the quantities as billed on the invoice.

19. Call the client, and perhaps deliver. A great feeling of excitement accompanies the phone call to say that everything is finally ready. Often, we tell clients their album is so beautiful, we don't want to part with it! When clients arrive, we try to have all the albums and gifts laid out for inspection. Sometimes we do deliver, especially large framed pieces. We promise to do all this in ninety days and usually achieve this deadline. If you're starting to work digitally, it might be wise to initially give yourself extra time. In order to keep clients involved, we call with progressive updates. In the spring, we're generally a bit faster, but occasionally we run into challenges and have to tell clients we'll be late. We always try to honor a special request for fast delivery of a gift. Clients understand our schedule, because we carefully demonstrate how art takes time.

Video and On-line Proofing

Video, slide, Internet, and electronic proofing systems are getting better and better, and are definitely a good answer—certainly for volume studios, and whenever circumstances dictate that choices must be made quickly or by clients who are far away.

Whatever proofing method you use, the goal should be to present the best product to the client.

In a great many parts of the world, it's expected that previews will be ready within two or three days, or even the next day to be shown at brunch. Rapidly made previews here or abroad always seem to drop in quality to the level of the grocery store mini-lab. Video proofing or scanning, although labor intensive, could therefore represent both speed and a boost in consistency by bypassing what is perhaps the weakest and most frustrating link in the production chain.

Reading memory cards directly into the computer becomes an awesome, speedy technique, especially for candid photographers in many parts of the world who work mostly on speculation, assuming either VHS or Internet access would become sufficiently common and cost effective. This opens the hitherto untapped wedding guest market of party guests, who can now go online to see—and potentially buy—images.

Presentations on video or computer screen have for some time been heralded in the United States as money saving, because the photographer no longer needs to buy conventional first-run proofs. An analytical look at your annual expenses will prove that time—yours and your employees'—is far more costly than lab services.

Many experienced studios that have been digital for years report a return to showing at least the formal poses, if not the entire selection of images, to the bride in paper preview or magazine proof form. Internet presentation seems at this time to be more for the new "friends and family" market. I'm sure my time is most wisely spent consulting, photographing, and designing, and not in the repetitive production of computerized proofing. However, it is time well spent to carefully cull and edit images electronically or with actual previews, as well as to sequence and label them. Most labs offering custom black-and-white services do not cut film, nor put them in individual twin-checked glassines; they're returned unlabeled, either in a roll or in an acetate page,

necessitating further in-house preparation. Scans of 35mm negatives are reasonable, but 120mm is not; you may have to pay again to rescan for the larger megabyte file needed for larger-than-proof-size prints. There are no current affordable, speedy scanning devices for studio use.

There's an extraordinary amount of interest generated by the concept of the proofless studio. The lab scans and archives the negatives, or the studio reads memory cards into the computer. The client selects on-line. Many photographers feel that the impactful immediacy of viewing boosts total sales. There is no doubt that medium-quality photographs will sell better with quick, emotional presentation; I have observed, however, that the finest imagery practically sells itself. While the proofless studio system cannot as yet satisfy my requirement for design control that necessitates viewing the entire selection of images at once to achieve story continuity, it undoubtedly works well for sporting events, fundraisers, school photography, groups, and certain types of portraiture, such as special holiday offers for children.

A number of e-commerce labs offer partnership with the backing, equipment, experience, and personnel to turn out quality printing and to carefully account for orders and costs. For custom orders and weddings, the photographer or studio associate generally crops images in-computer with specially designed software and lists specific printing instructions. The weak link in the chain is that lab personnel still have prep work to do by hand, often still cutting negatives and taping them to aperture cards, or at the very least opening the files and balancing the color. It's an accepted fact that lab communications are a studio's most critical business relationship; this is the toughest challenge to consistent quality of wedding photography. Communication frustration is the main reason computer-literate photographers are moving back into the realm of making their own prints, just as was the accepted practice decades ago.

Montage

One of the most exciting parts of postproduction is the album design that will eventually make the two-dimensional photographs read as a "three-dimensional" story. Montage software from Art Leather is an excellent graphic recordkeeper, if for no other reason than that it eliminates the guesswork about handwriting on order forms.

Years ago, I devised an analog system to map out my design as a guide for album assembly, along with an in-house tally sheet that was color coded to collate all the separate orders. My manual system actually looked like the current shape of Montage, which is simple, effective, and reasonably error free—as long as the order entry is done carefully. I still record the nonstandard and odd-sized designs by hand but, I am anticpating the new customizable contemporary magazine layout templates for montaging multiple images.

Basically, if print information is correctly entered, the master order list will remind us of every special request for sizing and retouching that we've promised. The graphic map and page descriptions are very easy for the client to understand, and extremely easy for any production employee to follow. If you scan all the negatives, the resulting thumbnail images make the map even more visually valuable. What a boon to out of town clients! We use the imaging-capable software, because it is compatible with Windows XP, but most of our clients like to make a separate trip in person to review the layout. We use the preview prints like a big set of playing cards laid out in sequence so that clients understand the total visual appearance of the album sequence at a glance.

Montage's programmed ability to fax your order directly saves time and lots of fuss. Use the comment spaces to ask for individual customization. When I visited the new Art Leather factory, I was impressed that, in spite of lots of mechanization, much of the manufacturing process is completed by hand. It's true that other companies producing beautiful custom albums are also handwork oriented. What's amazing about Art Leather's facility, however, is how—considering the huge number of orders they receive daily—each album, nevertheless, is approached individually because every photographer wants something different.

The most studio-friendly feature of Montage is the pricing section, which can standardize invoicing and present an understandable bill for your client. Album assembly can be done in the Art Leather facility so that by sending in the print set, you can purchase a turnkey product.

By scanning and importing thumbnail images into Montage, you can make a color album map with the exact photos chosen. This can make long-distance presentation even better and much more legible. With a bit of ingenuity, you can also adapt Montage to record the album sequence for other manufacturers' products. Even without item numbers, the printouts will still help you in the sales and assembly phases, and of course, there are other programs that offer similar design capabilities. Laborious presentation mock-ups done by hand are not nearly as much fun for clients, who really enjoy the fun of technological wizardry in photography.

Capri, Leather Craftsmen, Ideal, and Zookbinders are some other excellent companies that will create a completely finished product, ready to hand to the client. Once perfect prints are produced, the photographer has nothing further to do, because the album manufacturer takes full responsibility for mounting, assembly, and cleaning. Apple Computers recently announced the personal-photo-story trend of the future with its simple and inexpensive program for amateur album makers.

Art Leather's order program allows us to limit product costs by ordering the exact number of mats we need, yet also stock popular items to accommodate last minute changes. Since we permit clients to choose from among all the available color and configuration options, it wouldn't be possible, physically or economically, for us to keep inventory in all of them. This component-streamlining lowers initial cash outlay, eliminates inventory and taxes, and improves cash flow—benefits that every small business needs to stay viable. When you have the opportunity to use technology to save time and improve your product, seize it!

Sequencing and Cropping

Sequencing and cropping can be compared to what Hollywood film editors call continuity. It's like a mosaic: one piece out of place and the meaning is unclear. It's necessary to lay out each action series as a unit, as well as the entire project design, in order to review it as a whole. The correct art term for the mosaic is *exploded panoramic optic*.

The photographic artist teaches clients to perceive how raw materials, namely the preview images, create a stylish, concise, and lyrical album. Through postproduction your samples will look different from those of other studios, so clients have a stronger reason to remember what only you can do. As you improve your postproduction techniques, overall album quality will soar, and your best advertisement is a book that gets shown more often.

Basically, 90 percent of all dissatisfaction with photos comes from problems of composition. In black and white, it's necessary to crop more than in color due to the need for increased impact. Observe your negatives carefully to see what you have caught on film and can now capitalize on through cropping and sequencing.

Extensive negative cropping often offers artistic redemption as well as correction of technical flaws. As you gain experience, not only will you crop tighter, but you'll also start to previsualize in-camera compositions that are more suited to black and white.

To make postproduction quick, cost effective, and accurate, start with a standard cropping guide and a set of album mat shapes to lay over previews. Although electronic systems now mostly have cropping capability, it seems much more effective to hold the actual preview in your hands. Previews also make it really easy to verify details and determine retouch needs. The final result is best visualized if full pages of images can be quickly compared to see how individual crops will look together.

If you use handmade albums, such as Art Leather's imported Euro Collection, or you design and print your work digitally, you're not bound by conventional shapes and cropping sizes at all, though most photographers still find it hard to break away from the common industry standards. Any album, of course, will look better as a whole if some continuity of image shape and size is preserved.

CONTINUITY

Album continuity means:
- ❖ A beginning that grabs interest and an end the wraps up well.
- ❖ A good story line that keeps events in order and doesn't jump around.
- ❖ Action that's explained by the images themselves, without anything extraneous.
- ❖ Variety of angles, atmosphere, VIP faces throughout.
- ❖ Believability of color and/or tone (for black and white) from start to finish.
- ❖ Vibrancy and movement of the entire sequence.

The 6 x 6 format is undoubtedly king when it comes to creative cropping. The extraordinary flexibility of standard aperture cards for machine cropping applied to 6 x 6 provides the ultimate way to achieve designerly cropping at a machine-print price when true custom services of dodging and burning are not needed.

Note that 35mm photographers give up the incredibly creative aperture card system by their choice of format; but then, they're more likely to be doing their own custom darkroom work or using the services of a mini-lab's variable crop enlarging machine.

I have often had to defend myself against the criticism that I spend too much time and money on considerations of artistic quality when most clients simply don't know the difference or care. I firmly believe that most of *my* clients *do* make buying decisions based at least partly on quality. And, even if they themselves don't fully appreciate the nuances of fine-art photography and the permanence of quality presentation, I'm betting my future referrals that someone they know *does* recognize the difference and will, in turn, be influenced to buy. These are the clients I prefer.

Consider design in relation to the two main client complaints: people (faces) that are too small and a lackluster finished product (due to sameness of photography and dullness of color and spirit).

On the next four pages is an entire album in it's final form. Its title, "Chapters of Love," is visually echoed by the blank page that precedes each new section and by handcoloring of each lead photograph. I still prefer to lay out preview prints so that I can see how they flow together before making up my mind on the final album sequence.

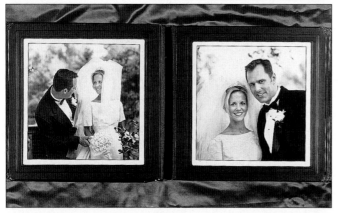

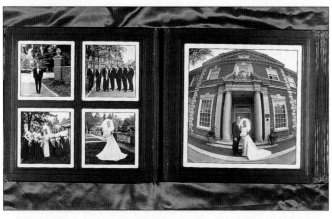

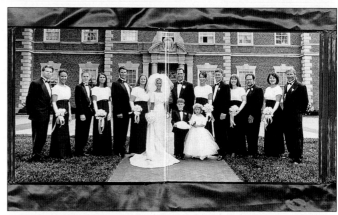

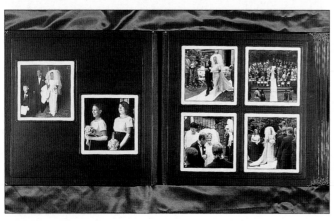

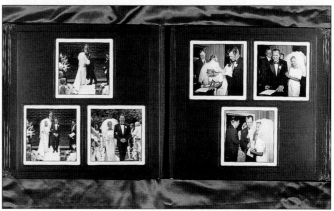

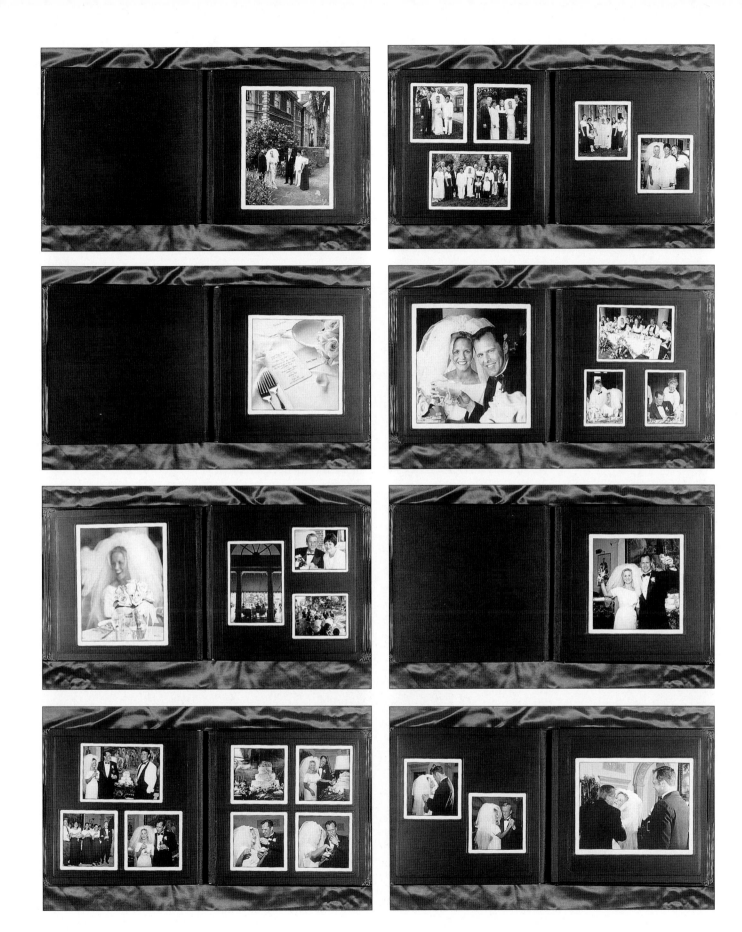

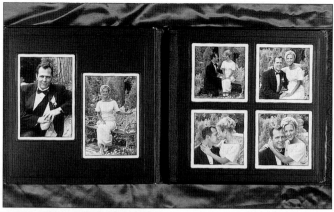

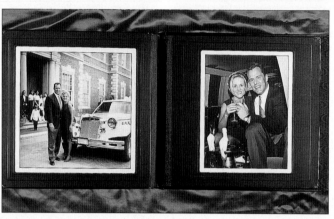

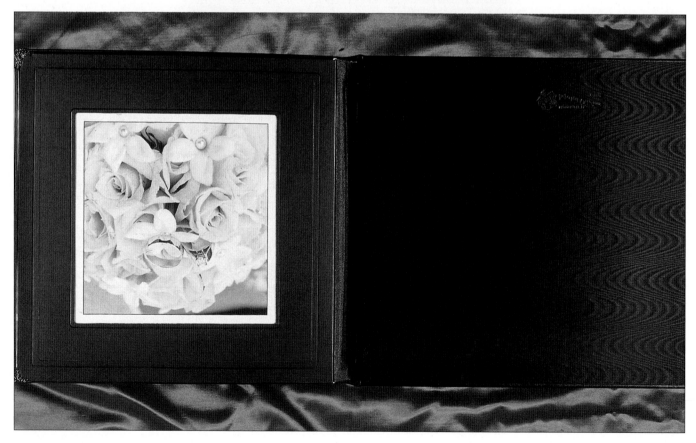

Cropping Primer: One Image, Many Solutions

When there are compositional faults in an image—such as subjects that are too far away, too close, crooked, off-center, or showing flash fall-off—cropping is done to try to fix problems. But, in the process you use up all the potential flexibility of design just to arrive at an acceptable composition. The implication is that nothing further should be needed if careful framing is done in-camera. It's only when you have a really good image, however, that you can play with altering its meaning and impact with selective cropping.

When using aperture cards, it's easy to see how many more choices there are for 6 x 6 than any other format. This is primarily the case because it's hard to get a square out of a rectangle, and even more difficult to change a horizontal framing to a vertical. The 6 x 6 makes it possible to reinterpret negative space side to side and up and down, as well as allowing for radical enlargement of a small area.

To see the difference cropping can make, lay a variable cropping guide on top of the preview and watch the image's meaning change as if by magic. I find this is easier and quicker to do manually, though computerized cropping is an equally valuable tool. If you read negatives well, you can also use a light table and view alternative aperture cards right on top of the negatives. Don't just look at the superficial relationship of figures, objects, and backgrounds; dig deeper into visual value to see how one cropping solution is more traditional, one more pictorial, one with more emphasis on expression, and so forth.

Fortunately, at this very advanced level of artistic design, there really aren't any wrong answers—just the challenge of finding the best compositional form to follow a particular image's function in the overall meaning of the wedding album.

SEEING SQUARE

I personally "see" square composition, and as often as I can, I use all of the negative area to make my meaning. I feel the square format permits breathing room for the subjects, something like the way Degas painted ballet dancers, leaving empty space for them to move around the stage. Square format can offer an unusual take on either a typically vertical individual portrait or a horizontal group without environmental confinement of the background.

The big, bright composing screen of a Hasselblad is what I miss most with digital cameras. I find the tall, narrow image proportion of 5 x 7 a challenge that may result in problems such as more headroom than desirable or cut-off feet. A tall, narrow 5 x 10, however, is a compositional joy—literally a slice of life. *Tip:* To get a square from a very tight negative area, order a 5 x 7 and cut two inches off the long side.

To make a square cropper, recut the aperture of a standard rectangular variable cropping guide, available free from many labs. You'll have to close part of the existing opening with tape or paper. Form two equal-size, equilateral diamonds with the points precisely oriented to top, bottom, and both sides.

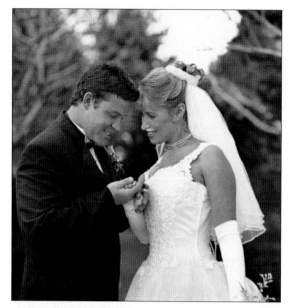

Cropping a fairly traditional ³/₄ pose can achieve excellent nuance of storytelling action and emotion.

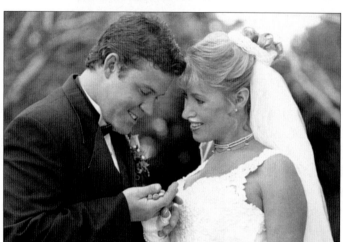

Try turning a straight, centered image for a rock'n'roll, photojournalistic style.

Choosing a Lab

Everyone agrees the best advertising is word of mouth. To ensure that this type of advertising continues to bring in new clients on a consistent basis, you can't work with just one bride at a time. Using a lab or private printer is, therefore, the only way you can accomplish more photography for more clients.

A "bad" lab is one that prints a negative to a different contrast range and skin tone than you felt you requested. However, a "good" lab for you isn't necessarily good for everyone else. The "very good" lab has the expertise and flexible innovation to respond daily to varying client needs on an individual basis.

In this period of huge growth of black-and-white photography, many photographers don't realize the medium's extra cost or technical demands. Question labs carefully about their chemicals because film/developer combination determines what you can or can't do later with a print. A high-production lab's mechanized dip-and-dunk system using a fine-grain developer with moderately solvent action will probably rule out any potentially troublesome variables. If this isn't your preference, make sure your lab will follow your individual developer specifications, or use a smaller facility that processes by hand in custom developers.

Generally, it's wisest to refer to tech reps and data sheets, and then experiment with several film/developer combinations. Commercial photographers often set rigorous tests to check out the consistency of their lab's processing time; so should you. What you discover may enable you to double the quality of your images.

The argument between those who make their own prints and those who use labs or individual darkroom technicians will always continue, particularly with the advent of affordable digital printers. However, weddings require very involved business marketing and customer service. Photographers who do even a modest volume of weddings have little time to deal with a studio darkroom, much less split-contrast printing or digital manipulation.

Assuming an average of ten minutes per print, a 100-print storybook album will require almost seventeen hours in a nonmechanized darkroom! Preparation and printing of digital files can easily take as much time or more. I don't know any photographers with serious volumes of wedding commissions who do all their own printing. Black-and-white niche photographers, just like their color-minded colleagues, find their time is best spent with clients because a steady volume of new business is still needed to stay competitive and viable in the wedding market. Even satisfied clients active in recommending your services won't be able to provide sufficient referrals if there are too few of those clients at any one time.

Many high-production portrait labs feel that the popularity of black-and-white photography is too cyclical and the volume too low to support the cost of equipment and relatively higher skill level required of personnel. Commercial labs are a good option, not only because they handle a lot more black and white, but also because they are sensitive to the mystique of fashion and advertising styles. The frustrating problem is that you may get the print you wanted one day, but a copy ordered later may be quite different.

Fine black-and-white printing results from a costly meeting of mind and product through continued negotiation on questions of contrast range, tone, and snap. It's usually misdirected thinking to try to save money by ordering machine-made candid prints. Cheap black-and-white prints are just that. My clients can tell the difference, and they're willing to pay more for better quality.

Digital printing will soon supplant conventional color darkrooms, and you'll need to learn to do your own manipulations or be able to specify in detail what you want a computer operator to do. As yet, the finest black-and-white printing remains primarily the province of the talented darkroom technician. Don't think of digital printing as a mechanical and inartistic invader. We'll still be handmaking our photographs—the techniques and devices will just be different. Art and design will live on.

TOTAL USE OF A LAB

Give your lab every dollar of business you can. This relationship isn't like banking, when it's often wise to diversify. Your relationship with your lab is the most important of your business, and the more business you give just one lab, the better the staff will know just what you require. Especially if you opt to photograph mainly in color and then translate to black and white, or if you use film and then print digitally, you must find a specific lab or individual who understands this art process inside and out. Be prepared to pay more for the service, but then, your clients expect to pay more, too.

Film and the Reproduction of Tones

I've known only a handful of people who claim the ability to mentally reduce the contrasty riot of color around them and envision shades of gray. The rest of us know vaguely that grass and asphalt reproduce a convenient mid-tone, roughly a Zone V. That's useful information, but hardly precise enough.

To help previsualize monotones, use the old watercolorist's trick of viewing subject matter through a piece of light reddish-pink acetate. Colors will be substantially muted and geometric planes of tone will become evident—a sort of architectural map for planning relative brightness, as well as composition and dimension. Incidence, reflectance, and contrast must all be taken into account by themselves and how they affect one another. In black and white, contrast is all about choices made during exposure and in the printing process, whether it's conventional photographic or digital. Anything you can do to improve exposure consistency will pay big dividends in printing ease and homogeneity.

In practice, many scenes are both flat and contrasty at the same time. For example, a façade lit by open gray sky at an angle will be far flatter than the couple standing in front of the façade in full downlight (direct overhead light). Not only will the dress suf-

THE INFLUENCE OF KODAK'S T-GRAIN

Eastman Kodak's T-Grain films captured huge market share in the last decade and haven't let go. Other manufacturers scrambled to reinvent or update their own products, because photographers and the public almost universally and immediately fell in love with the fine grain, smoother look. All the newer-generation films, such as Ilford's Delta series, are much more tolerant to the wide variety of conditions imposed by location photography.

fer terribly with over exposure that will be difficult to burn in realistically, but also the eye sockets will be deep with shadow. Use every technique you know to lower contrast in strobe conditions like altar poses, close-up candids, and any other harsh light. Soft candlelight close-ups are among the infrequent wedding situations in which flat lighting should be raised to a substantially higher contrast level. Fortunately, black-and-white printing paper and filters can reproduce a wider contrast range than those for color, approximately five stops in comparison to two to three stops. Warm- or cool-tone papers with slight variations in faint color bias are additional tools for customization.

Exposure with new-grain-structure films is somewhat less critical; a fair amount of overexposure and modest underexposure don't appear to greatly affect printability. Loss of sharpness and increased grain aren't as problematical. However, true Zone System manipulation in the manner of Ansel Adams has become impossible with these exposure-tolerant films. If you want to overexpose for the pale-face fashion look—or otherwise manipulate film contrast with exposure and development—regular Kodak Tri-X, Plus-X, Ilford FP 4, or HP 5 will be more effective. In the past, careful exposure has always permitted me to push-develop slower films by two stops with favorable client acceptance. The newer high-speed films benefit the methodology of photojournalists, who always seem to work in tricky, low-light locations. I like to use them especially in winter, when most events take place in

Photographers who insist on working in available darkness really enjoy the benefits of Kodak's TMAX and Ilford's Delta ISO 3200 films. Lighting in this hall was so dim that, in spite of fast film, I had to lean on a nearby pillar for camera stability.

halls with lower lighting or with candlelight exclusively, and when window light is weak and of short duration.

∽ INFRARED FILM ∽

Infrared film always attracts a few takers, but remains a handling nuisance. The same look can be created with reasonable success by digitally altering the RGB values and characteristic curve of the film. The most prevalent image I've seen in infrared is the bridal couple or wedding party walking away from the camera. Since blue sky will turn much darker, clouds will stand out brilliantly. Deciduous trees, with either summer or fall foliage, will show greater differences in tonal rendition than evergreens. Backlight and sidelight cause magical-looking halation, and wedding dresses are super white. Tuxedo lapels will generally turn a lighter tone than the entire garment because they're made of a shinier, synthetic fabric that reflects differently in infrared light. Our very informal method of guessing exposure is so accurate that we use one roll of infrared spanning two or three weddings, giving each wedding about a dozen frames of exotic accent to the total coverage. A single frame, or a series of images using this or any other specialty technique will become excellent wall art.

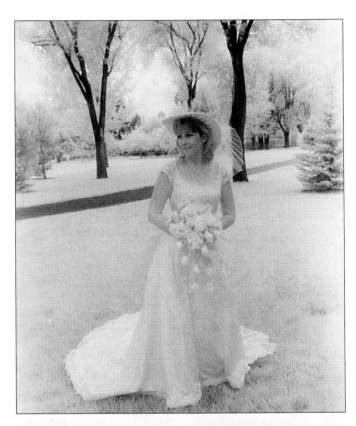

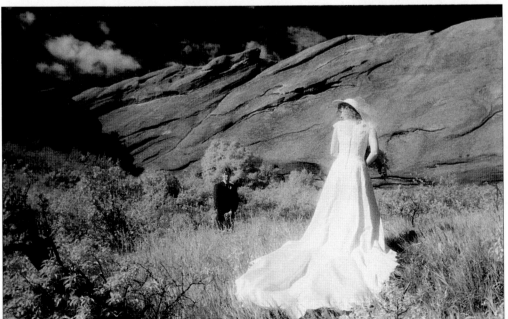

These three examples show the effects that are possible with infrared film. The image of the bride alone was taken in shade under trees, the bridal couple was photographed in full sun, and the famous Bell Rock of Sedona, Arizona, shows sidelight infrared effects.

Since meters read visible light, exposure for infrared film with a #25 red filter is not metered, but can be estimated with a high degree of success. By test, I found that subjects in direct, full sun require 1/125 sec. at *f*/11 to *f*/16, in sidelight about *f*/8, and in open shade *f*/4 to *f*/5.6. Church interiors that meter 1/2 sec. at *f*/5.6 on visible light are generally well exposed at 1/8 to 1/15 sec. in infrared. Experience and bracketing pay off; one or two practical tests will fine-tune the settings appropriate to your own equipment and typical situations.

Overexposure of an image causes heavy grain; underexposure loses snap. The focal-point shift for infrared light is rarely an issue because of the higher *f*-stops used in bright light and the typically greater camera-to-subject distances chosen; at close range, of course, where depth of field is an issue, do shift to the infrared indicator after focusing manually. To avoid fogging, load the film in a changing bag, closet, or very dark room, and return it to a clearly marked canister after use. Ilford's infrared look-alike film SFX does not require loading in the dark but doesn't really produce the same halation effect.

To create the infrared look on the computer with custom manipulation in Photoshop, begin in the channel mixer of the layers palette with monochrome checked. Adjust the green layer value of a color image to +200, and then experiment. Slightly elevate the red, lower blue to about -140, and alter the characteristic curve to your visual preference. Another formula lowers the red to about -30 and blue to about -70. Halation effect can be added with Gaussian blur to the green channel at 10 to 30 percent opacity and a two- to five-pixel-width setting. This is a *very* difficult alteration to make, both subjective and serendipitous.

～ SEPIA TONE ～

Kodak's TMAX 400CN has caught on quickly for its sepia tone. The orange-based hybrid film allows reasonably repeatable, one-color tinting of the print on color paper. Photo labs like working with Kodak TMAX 400CN hybrid film because it is developed in standard color chemicals and printed on standard color paper. Mini-labs seem especially capable of printing this film well. TCN captured photographers' imaginations because both sepia-tone and regular neutral-tone prints are achievable at machine-print color prices.

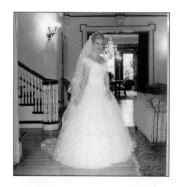

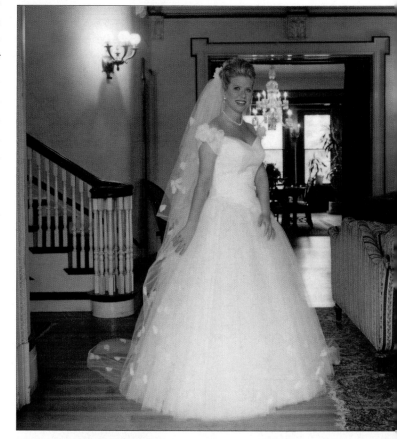

Clients are fascinated with the soft, old-fashioned sepia brown and often ask for it in particular. They also like the high-fashion look of all pale green, blue, rose, or tan possibilities as well, even though these colors are more popular outside the United States and have a more commercial look.

USING MAKEUP TO CAMOUFLAGE BLEMISHES

Facial blemishes can look frighteningly dark in black and white. Scars, wrinkles, and flaws all show up much more clearly, and with more contrast. Ask any cosmetic artists to make up a person for photography, and they should immediately respond, Color or black and white? The typical base coat for overall skin tone and blemish concealment is very different, in fact paler, for black and white than for color. Many brides tan artificially to "get a little color." That means they'll look darker than normal and may select makeup that's a bit darker still. Black-and-white film renders most skin darker than natural, especially in contrast to a white wedding dress, in which you are already struggling to hold detail. Obviously, correct makeup can help to avoid the appearance of splotchiness and too-dark skin tone. This concern is a valid reason to consider photographing on color film to lighten and soften blemishes, and then printing on black-and-white paper later by request.

Always take care with makeup application. Hoping to avoid the green overtones that some darker skins can take on in color reproduction, I recommended a particular makeup artist to a client with an olive complexion. In spite of a satisfactory trial run, my client decided to buy cosmetic service elsewhere for the actual wedding. Thinking to counteract the olive tone, the second makeup artist used a pale base suitable for black and white, and stopped application at the chin. A good part of the client's neck and chest were exposed because of an off-the-shoulder gown. The result on color film was a greenish body and arms topped by a face that was as white as a ghost. I was able to blend the face deeper with Kodak dry dyes (flexichromes) on the prints after the fact. The black-and-white prints were quite unattractive. The client was so distressed with how she looked in the previews that her order was minimal in spite of my efforts.

Seize any chance you can to visit photographers of stature in Japan, China, and southeast Asia. Glamorous wedding makeup and posing has been refined in this part of the world to rival the heyday of Hollywood in the '30s and '40s. The bride and the couple will be photographed in the studio and on location in a variety of fabulous clothing (often provided by the photo studio itself) from both eastern and western traditions. A studio I've visited in Jakarta, Indonesia, has no less than eight large and fully equipped camera rooms, each with more exotic props and scenery than the last. In Taipei during Chinese New Year, couples in formal attire are seen everywhere, posing at national monuments with an extensive photo crew in tow. (The same thing is popular year-long at the ancient ruins in Rome.) And, the makeup will be exquisite!

As one manufacturer put it, the wedding day is the most exacting cosmetic problem a woman will ever face. Carefully planned makeup combined with extraordinary print artwork will produce a flawless, porcelain look to the face. This style has recently won many awards in the United States, but in the larger scheme of photographic art, it is what the oriental bride expects on a daily basis.

~ INNOVATIVE GRAIN ~

It's good inspiration to see innovative uses of grain. If photographic artists are to be sensitive to changes in tastes and trends, we need to read the magazines that brides read and be prepared to show samples of current stylistic options in addition to more classic elegance.

A small percent of clients are interested in the old-time newspaper look of heavy grain structure. It's achieved by use of very fast films, push processing, overexposure, heating of film during development, or use of specifically grainy films, such as those from the 3M Company. Innovative wedding photography follows the look of fashion magazines, and cutting-edge black and white takes equal inspiration from advertising and photojournalistic art. Heavy, blotchy, contrasty grain structure is currently enjoying a resurgence. Technique explains the meaning of the photograph: In several recent *Martha Stewart Weddings* magazines, a few bridal gown ads appear in soft, definitely grainy, textured color, giving the impression of being looked at through colored gauze.

Consistent Printing

~

When a single print is being created as wall art, the photographer can exercise wide freedom of choice in papers and chemicals. All of the album prints, however, need to look like they go together as a unified whole, although negatives will have been made under the widely varying lighting conditions that exist at weddings.

In order to balance time, cost, and quality with the large number of prints required for creating a wedding album, some standardization is necessary, and at the same time you must take into account the style of the event, the style of the photography, the type of presentation, and the client's preference for tonal bias. The main lab concern must be achieving consistent tone and density throughout the series of photographs that are destined for the wedding album.

In color photography, I fix most small variations with dry or wet dyes to change or intensify tones. In black and white, the only similar fix that exists is a tonal wash, which will add satisfactory density to open sky for example, but cannot address lack of detail. The darkroom technician alone must accomplish the subtle tone-on-tone reproduction of the wedding dress and make it believable in comparison to the contrasty black tuxedos—all while keeping the faces natural.

A further problem in black and white photography is that effective contrast decreases very noticeably as image size increases. With greater enlargement, the exposure doesn't increase in a simple linear fashion but is actually even longer, and the filter grade increases, too.

My opinion is that split-contrast printing is practically a miracle cure for the vagaries of lighting conditions and, to some extent, of incorrect exposure, because it achieves very subtle differences in contrast and tonal range. This concept is a technical extension of the many contrast grades of paper, or the number of filters available for variable contrast printing and the relative ease of burning and dodging. In color, there are limited choices per manufacturer; in practice, Kodak's Portra paper seems to me to be the single most viable choice for attaining a pleasing rendition of skin, white details, and truthful color relationships.

~ PAPER ~

Paper choices for completely custom work are varied. If you're mixing black-and-white and color photography in an album, pick a paper surface that will be uniform throughout. Ilford's Pearl or Kodak's E surfaces are longtime favorites for their luster and texture, but I prefer matte for its simplicity.

Kodak Polymax, Ilford Multigrade, or Agfa Multicontrast papers should be considered the standard for weddings due to ease of handling, reasonable expense, and also the artistic capability of split-contrast printing they provide. Kodak's Polymax is a great option for its extended contrast range. More detail can be achieved in the extremes, so a wider range of negative exposure will create an acceptable print. Beware the European-trained printer, who may be in tune with a far more punchy level of contrast than American taste accepts. Ilford Multigrade is one of my favorites because of its slightly warmer and richer tone, which I feel offers more dimensionality for wedding subjects. Gloss prints of any

SPLIT-CONTRAST PRINTING

Split-contrast printing can actually be done with any enlarger, but the technique is cumbersome. It's essential not to jar the negative carrier or the enlarger head when changing the lens f-stop. The Ilford Multigrade 500 enlarging system makes this process feasible even in commercial lab conditions, because the light-source voltage changes automatically to match each contrast filter, and the operator need not touch the head to change filters or lens aperture.

The general instructions are to start by printing a negative for the overall effect; this is the primary exposure that will define the overall appearance of the print. The first exposure is typically made with normal-to-flatter contrast. This allows better detail in the wedding dress, which may also be burned in at this point along with other highlights needing a density boost. Faces may be slightly held back, so they don't appear too dark. The second exposure is made with higher contrast filtration and short duration to deepen blacks. Light tones won't be much affected by this part of the exposure. The variable voltage enlarger head is really helpful for this step, because the use of a 4 1/2 or 5 filter could make the second exposure very long. If a subject is very contrasty, an optional third step is to burn in sky and dress with a 1 to 1 1/2 filter.

kind are not user-friendly in wedding albums because they're highly reflective, and in daily use, they attract fingerprints and scratches. Print spotting and enhancements are certainly easier done on matte and E type papers.

While gloss-print color albums sometimes score well in professional association competitions, I can't recommend glossy black-and-white paper because it immediately appears cheap and unaesthetic. Do experiment with Kodak's "metallic" paper, however, for heightened drama appropriate to some subjects.

Both regular and split-contrast printing on regular multiple-grade resin-coated papers, particularly on Ilford's RC Pearl Multigrade, work as well with black-and-white negatives as when translating color negatives to black and white. The secret is, of course, knowing when to change contrast filtration, and by how much exposure time. Award-winning quality requires experience and intuitive judgment—the main reasons to pay for custom printing. Again, overall communication is the key with your printer.

Black-and-white conversions from color negatives or digital files can be accomplished by desaturating to grayscale, but the professional will want to use a more sophisticated technique of altering the color source channels in Photoshop. Select the channel mixer under the layers palette with black output and monochrome mode. Moving the RGB sliders, you'll imitate the effects of filtration. Eliminate this exacting handwork by purchasing a plug-in program to simulate the black-and-white film you prefer.

The emerging digital print arena is dominated by Epson, whose pigmented inks and matte archive paper have a beautiful finish, great depth of colors and tones, and a touted 100-year life expectancy. Yes, digital prints simply look different, but expert computer manipulation of the original image rivals the visual richness of split-contrast printing. Some digital black-and-white prints display dramatic tonal shift (metamerism) when viewed under different lighting conditions. As surprising as this effect may be, it doesn't detract from the extraordinary depth of detail and tonal range reproduced. I take the attitude that digital black and white on inkjet or photographic paper is an interpretation, not a replication, of traditional materials.

∼ THE LOOK AND LONGEVITY OF FIBER, RC, AND DIGITAL PRINTS ∼

Real fiber paper, with its proven history of permanence, has an unmistakable physical feel and look to its surface, different from the plasticlike coating of RC (resin-coated) paper. Both types will almost certainly be overtaken in popularity by the excellent look, feel, and manipulatable properties of digital printing.

The debate of fiber versus resin-coated papers is still continuing. A full wedding album of either fiber or digital prints may well be out of the financial range even of the client prepared to pay a premium for black and white photography. Only the client who has worked in a museum will know how to display and care for fiber prints. It's challenging to flatten fiber prints and keep them flat over time under changing temperature and humidity conditions. Fiber prints cannot be transferred to canvas, and they're not recommended when making flush-bound albums in which prints are mounted right to the pages. Many times, fiber prints are marred by bad wrinkling under their mats in traditional album presentation. Consider offering this kind of work prepackaged with appropriate framing and matting, because in this situation you control what happens to the prints.

The question of paper's archival stability—which formerly weighed so heavily on the side of fiber paper—is now probably moot. Aesthetics aside, most experts agree that RC papers and fiber are about equal in terms of longevity. Pigmented inks used by the best archival digital printers have been shown, in accelerated permanence testing, to have a similar or even greater life expectancy. All types are differently susceptible to deterioration by different elements.

Fiber prints are more susceptible to fungus, rot, mold, mildew, and chemical contaminants from incomplete washing. They wrinkle in damp conditions and crack when very dry. RC prints are more susceptible to fumes from plastics, paint, and cooking oils, which exist in every home. Both should be displayed under a window mat so that the image does not touch the glass, which should be cleaned only with dish soap during the framing process. Some foam boards used for backing give off harmful vapor, and lacquer is now seen to increase susceptibility to some environmental contaminants. Water-based finishes may prove to be a real boon in this regard.

Accelerated, multiple-stimulus testing of RC papers points to a life expectancy in excess of 100 years, but beware the multiplicity of unknown papers and processing chemistry in the contemporary marketplace. Inkjet prints made with pigmented inks are very lightfast, but on some papers the colors will run if spattered with water drops (or any liquid), or if humidity is high enough to condense on the surface. Ozone is the main contaminant; therefore, in portrait applications, prints should be sealed in frames behind glass. In most commercial applications, inkjet prints are laminated to negate this problem. Roller coating or sprayed-on finishes specific for inkjet do seem to perform the same function in albums.

Borders

Once the concerns of paper, tonal range, and density have been settled, consider the question of image edge treatment, which though rarely utilized in color, can play a vital role in creative black-and-white presentation. Edges will be defined, to a large extent, by the album type: flush mount, window mat, or mat slipped into a larger page. Color of the page will be another factor. Check out commercial and advertising applications for design and printing inspiration. The ubiquitous plain white edge around a black-and-white image can be as thin as a pin line, double the width of the actual image, or any dimension in between. I like to use about a $1/4$-inch visible margin on smaller prints, $3/8$-inch on 10 x 10s. Essentially, the idea is to set the photograph area apart by means of negative or empty space.

It's popular to leave 35mm sprocket holes showing, and also the letters and numbers that simulate the edge of larger formats. The enlarger's metal negative carrier can be filed out to produce a rough, irregular, heavy black border. Naturally, this technique works easily only if you plan to print the full frame. A variation of this technique is a Kodalith negative that will print a graphic background of brushstrokes, or any other shape. A frayed, darkened edge inside the image area can be produced with a second exposure and a dodging tool cut slightly smaller than the full image area.

My favorite technique is a simple, neat pin line printed in a one- to two-inch white border, about $1/4$-inch out from the edge of the photo. A Kodalith is made by computer for each exact size and shape you will be using. After the exposure is completed for the photo in the regular way, the Kodalith is put in place, with care taken not to shift the paper, and the paper is exposed again for the line. A custom variation on this idea is a partial border, like a corner angle, or a discrete line of flowers, leaves, shapes, or even your signature. You'll go to a bit of trouble and expense the first time, but once you have your masks you can use them again and again.

A popular brochure technique is to have the main full-density photograph underlaid with a 50 percent or lighter screen, either of the same image or a totally different one, perhaps an overall pattern. For a wedding album, this is done by simply overlaying the printing paper on the easel with a precision cut shadow frame mask part way through the exposure. If two images are used, registration is easily handled digitally but is much more difficult in the darkroom.

Digitally created edges have effectively supplanted costly and labor-intensive handmade borders. One of the best border plug-ins for Photoshop is Photo/Graphic Edges 5.0 from Auto FX Software. While computer manipulation is still very much the province of the individual practitioner, reasonably priced templates can be purchased from any printer offering computer typesetting. Hundreds of shapes, borders, brushstrokes, and frames are available as copyright-free clip art from the *Art Explosion Gold Edition* users manual, among others. For use in pixel-based Photoshop programs, it's a good idea to make clip art into a Kodalith and then scan it so that it will smoothly enlarge and reduce as it's applied to different sized images. There are also plug-ins that let you use a menu of templates or design your own. Build a library of designs for quick reuse. Considering the ability of the computer to create different effects, the concern is not how radical and various those effects can be, but rather how to exercise symmetry and classic good taste in postproduction. To be memorable, the wedding album must still focus on the mood and content of the imagery, supported by the techniques of presentation.

A NOTE ABOUT BORDER CONSISTENCY

Whatever the technique employed, it must be consistent throughout the album. For most photographers, the more appropriate use for a creative border will be to style a stunning single piece of wall art. Be prepared for the effort to go digital, but here's yet another service for which you can charge more, too.

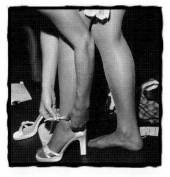

These ten border variations were made mostly by computer. Clockwise from top right they are: filled-out negative carrier, pin line, irregular brushstrokes, torn edge, pin line with margin, drop shadow, 120mm film, drop background, interior burn, and 35mm film.

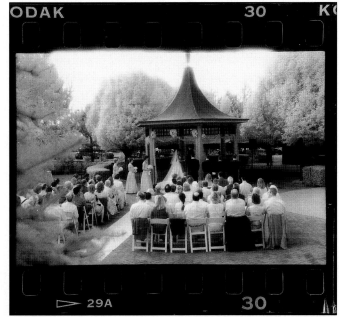

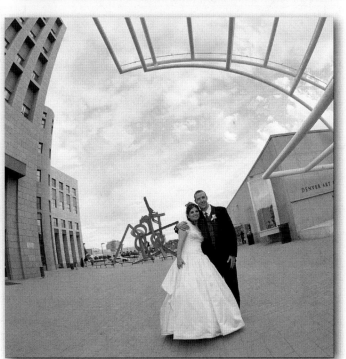

Digital Retouching

The question always arises of exactly how and when to retouch or enhance wedding album photographs, and, of course, how to charge for the service.

Most photographers I've met charge extra for enhancements and corrections, or a offer prepriced good/better/best finishing options plan. I include simple dye enhancement in the price of event photography. I charge extra for removing braces, removing severe hair frizz, opening eyes, or portrait-style wrinkle softening and blemish removal. These services, whether done digitally or on the negative, are priced by quote.

Digital results are first class in most circumstances, but can be failures in others. The main problems I've experienced have to do with instructions not completely followed, sharpness lost in hair if a correction surrounds the head, and older faces appearing puffy— like plastic dolls—after wrinkle softening, or an imported face appearing sharper than the base image due to differences in scale.

Digital retouch failures result from overworking an area, contrast buildup, and color crossover on the new negative, or from studio-to-laboratory calibration differences. Of course, digital removal of any unwanted background items, switching of heads, opening of eyes, and/or adding or subtracting of people from a group photograph can seem like magic—and are both cost- and time-effective. Correction requests arise most frequently in group portraiture, where the goal is to create the ideal image of both the people and the setting. In the not-so-distant past, sophisticated

Sometimes it's necessary to create the perfect group by montaging parts of several negatives together. In five tries I was unable to capture the attention of both adults and children at the same time, and their patience was too exhausted to continue. So, I digitally inserted portions of the first four attempts into the fifth "base" negative to achieve the final image (bottom right). This example is relatively simple because there's little difference in the pose and none in the lighting. It's rewarding to create a better-than-real negative for a client who has a vision of an ideal and isn't afraid to embrace the technology.

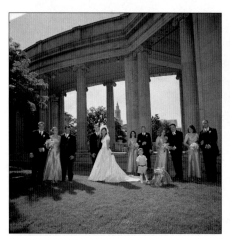
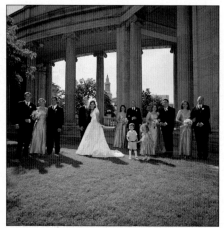
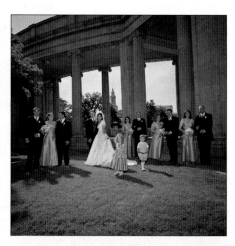
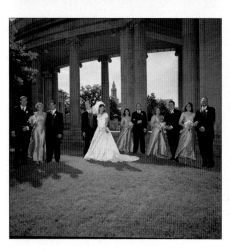
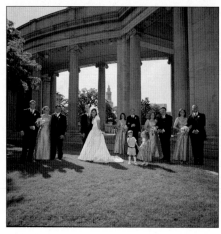
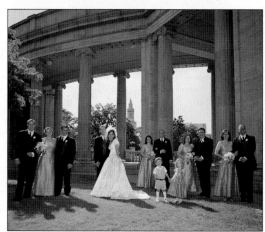

RETOUCHING STEPS

STEP 1 Just as you would use a strong magnifier when applying retouch dye, enlarge the image dramatically on the computer screen when doing digital retouching using Photoshop. Practice helps develop a steady hand when drawing a stroke with the mouse or stylus. It's very similar to the eye/hand coordination required to manipulate a brush and dye.

STEP 2 The basis of every good computer enhancement is the careful preparation of the image. This step addresses density. Don't use the easy, less-precise fixes of the brightness and contrast slider or the histogram slider. Instead, use image/adjust/curves, a non-linear correction that closely resembles the way film response is graphed for Zone System manipulation. Sample both shadow and highlight points, and plot them on the curve, as well as anchoring the highlight with a third point halfway to the upper end of the graph. Change the toe (shadows) first, then the shoulder (highlights), by pulling them out of the straight line into a curve. Even very incorrectly exposed or color-contaminated images can be magically altered by adjusting the RGB curves separately, not as a whole.

STEP 3 This is the ultimate color correction through "selective color." Move the black slider to see which selected color from the menu affects the image most. It's like viewing a photo through color-correction filter gels. You can lasso a single problem area and correct it individually. Saturation adjustment, flattening, and sharpening complete the preparation.

ADVANCED RETOUCHING

Adobe Photoshop 7 has two new "healing" tools—the Band-Aid and the patch—to fix retouching problems that I thought I would never be able to address in the computer: shiny foreheads, eyeglass reflections, and wrinkles. These two tools operate in various modes and as complements to each other.

Here are some advanced ideas to get you started.

❖ Loosely encircle a blemish with the patch tool in replace mode, and drag it to a clear part of the face. In normal mode, the Band-Aid tool copies texture, and the program actually interpolates the surrounding color to blend automatically. In replace mode, it copies texture and color. You can sample and paint with a brushstroke or dots.

❖ Use a one- to five-pixel Band-Aid brushstroke in lighten mode to make wrinkles more shallow, but not remove them.

❖ Reconstructing the shape of eyes obscured by eyeglass reflections takes various steps, just like with dye. The patch zips out the reflection; the Band-Aid in normal mode blends the area seamlessly, and in darken or replace mode, it redraws the eye. Enhancements are gradually built up and blended just like dye or pencil work—and, of course, you can so easily erase if you don't like what you've done.

print finishing was always done with airbrush, Flexichromes, colored pencil, oil paint, and lamp black; I've seen beautiful results achieved by consummate enhancers using these tools, but I know that these techniques are hardly archival. Digital artwork will completely update my postproduction niche.

Nik Multimedia offers an incredible plug-in called PenPalette. It effortlessly cools or warms selected areas of an image, changes color tone and contrast, and selectively converts to black and white. I use this program to correct and balance tones, just like I used to do smearing Kodak Flexichrome dry dyes into the print surface. PenPalette requires the Apple OSX operating system.

Think of the computer as simply a new, permanent way of perfecting traditional enhancements. The foundation of style doesn't change, but you must learn delicacy and seamless natural rendering with the new tools. The main difference is that you must perceive problems, decide what to do, and manipulate the picture all while looking at the image on a computer monitor, rather than holding a photographic print in your hands. Therefore, the size, quality, and calibration of the monitor is critical. A big 21-inch or 22-inch monitor with the lowest dot pitch you can afford will make precise work much easier. The beautiful Apple Cine flat screen monitors require relatively little color adjustment. Use of a large tablet and stylus rather than a mouse gives the same feel as holding a retouching brush. The creative part of enhancement remains in deciding *what* is to be done; only the tools have changed. They are more accurate, efficient, and, best of all, repeatable.

Spotting and Enhancement with Dye and Oil Paint

Handcoloring of black-and-white photographs is on the tip of everyone's tongue these days. Almost as old as photography itself, coloring has suddenly become new and exciting again to photographers and clients alike—but with new inspiration that combines glamour, nostalgia, romanticism, surrealism, and whimsy.

Spotting corrects faults. Enhancement removes unwanted elements, tones down highlights to soften wrinkles or improve facial texture, removes highlights to improve composition, intensifies tone, and fills in or completes a pattern or texture.

Most beginners mistakenly think tone match in color is more critical. However, even a slight tonal variation in black and white is instantly noticeable, and you're better off leaving an exposed area alone than risk a hint of magenta or green where there shouldn't be.

Dyes applied to color in background areas are actually very forgiving. Blending in shiny foreheads, raccoon eyes, and wrinkles are also comparatively easy techniques, so long as you constantly wash out your brush to avoid color contamination. If you're using sepia or other overall toning colors, then obviously, color spotting rules apply.

Spotting requires a good deal of practice and patience, especially if a print has scratches and pinholes in exposed areas. Enhancement is much more subjective and creative; it's much easier to do than spotting, but harder to figure out what will look good. Dye work will solve almost any problem where a lighter area is filled in with darker tones. Often, a few brushstrokes of color make the difference between an adequate print and a superior one.

The main problem of color enhancement is impure or muddy tones. Dye mixed with gray pigment by the manufacturer or inadvertently by the artist is the culprit. Sometimes an artist just works too quickly, and doesn't thoroughly wash out the brush between colors, especially before using sensitive flesh tones. Pēbēo's pure color dyes are not contaminated by gray content. Kodak dye users may find Pēbēo colors more flexible. Dr. Brown's brand tends to be extra vibrant right out of the bottle and, therefore, less suitable for portrait photography. Marshall's dyes have a wider selection of useful colors, so they require less mixing. SpotTone colors are no longer appropriate for use on black-and-white prints, because all manufacturers' paper tones have changed radically since their formulation; however, I find them excellent for blending neutrals on color prints for anything from leaves to skin and hair color.

For most uses, dye right from the bottle is far too concentrated, too runny, and unmanageable for delicate photographic application. I put several drops of each dye color on a palette and let them dry. I organize the colors in families (groups of similar, related colors) and label them by name with permanent marker. I space the colors widely so that they don't run into one another; this allows space for mixing. I use all twenty-four Marshall's premixed colors, the six SpotTone colors, and Pēbēo's #8050 and ND (which blend almost invisibly with contemporary black-and-white prints and are less likely to change color while drying).

Most beginners prefer to spot with a tiny 000 brush but later graduate to a 0, which will carry more dye and enable faster working but still provide the same fine point. Naturally, a 000 size will still be valuable for very small details. Test brushes before buying. The hairs should easily make a fine point when wet with water; there must be no stray hairs. Always rinse and dry brushes so that the hairs don't get bent or splayed out.

Keep a tissue or very soft handkerchief ready for blotting, but beware of tiny fibers, which will stick in the dye. Some photographers wear gloves while working on a print, but if you don't, rest your hand on a soft, absorbent paper to avoid transferring finger oils to the print—or else be prepared to clean every print with Unseal, which is a kind of "dry cleaning" solution for art work.

When picking up dye from the palette for use, I control the color by severely limiting the amount of water on my brush. I recommend working with a very dry brush except, of course, when filling in a large area with a color wash. Much spotting is done with a pointillist motion (a straight up-and-down repetitive touching of the brush point to the print) to simulate grain. Filling in the entire spot smoothly would result in a dark blob easily distinguishable from the surrounding area as the original spot. This dotting motion is also handy for making leaves on trees or bushes.

You should always build up to the correct color/density with several touches of the brush rather than putting on too much all at once, or risking depositing color outside the edge of a spot or line and then being forced to remove it and rework the entire area.

It's best to approach eyeglass reflections by filling in the dark areas—the fold of the eyelid, the edge of the eye, the eyebrow, the

rim of the glasses—first. Once that's done, most of the reflection will have already disappeared. Then, fill in the lighter areas. You'll find it easier to mix the right color if you proceed in this order.

To disguise lines or scratches, and enhance wrinkles, use a stroking motion. My hand functions most precisely in a roughly vertical, top-to-bottom stroke. A scratch may well require a 000 brush, and may change color along its length. I always tackle the darkest areas first, moving to lighter ones as the intensity of a single brushload of color diminishes as I work. In sensitive skin areas around the eyes, I start with a tone that's too light and add several layers to build to the right density. Note that skin tones vary dramatically; there is no typical "flesh" color. You may need to add a hint of olive, orange, red, dark brown, gray, or even lavender. Remember to intensify or add catchlights in the eyes with a touch of gouache, the brilliance of which can be subdued with colored pencil after drying.

Exit signs, fire extinguishers, lights, golfers, or miscellaneous people are often removed from the background. First, neutralize any green signs with red and any fire extinguishers with green, then darken the element. It will be a dark shape, but it's much better than a lit sign or unsightly box. Black-and-white retouchers need consider only tone rather than color layering.

Light bulbs, fixtures, or reflective highlights should be avoided during the photography if possible. If you do have to retouch one of these items, it's often better to just tone down a light, rather than remove it entirely. Miscellaneous people or objects either nearby or in the background are a difficult judgment call. Sometimes, a disembodied face that pops up out of nowhere can be made to look like a bit of texture in a dark background. Golfers are easy; I turn them into trees or bushes!

Dye washes are good for enhancing areas of an image that recorded too pale. In black and white, I use dye wash most frequently to put denser tone in open sky areas, which typically record pale or even blank. Pastel chiffon dresses and sunsets often need a little intensification. Another use of color wash is to improve the look of unfortunate highly-patterned or brightly colored clothing choices.

The secret to applying a dye wash is to prewet the surface of the print just moist enough to make the emulsion swell so that the dye will flow gently and evenly. Choose a moderate size brush and wet the entire area, without going over the edges. Mix quite a bit of dye, depending on the size of the area. The clear lid from a yogurt cup can be set directly on the print to see if you have the tone right. Allow a great deal more drying time for dye washes than for simple spotting.

USING PĒBĒO OILS

Sometimes, you may want to use oils rather than dyes. Large areas can be colored more smoothly in oil, but small details are far more difficult. Pēbēo oils eliminate the need to prepare a fiber print with smelly solutions. There's no longer a need to print on Ektalure or other off-white papers to disguise the inevitable color shift of these solutions over time. The Pēbēo oils themselves are so homogenized and smooth that they don't separate; they blend with amazing evenness. To use:

❖ Squeeze out very small amounts of the desired colors on a small palette, leaving spaces around each color to mix the shades you want.

❖ For a large area, apply a small blob of oil, and move it around in any direction with a cotton ball, swab, pad, or even your finger.

❖ Color will probably be initially darker than you want; blend the area just a bit more, both to reduce density and eliminate any splotchiness.

❖ Use a toothpick wrapped in just a few fibers of cotton to color and blend tiny details.

❖ Remove any mistakes or overlaps with cleaner or eraser; *note:* Pēbēo oils dry somewhat faster than other oils.

To correct many misapplications of dye, I immediately load the brush with water and scrub ever so gently on the affected area. When this treatment isn't enough, dot a tiny drop of Pēbēo dye remover on the spot and let it remain for ten to thirty seconds. You'll see the intensity of the dye decreasing. Then, whisk away the solution with a cotton swab soaked in water, blot, and swab again, or wash the whole print gently with water if the affected area is large. I let the print drain vertically if I've washed the whole print, or dry with a small hair dryer.

Pēbēo again comes to the rescue with a two-part bleach and neutralizer solution. Dot the powerful bleach on the print with great care to limit spreading since the liquid will bleach everything it touches. Black spots will magically dissolve. Stop the lightening action instantly with another brush dipped in the neutralizer. I wipe the affected area of the print with a wet swab or tissue, though rinsing is not required. The procedure can be repeated for further lightening.

SpotPen Handcoloring Techniques

~

Until recently, the handcoloring of black-and-white photographs was a complicated process that involved the use of specialty fiber papers, chemical surface preparation, and retouch lacquer, resulting in uneven blending, and lengthy drying times.

SpotPens are a time- and money-saving coloring method, because they can be used on any paper—glossy or matte, RC or fiber—and are almost as easily applied as highlighters to a textbook.

This innovation helps even the novice colorist achieve great results the very first time. The pens are available with both broad tips and brush points. The colors are highly pure and leave no surface residue on the finished dry print, like the rainbow effect of oil on water. And, they're deemed very lightfast. While some artists prefer more intense, overall coloring, my preferred style is to color only selected areas with subtle tones for an elegantly simple look.

The secret is to use SpotPens more like dyes than oils; that is, to start with lighter color application and gradually build density, rather than applying a thick amount of paint and then buffing and blending away to the desired tones, as you would with oils.

MY STEP-BY-STEP SPOTPEN DIRECTIONS

Moisten the print surface with Kodak's Photo-Flo film-wetting solution (1 tsp. to 32oz. of water) until the emulsion swells to a slightly tacky consistency. Make sure your lab is using fixer with hardener, or if that's not possible, let the print cure at least five days before handcoloring, otherwise emulsion peeling will almost certainly result. If you apply Photo-Flo selectively, just to the area on which you're currently working, it acts a bit like a mask or frisket and helps to prevent color from bleeding into other parts of the image that you may want to keep clear.

Prior to using a new SpotPen on delicate photo emulsions, it's very important to soften a new pen tip by scrubbing it vigorously on cardboard.

Start coloring with very light tones, with almost no pressure and a circular motion. While working, have cotton in your other hand to quickly alternate marking and blotting off excess color. I color skin last, to avoid color bleed. I often use #50 for women's skin tone and #44 for men's. The soft tones build smoothly and easily, and I can blend in a little pink cheek, just as with oils but quicker and with better control. For jeans I use #21; jean clothing is the hardest to get smooth, because the fabric is blotchy anyway. Both #11 and #29 are good hair colors. I often end up reducing red/brown hair tones, because I want only very soft color. Sometimes, hair is very difficult to do perfectly; I may layer #24 olive and #15 lavender over the original brown before being pleased with the result. Layering is easy to do because colors dry in just a few minutes, but be aware that reworking will quickly scar a print if you press too hard.

Use broad-tip pens for large areas. I seem to have better results with the chisel point, rather than the flat side of the pen. The brush-tip pens do wonders for tiny details. Belt loops, leaves, and lips are a breeze, with no color bleed to clean up!

If, especially at first, you've made some awkward pen strokes, you can lighten and blend colors with a cotton swab saturated in Photo-Flo solution. You can look like an expert by taking off just a bit more tone in highlight areas to create a three-dimensional rounding effect on faces and fabrics. Pen nibs can also be dipped in the solution to dilute colors. Another way to lighten a tone or mistake is to simply "erase" or blend it immediately with the RemoverPen, the tip of which must then be blotted on a cotton pad or paper towel so that you don't contaminate colors. SpotPens leave no mess on your hands, sleeves, or the rest of your print.

An advanced and very sophisticated technique is to use liquid frisket to mask off areas that might accidentally become contaminated with dye due to proximity and size, for instance a dog's red tongue against its white fur. Pébéo's masking solution is dark purple and a bit smelly, but it works very easily, including the clean-up. To use, paint the masking solution on and let dry before coloring the image. Remove it either with remover solution or by pulling it up with Scotch brand removable tape.

I've won several awards by selectively handcoloring details, such as flowers, on a sepia print. The effect is subtle and exciting, adding another layer of visual depth and dimension. SpotPens, which are the obvious choice for this technique, shouldn't be applied to Kodak's RA4 prints, because their colors will shift chemically; Marshall's dyes are a good substitute in this case.

Engaged couples love to be photographed with their pets. The warehouse look is also popular and lends itself well to handcoloring.

Antiquing

Antiquing is an enhancement technique that differs from the more ubiquitous methods of handcoloring in that it takes inspiration from old master paintings and will give the feeling of age. In photography, it is done with oil paints.

Before antiquing you must remove dust spots and retouch any problem areas on the print with photographic dye in the regular manner. Oils won't stick properly on glossy prints, but matte and E surfaces are both just fine.

A high-key photograph, or at least one with mostly paler tones and little or no very dark areas, will work best. Portraits and still lifes are naturals for antiquing, but a landscape or a scene of old buildings could be appropriate, too. Antiquing done on low-key portraits seems to me to appear muddy rather than intriguing. The change in feeling is far more dramatic when antiquing is done on a light-tone image.

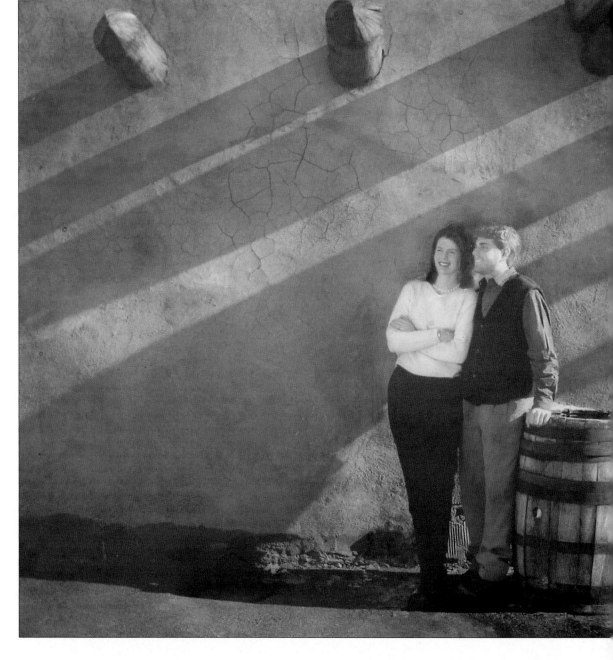

These three versions of this full-length portrait compare antiquing, with sepia tone with some oil color (right); handcoloring with Spot-Pens (opposite top); and natural black and white (opposite bottom).

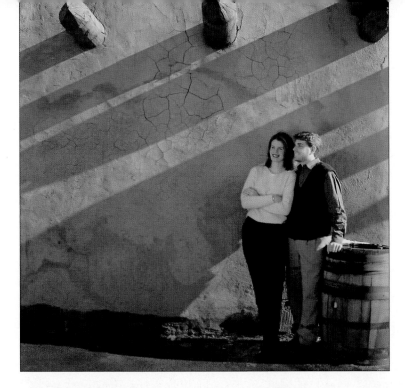

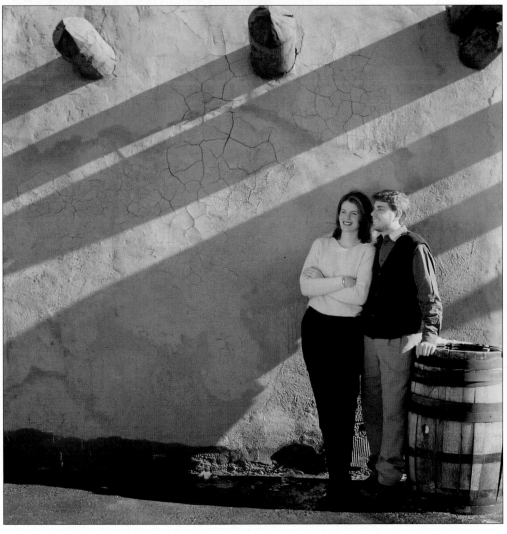

STEP-BY-STEP ANTIQUING PROCESS

The oil paint colors recommended here are just suggestions; there are no right or wrong answers, but remember that the technique is meant to be old looking, so browns and blacks will always be good choices.

WHAT YOU'LL NEED

❖ Photographic oil colors of your brand choice (such as Pēbēo, Windsor & Newton, Marshall's)

❖ Solvent (odorless is best)

❖ Small glass or ceramic dish (for the solvent)

❖ Cotton balls to remove excess oil and Dacron balls to apply and blend

❖ Cotton swabs

❖ Toothpicks to make color applicators for very small areas

❖ Piece of cardboard (or other stiff, disposable backing on which to tape down print)

THE BASIC STEPS

Apply the main background color to the entire print surface using a circular motion. A good starting color mix is $2/3$ Pēbēo #40 black and $1/3$ Pēbēo #46 burnt sienna. For an 8 x 10 print, you'll need a blob of black oil about as big as the end of your little finger plus half again that much of burnt sienna. If there are people in the photo, don't color the flesh areas. To remove any colors from those areas, moisten a Dacron ball in solvent, squeeze it out, and pick up oil color with it. Or, try using just a dry cotton swab. But, be careful not to remove too much.

Use a Dacron ball to spread and even out the oil overall. During this stage, begin to smooth out lines left by the fibers. Continue to smooth at all subsequent stages. Of course, you may wish to try leaving fine lines on the image for a specific artistic look.

Use a cotton ball to remove excess oil paint. I often leave the print corners a bit heavier to give the impression of vignetting or extra aging to the edges. If in doubt, put more oil on at first and adjust the density at this stage. Cotton will leave distinct lines in the oil, usually necessitating a last blending with a Dacron ball.

Now, mix and apply oil color to the skin areas and facial features. A large portrait in which face size is also large will require changes in color, from highlight to mid-tone to shadow. Pēbēo #44 flesh color will rarely be satisfactory by itself or even mixed with one other color. I like a mix of $1/4$ #41 yellow ochre, $1/4$ #44 flesh, and $1/4$ #43 burnt umber combined with $1/4$ #46 burnt sienna. Pēbēo #31 dark red is a good lip color. Also select eye color—along with hair and any other detail not covered by the overall background antiquing—at this point. It's most effective to apply and blend all these areas with a small bunch of Dacron fibers wound around a toothpick.

To emphasize highlights and create rounding of cheekbones, nose, and forehead, blend the color softer and lighter in those areas. Also remove color to highlight folds in fabric or three dimensions in any part of the scene. Details are small and delicate, so, again, make your own tiny applicators. Ten or more applicators can be made out of one Dacron ball, and often, I use twice that number on one piece. Be sure to discard the fiber applicator often and take a fresh one to ensure that you're working quickly and *cleanly,* without smudges.

Finish blending the oils on faces, arms, legs, and the other selectively colored areas. Blot lips and eyes to make tones more muted.

Further blend all background areas to as smooth a texture as you desire. Be especially careful not to smudge any of the other colored areas, or you may have to remove everything you've done and start over.

It's wise to let the print dry for several days before matting or mounting. In Colorado or any dry climate, usually half that time is sufficient, but remember that oil paints dry from the outside inward—from the surface down—so a piece may feel deceptively dry to the touch.

Sealing with lacquer or water-based spray is desirable. Prints can be mounted, as the oils will not be affected by heat. Overlaminate is another good alternative. Before you spray or laminate, examine the print surface carefully and use a tweezers to pluck out any tiny fibers that remain stuck in the oil. Be very gentle and don't gouge or take a nick out of the print surface.

Giclée Printing

To make a giclée print from a photograph, the original negative or positive—black and white or color—is scanned, manipulated by computer in the manner of the artist's choosing, and output via inkjet printer on a variety of substrates including paper, canvas, vinyl, metallic Mylar, vellum, or anything that will bend in the printer and to which ink will stick.

My favorite is lightly textured watercolor paper—thus, the popular name *watercolor prints*. Actually, there is a technical difference: Watercolor prints are generally output by a 300-dots-per-inch (dpi) printer. The quality of either quite small prints (greeting-card size) or much larger ones may tend to have insufficient sharpness, detail, and color saturation for portrait subjects if not printed at a very high dot count. Originally, experts have in the past defined giclée as produced by an Iris printer at 1200 to 1400 dpi. New printers can be set for a wide variety of dot patterns.

The type and quality of the scan will make a big difference in your result; try not to use an interneg for a scan. Epson brand printers offer options for portrait, commercial, and landscape photographers through different ink sets and many papers. Colorspan brand inks have also recently won awards for longevity and may be used in other types of inkjet printers.

In this text, I'm using the terms giclée and watercolor more loosely and interchangeably, because the wedding photographer views them as the same product. The finished piece will accept further enhancement with colored pencil, pastel, and even watercolor pen. Since giclée is ink, beware of color bleed that may result from a stray drop of water on the piece. Instruct your clients not to hang giclées in direct sunlight or even very bright indirect light, just as with any piece of fine art. As an extra precaution, we always include museum-grade conservation glass in the price of a framed giclée print.

Serigraphs, etchings, and monoprints often have wide, plain margins and torn edges. I particularly like to mount a giclée as a "float," showing the torn edge and blank margin. Cut the window mat $1/4$ inch to $1/2$ inch larger on all sides so that the background mat under the print shows through the gap. The background mat can be a pale neutral or a medium color that picks up tones from the print itself. It will look darker than it is, because it is in the shadow. A double top mat always looks good. The archival foam core float elevates the print for an elegant, three-dimensional shadow box effect.

Not all negatives make good giclées. A fairly decent subject head size of more than an inch or so is needed to reproduce facial features with detail. Brighter colors with an overall medium to high-key tonal range and a graphic feel make for good reproduction. An image brimming with storytelling power, for instance an already soft and romantic natural-light portrait of the bride, will work really well. I have, however, seen several effective giclées from contrasty negatives with deep shadow areas. It's not necessary to pretend to be a painter or printmaker, but giclée is so new and so much fun that you can make the medium your own and produce viable, conversation-evoking wall pieces.

Sample Albums

Rule #1: Show what you want to sell. Rule #2: Unusual angles, use of special lensing, artistic portraiture, and superior grab shots are all for show;. they're how you win awards and get clients in the door, but tradition often sells better. Rule #3: Don't mix the "greatest hits" of several events in one sample book.

An anonymous quote from the golf world says it best: You drive for show and putt for dough. Show a complete presentation of a single event, not just the "fireworks"; be proud of the total effect. This is the most honest proof of your ability to convince both public and peers alike. Have at least one complete set of previews to demonstrate the quantity, comprehensiveness, variation, technique, and complexity of what you can offer. Remember always that the simple, technique-intensive images—namely excellent groups and recording of traditions—will net the most sales regardless of your style.

If you believe in multiple styles, as I do, and have the talent to be proficient in them all, you must also be prepared to show everything you can do. This means the advanced photographer may have a large investment tied up in samples. Extremely careful or even ostentatious handling of pristine samples by sales people demonstrates by example the value of your fine photography.

Don't try to sell anything too quickly; observe which books stay in clients' hands longest and which images make them smile or cry. Once you have a clue to a couple's taste, use words that relate to *their* style. Words like *classic, traditional, posed,* and *looking into the camera* all speak about wedding portraiture. Those interested in photojournalism will react well to *just as it happens, action,* and *real life.* When you feel certain you've figured out what level of service and what stylistic mix it will really take to produce an appropriate coverage, recommend a package, tell them why, give them options, and then stand back. As much as I'd like to say that quality alone is the deciding factor, I've found time and again that communication, perceived value, and customer confidence win the contract.

Varied options beg for creative presentations. I offer five lines of commercially produced albums, which I often alter in ways never imagined by the manufacturer. If you aren't aware of the huge scrapbook craze, look at what people are buying by the ton in craft stores. Books created from scratch with handmade papers in my own designs are a big seller. Clients are finally beginning to realize they can buy commissioned art from photographers. Photographers who push their art to the maximum will attract a much more exclusive clientele, and will be able to charge a nice price for the added value. Voilà! Niche marketing made simple.

Custom presentation poses a supply problem. Since we work with just one album at a time, we can rarely take advantage of quantity price breaks. Minimum orders may make a product line prohibitively expensive, and we can't afford to stock excess inventory that may not be used for a year or more. The exceptions, of course, are generic gift folios and smaller guest or family books, though these items, too, must not be overstocked. It's well worth paying a bit extra for the individually priced product from a supplier who understands that you serve clients one at a time.

~ WHAT TO DISPLAY ~

A prominent colleague of mine advocates making up only one sample album (of your most costly package) for each of the major faiths in your area. Have this limited number of albums all displayed on individual racks or one table. Keep samples of other, lesser coverages or parent books under the table or in a cupboard nearby. Since I'm specifically known for outrageously individual designs, I show about fifteen complete albums in a wide variety of styles and postproduction presentations. While I prefer to impress couples with variety, I recognize how my friend's inventive sales presentation can imply value and sell larger packages.

Album Styles

Album design is rather like sewing; it is an intimate activity, interior and collaborative between artist and participants, that stitches together memories. It is an unusual construction that effectively turns the two dimensionality of loose prints into something three dimensional. *Volumetric* is the word used by art critics. People love the way memories become a tangible thing they can hold in their hands.

The black-and-white wedding photographer is on the cutting edge of design and proud of it. To achieve style, offer unique album looks that clients can't obtain anywhere else. Fortunately, there's no one right or wrong style; form simply follows the function of the images and the client's taste. Most studios show only one or two album types, not only because they are able to produce fewer styles but also because they want to leverage their buying power and lower their inventory with standardization. Often, I see top-notch creative images in presentations so trite and tired that their excellence was made ordinary. A carefully constructed album will, however, turn garden-variety photographs into a story much more interesting than the mere sum of the parts.

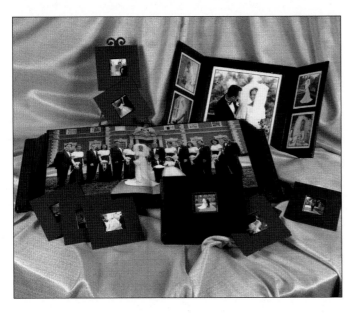

Generally, all black-and-white weddings, as well as those half in color and half in black and white, are better presented in simple, sparely designed albums. *Classic* is almost always the word clients use when describing the black-and-white look they've imagined.

Ubiquitous gold pin lines on mats generally strike the wrong note. Most manufacturers now offer black or silver gilding on the edges of pages and no gilding on mats. Snow white mats, though more damageable, often complement black and white, just like the stark matting favored by fine-art photo galleries.

If you decide to combine black and white with color on one page, generally the best suggestion is to make the black and white image a very different size and shape than the color images set around it. You must definitely plan how borders, empty margins, or multiple prints per page can be turned to stylistic advantage by demonstrating the difference of black and white. The meaning of the photographs themselves will be subtly explained and amplified, if the presentation follows through from the original style.

There are design lessons to be learned from the popular personal-storybook scrapbooking craft. Clients are now much more aware of quality and archival products. Handcrafted art must not take on the negative connotations of unprofessional or imperfect workmanship. Bold collaged shape combinations are great in color, but I find that simple squares and rectangles of any proportion generally have a better feel in black and white. I like to fit images together in a mosaic without overlapping, or in window mat openings. Old-fashioned paper or Mylar corners introduce another stylistic variable that is in demand. Our handmade albums are made by a local bookbinder to my specifications of cover materials, rice paper interiors, and ribbon or raffia binding. They can appear either Victorian, steel-and-glass contemporary, or natural and earthy. Note that you can't afford *not* to offer album-style options if you want to capture the higher dollar market.

In the United States, a huge variety of velvets, polished woods, sterling silver, polished aluminum, metallic fabrics, glass, and paper albums are available, in addition to the more user-friendly natural and artificial leathers. The trend is toward larger sizes. The main problem with many specialty styles is that manufacturers give far less concern to the interior pages, which are

My favorite total wedding collection is a large Onyx Art Leather album with about 120 images, a wing folio with 5 prints, and a small image box with the 10 or 12 favorites of the day. Along with an unusual wall portrait of about 20 x 20 inches—in a float frame perhaps—this is everything a bride needs for her home.

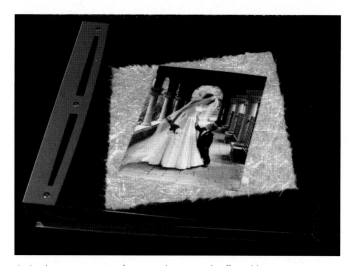

Art Leather imports a trio of gorgeously oversized coffee table presentations: one in grained wood, one in aluminum with a cover window for an image, and the third with a glass cover. All have art-paper pages and limitless design possibilities with loose mats and rice paper layered with the photos. Also imported are two trendy albums from Australia: a magzine-style flush mount and an oversize portfolio-style book with special gatefold panoramas.

often plastic or cheap looking, make it hard to secure the photos in place, or may become frayed and fall apart after a short time. It's the pages themselves and the type of mats or the attachment method that make or break a black-and-white presentation.

Art Leather Manufacturing appears to serve the lion's share of the custom market in the United States, due, in my opinion, mainly to the trendsetting variety and flexible creativity of their products. Additionally, I like the afforded ease and savings of ordering only those page and mat components you need for a single job, rather than being obliged to buy in quantity. The lifetime product guarantee is a nice benefit.

Art Leather is also my standard because I can ultracustomize the cover material and color with a wide choice of sizes, imprints, imprint color, cutouts for a cover print, silk lining color, page color, edging color, mats with or without gold pin lines, black pages for collaging, and double page panoramas. The Onyx album group—with all-black engraving, split-leather cover options, rice paper cover liners, page edges, and unadorned mats—directly addresses the black-and-white photographer's need for minimalist fine-art gallery-style presentations. The Powder White series products also work well. The covers are the most durable I've found, and the cleanable pages are strong but not so heavy that a book of 100 prints is hard to lift. The flat, open channel that holds pages in place allows the addition of one or two extra pages, if the design changes after you've ordered the spine

size. Clients really appreciate the fun of choosing options.

Incidentally, at national competitions I've noticed that the majority of award-winning albums at this time come from Art Leather; are black, dark-colored or white; and contain 100 or more images arranged in storybook style. Only a few really unusual, smaller, trendsetting books are among the awardees, but their number is growing.

The look of the Art Z album line of Olson Designs is sheer minimalist photojournalism. Space for a 3 x 3-inch print is indented in the fine leather cover. Textured art paper pages have debossed opening combinations that favor standard-size 35mm work but are by no means incompatible with 120mm. Openings are just on one side of the page to increase the appearance of portfolio presentation; we've nevertheless assembled pages back to back in order to change the look. Albums are made in two capacities, the smaller of which is quite suited to an iconic coverage of forty to fifty favorite images, the larger double that. Matching boxes and carrying cases complete the ensemble.

Renaissance is another company whose product finds an honored place in our collection. I especially like the cover with Italian-style tooling. The pages are luxuriously thick—with edge gilding—and come in several colors with matching mats. You must conform to the exact page count for the book to work properly. Pages fit into set channel sections, which enable them to stack very evenly and fold flat. Overall, a finished Renaissance album weighs rather a bit more than others, but the look is very well suited to black and white alone, or in combination with color. There's also a new line of magazine-style Renaissance books.

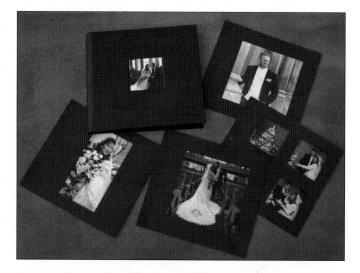

There's real beauty in the smaller intimacy of the Art Z albums, which have proved to be the forerunner of even more avant-garde products that offer wallet- and contact-print-sized openings.

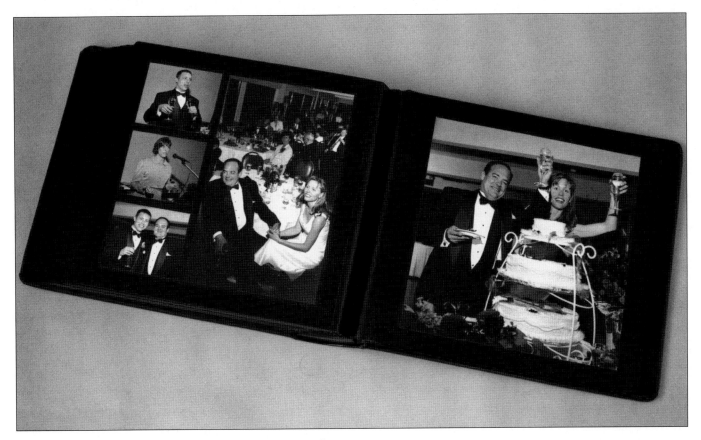

Our international merit award-winning sample is mounted as a mosaic collage, which was inspired by advertising design. All prints are cut in squares or rectangles, and irregardless of individual size or quantity, are fitted together on one page into a 10 x 10-inch total area.

Albums by Jorgensen of Australia and the Maxima Nouveau collection have fun pages that look like a cross between a rock video and an avant-garde fashion magazine. The precut mats have openings in interesting diagonal and mosaic arrangements. A good many mat openings are quite small—a style favoring candids or series photos and wedding photojournalism. The basic format idea is a great way to break out of the traditional mold into a lively presentation.

Capri, Ideal, Leather Craftsmen, and Zookbinders are New York–based firms that have long specialized in top-quality bound-leather books with prints permanently mounted in place. The huge advantage of books bound by the manufacturer is that when the package arrives, you have nothing to do but deliver the art and collect from the happy client. If you value time as money, you'll see how you can be financially ahead.

Flush mounting is more popular on the East Coast, but I'm fascinated with the new ways to bend this no-mat style to my own designs. I used to feel that an all 10 x 10 album was very boring. Full or $^3/_4$ panorama pages are shaped differently at the center so only a tiny break separates the two halves of the image. They cost more, but will not crack or crease over time. Capri's new artificial cover material actually feels better than many leathers.

In addition to a large inventory of standard mattings, any of the custom binders can mount a page with a smaller image inset directly into a larger one. Ask for the individual supplier's standard sizing for circles and ovals so as not to incur a template charge. Squares and rectangles can generally be cut to any size and proportion without extra cost. There are also clever montage pages, very useful for storytelling black-and-white work. All albums mounted by the manufacturer require that the surface of the prints be perfect and the composition exact. There's no opportunity for straightening or centering as there is with a window mat, which allows the freedom of making small last-minute adjustments in-house.

～ DIGITAL BOOKS ～

Digital books proliferate at trade shows but remain in their design infancy. Since imagery is scanned, each face can be retouched to perfection—though very costly if outsourced, and time- and labor-consuming in house.

The easiest way to begin making digital or magazine-style albums is to purchase a plug-in program that has set page designs into which you drag and drop your own images. Most of the programs I've seen rely heavily on graphics, and only time will tell if they're artistically viable or just a passing fad. At this time, the majority of brides and studios I've surveyed say most magazine-style albums don't have a sufficiently classic feel; they look like any other nice but commercially available coffee table book.

We manipulate and montage images in Photoshop 7 and then output to our inkjet printer or prepare for photo printing. Although time consuming, computer production eliminates waiting on lab production and fighting quality concerns, as well as substituting for many postproduction steps, such as enhancement of wrinkles, double chins, bald heads, and the like. It's a natural part of the method to eliminate or change backgrounds, remove shadows, open eyes, and add and subtract people to and from groups. We're talking about an entirely new product—a service in which the whole set of images is digitally corrected to perfection.

Printing images for yourself on an inkjet offers little or no time or cost savings, except that you can set your own schedule. Writing to CD or shipping the corrected file over DSL phone line direct to the printer of choice are both quick, easy, and foolproof once concerns of color calibration have been mastered. Quality negative scans are key. Be sure to specify 300 dpi plus the megabyte file size appropriate to the finished print size and the printing device you'll be using. Machines vary tremendously, and the new generation of photographic printers need a fraction of the approximate eighteen megabyte file size required for an 8 x 10 as recently as six months ago. Digital capture bypasses the time-consuming step of film scanning, which for 120mm in the quantity necessary for a wedding book is also prohibitively expensive.

Be sure that extensive facial retouching has been done with Photoshop 7's new tools and hasn't made features look flat and porcelainlike, or puffy and plastic. With inkjet or photographic prints, you still have the choice of flush mounting, traditional matting, or having a library-style bookbinder make up a new, thin coffee table–style presentation. I'm hoping digital albums are glimpses at the way all photos will be done in the near future.

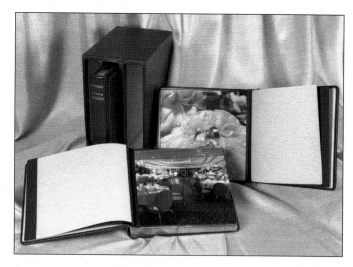

This is a triple-volume set from Capri in a slipcase, with imagery from a stunning Manhattan wedding. By separating the volumes into one for portraiture, one for the ceremony, and one for the celebration, I am able to collect a large number of images, say 100 to 120, yet make them read with ease and spirit.

If the photographer can't do manipulations in-house, digital book manufacturers offer a menu of effects, such as handcoloring or softened edges. Sometimes, several images are combined and output together in an elegant montage. My favorite is a panorama background printed very lightly in pastel gray with inset images in full tonal range. Sometimes, unrelated artwork that resembles a color wash or airbrushing forms a new concept in bordering or framing for the images. Albums created with impressive digital technology have a more lithographed or printed-book feel. The pictures themselves, as well as the presentations, are a bold new genre.

～ HANDMADE ALBUMS ～

An exquisite collection exhibited at the Woman's Museum in Washington, D.C., was my introduction to handmade albums. One book was contained in a walnut shell, another folded like origami. Each was perfection. You must consider, however, how sturdy a handmade wedding album will be. Beautifully crafted paper and silk books are available, but for many clients, they're too fragile or, after just a few viewings, begin to show the stains of finger oils.

While certainly requiring far more care than a hardy Art Leather volume, our handmade books will withstand repeated, though gentle, handling. Using just the right papers, glues, fasteners, and hinges, handcolored black-and-white images, those that are sepia tone, or those colored with watercolor, and Polaroid transfer art all look good in custom albums.

Contemporary Collaging and Magazine Techniques

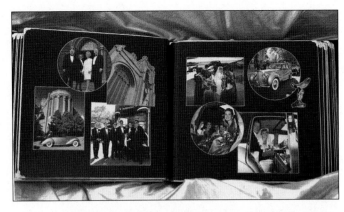

Collaging turns groups of going-away photos into a fun, action-packed series. No one would purchase a print of a Rolls-Royce radiator ornament alone, but as a cutout (on the right-hand page above), it adds just the right touch.

At first, I arranged standard size photos in neat, straight rows, and I assumed the entire book had to be collaged to preserve artistic unity. The result of full collaging quickly proved to be too much like a scrapbook. Past Kodak portrait brochures in which parts of images protruded over the edges of the frames soon inspired me to design irregular, overlapping cuts.

When photographing, make many more images—and make them in series—so that you'll have sufficient material with which to show different aspects of the action that will make for a great collage. Always photograph the wedding ceremony venue, both interior and exterior, the front of the reception venue, and the decorated dining room. Move in close for distinctive still lifes, such as the wedding dress waiting on a hanger, balloons fastened to a garden gate, a tray of bubbling champagne glasses, the cake ornament, a hand-embroidered ring pillow. This is the scene-setting material you'll use to add backgrounds and little accents appropriate to the collage style that will recall the ambience of the day. A collaged page of five or six bridesmaids in much the same pose, for example, is usually a must-have for every bride.

Many newer contemporary album styles have miniature precut mat options with openings for wallet-size or contact prints. Mosaic or "puzzle"-style mounting from the bound-book manufacturers are another answer when grouping a larger number of images together on one page. These presentations have led to digitally montaged magazine pages.

I assemble the majority of pages with precut mats, while collaging only those photos with either sequential subject matter or party-candid style. The most popular collaging style uses prints in irregular shapes, and other appliqué techniques, to create accents that don't overpower traditional elegance but promote a subtle layering of meaning. My newest collage style doesn't let prints overlap but indents them with an 1/8-inch margin in between.

Among more esoteric techniques are cut-and-paste pop-up books in which images unfold or protrude from the page. There

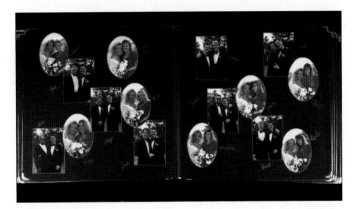

Another way to group a series effectively is to print the images wallet size, scatter them irregularly across a spread, and have the attendants sign their names beside their photos.

Mosaic collage, which is best suited to black-and-white photography, is formed from square-cut images laid together like tiles.

is definitely a market, albeit limited, for this style. The taste of black-and-white clients, however, will generally not mesh with what is to them an unnecessarily complicated or even juvenile-seeming look. The same is true of the rash of new concepts in

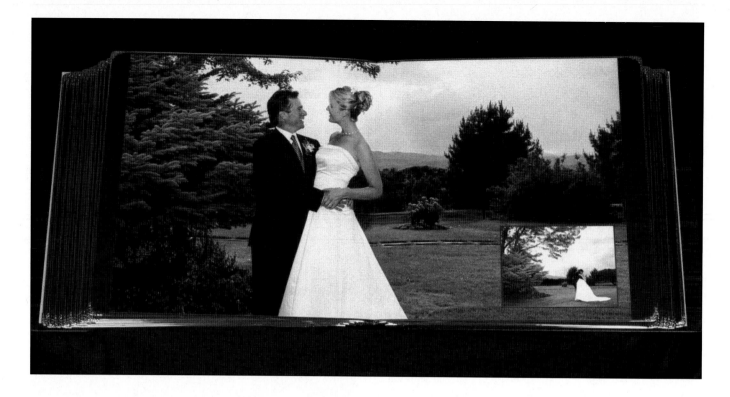

which each album page is a digital montage of several images and lots of graphics. Another style offers manipulated inkjet prints, which are combined with colorful airbrushing. The first has a very commercial, textbook appearance, and the latter doesn't look like photography at all.

I have collected confetti, programs, scrolls, napkins, matchbooks, place cards, and even chocolate boxes for albums. A real wedding invitation, not a photo of it, is a sure winner, as are bits of lace from the dress or ribbons from the bouquet. Three-dimensional accessories, such as strings of tiny pearls or metallic rope, must be glued into the album gutter so that they don't scratch the next page. Flat accessories, such as invitations and napkins, must be lacquered or, better yet, laminated with PrintGuard from the Seal Company. Usually confetti or sequins must be individually glued down with super glue or epoxy after everything else is done. Keep in mind that there's a risk of losing the "classic look" if you add too much nonphotographic material to the album.

Handmade papers, particularly those with flower petals embedded in them, add a popular and delicate touch. If used as an underlay, pick smoother papers, because texture will show through the print face. Torn edges made by gently pulling the paper fibers apart is the most authentic art look. Overlay mats highlight an image; they can be placed squarely for a tailored layer or at an angle for a rock'n'roll effect. Remember that handmade paper isn't necessarily archival; I lacquer it front and back so that

A hole can be cut directly out of a large print with a graphics knife or circle die cutter, and the resulting opening inset with a companion image.

adhesive won't penetrate and potentially cause discoloration. Lacquer also puts a barrier between the photos and plant fibers or flower petals in the paper.

A well-planned layout is the essential foundation for keeping a collage album from being overdone. I do much more than arrange images in chronological order. Facing pages must match in background, lighting, and subject matter. If you're trying irregular cuts, cut all photos on one page in a similar manner, or use just one irregular image for impact among a group of standard cuts. Pick only one or two collage or appliqué themes for any given album.

My approach, whether for handmade collage or digital montage, is to design photographs like the flow of a musical composition, with theme and variations, crescendos and quiet passages, all leading to a grand finale. Most of my clients order over 100 prints for their books, but regardless of image quantity, I advocate making an album map either manually or by computer to visually record the overall design flow and show it to the client at a glance.

For best collaging results, album pages must be sturdy but sufficiently lightweight that they can be put directly in the dry mount or laminating press. Art Leather products from both the traditional and Euro collections are well suited, because they can

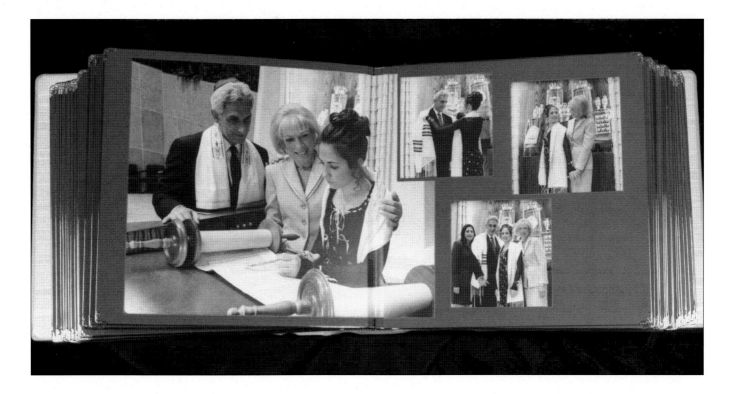

Panoramas are such a great invention, but sometimes the chosen image doesn't fit the required 2:1 horizontal proportion to fill the entire double-page spread. The solution is a collaged panorama: an odd-size enlargement falls across the center fold with several small prints inset to fill the remaining space. Try this feature for any series of images with an 11 x 14 as the centerpiece.

be customized in so many ways and come in such a wealth of sizes, shapes, and colors. Renaissance albums, with their thick pages and their blank mats, are another favorite option for the "tiled mosaic." We don't put Renaissance pages in the press, only the mats; all the art-paper pages by the various manufacturers can, in general, be pressed.

The most important adhesives for making clean, flawless collages are 3M products called Vac-u-Mount and PMA (positionable mounting adhesive). Standard procedure is for prints to be laminated in a Seal heat/vacuum press with 3M Vac-u-Mount for three minutes at 175° F, because heat and pressure combined set the adhesive a bit more firmly. If you don't have a vacuum press, use a mechanical press and substitute Spray 77 or Photo-Mount. PMA can be substituted for all collaging applications if no press is available.

Color prints are cross-pattern sprayed with Lacquer-Mat brand Pearl that's more durable than the lacquer finish offered by most labs. Black-and-white prints are not lacquered at all for fear of yellowing, yet I have never had any prints become marred in

ordinary use. Unseal is the unrivaled liquid to clean adhesive and fingerprints off the finished product without harming the art, whether prints are lacquered or not. Experiment with adhesives to develop a method that allows you to offer the guarantee that clients expect.

I prefer black-and-white album photographs mounted without gold borders or other ornamentation. For color books, I have tried outlining with auto pinstriping tape and Mylar underlays, which did not stick too well and were hard to cut evenly. The quickest and easiest outline option is enamel or gel pen, which

My interest in handmade papers and how to use them in albums came from my interpretation of paper use in Asia. This example shows both underlaying of two kinds of paper, as well as an accent overlay cut from a standard Art Leather mat.

STEP-BY-STEP COLLAGE INTRUCTIONS

Collaging is no substitute for fine photography, but combined with excellent camera work, it will open a new, creative doorway for your feeling and imagination, not to mention greater profits.

INTRODUCTORY PAGE
(USING INVITATION AND PHOTO)

❖ Lacquer the invitation or laminate it in vinyl. Most invitations will survive the 225° F heat necessary to melt laminate, but ask for a second invitation just in case.

❖ Choose an accessory such as ribbon or lace from the dress. To prevent unraveling, coat the cut edges with Dritz Fray Check (available in fabric stores).

❖ If the invitation isn't too big, add a photo, such as one of the rings or of the church exterior. Sometimes the invitation envelope is so distinctive it should be included.

❖ Coat the backs of the invitation, ribbons, photo, etc., with adhesive; stick them all down together; press with heat.

❖ Outline as needed with gold or silver enamel or gel pen.

IRREGULAR COLLAGE CUTS

❖ Using a mat template, draw the regular part of the mat opening shape on the back of a lacquered print.

❖ Cut the print with sharp, short scissors.

❖ Blacken the edges of the print with marker (do this from the back side of the print to avoid stray marks on the front); don't do this when using white album pages.

❖ Spray the back of the print with adhesive according to the manufacturer's directions and arrange on the page. If using multiple prints, put them all down at once and note that overlapping won't harm the prints.

❖ If you're using a heat/vacuum press, start with a setting of three minutes at 175° F. Time and temperature are important but not critical. The heat helps to set the adhesive.

❖ Outline as needed with gold or silver enamel or gel pen.

FULL PANORAMA OR HALF-PANORAMA COLLAGE

❖ Pick one main image and several supporting images to collage, more if it's to be a double-page spread. A full panorama may have an opening with a small photo inset.

❖ Lacquer, cut, and blacken the edges (as for Irregular Collage Cuts).

❖ Use a standard panorama insert with PMA adhesive. A panoramic insert won't be harmed in a vacuum press if you prefer to use Vac-u-Mount. Spray 77 and PhotoMount will also work in this situation, but they make it harder to position the image without damaging the print (especially Spray 77, which is a very high-tack adhesive).

❖ Outline images as appropriate with gold or silver enamel or gel pen.

RICE PAPER UNDERLAY AND OVERLAY MAT COLLAGES

❖ Select paper(s) and/or mat(s) to be used with a group of images. If paper is to have a torn edge, crease it and let a few drops of water run down the crease to weaken the fibers. Wait a moment, then lay paper out flat, and gently pull apart at the dampened crease.

❖ I prefer to lacquer both sides of handmade paper for longevity. Remember that many of these imported papers may not be archival and could eventually harm photos.

❖ Affix in the album with lamination, spray glue, photo corners, or ATG tape for the specific look you want.

must be applied after mounting because the enamel may melt with heat. I find that silver pen looks very good with black-and-white wedding photography.

Another artistic avenue I've tried is writing directly on the album pages. After only two books using sayings or poetry in them, I discovered that in most cases the writing is too distracting, and if the words are not exactly those chosen by the bride, the entire effect may be inappropriate. Emotionally charged poetry chosen by the photographer does produce impact in competition, but may very well be regional or individual in appeal, with most clients finding it cloying. Printing on a tissue or parchment interleaf is a good, but damageable, option. Writing that *does* work is having the entire wedding party autograph their portraits or write wedding wishes right on the album pages. If you have the talent to draw, tiny flowers, hearts, stars, or grasses make nice accents that may appeal to some clients.

The Portfolio Box

Historically, a photographic portfolio was a cleverly handcrafted case or box containing a mounted series of related images.

The first portraitist I know of who produced portfolio boxes was Julia Margaret Cameron—the wealthy hobbyist who photographed famous figures from the worlds of art and literature, as well as friends and children, sometimes in allegorical dress. Ansel Adams taught conservation to several generations and convinced Americans to preserve natural wonders; his portfolios are now considered icons of landscape photography. Most famous photographers, as well as the talented but not so famous, have produced at least one portfolio collection.

Portrait and wedding photographers should draw on the philosophy of the fine-art presentation box to display just a few specially meaningful photographs, whether from one event, a portrait collection, or perhaps to start a growing family history. It's pure coffee table art. Personal-imagination portraiture or family groups are well suited to box presentation, because the subject can easily bear rearrangement of sequence when the inevitable reshuffling occurs.

I show two complete wedding box samples, one in black-and-white photojournalist style, the other a more traditional event in a combination of black-and-white and color prints. I have certainly sold a number of wedding boxes, but mostly, these clients selected a relatively small number of favorite, iconic images. Sequencing can become an issue in a wedding box portfolio when the story line is compromised if a cake-cutting photo pops out of the box first. In most cases, therefore, the box does not satisfy the need for an album showcasing the full, step-by-step history of the wedding day.

I believe the portfolio presentation is most effective as a companion piece to the album—a little jewel box of the most special memories and an alternative way to help clients use photography as fine art in their homes. Sometimes, only one or two images from the wedding are combined with portraits from the past—the old homestead, a photograph from a special trip, and so forth. Personal-imagination portraiture is one of the best genres for this presentation. I exhibit a series of a gentleman in a historical Old West gunslinger outfit, a pregnant lady, a family group, a motorcycle fantasy portrait, a '50s-style Hollywood glamour study, and the growth of a child.

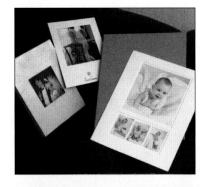

Archival suppliers, like Light Impressions, have long been manufacturing portfolios and boxes for museums and collectors. My favorite portfolio is a brushed-aluminum box from Pina Zangaro, with a Plexiglas covered window opening on the cover for one image.

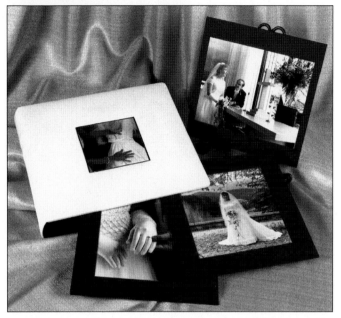

Art Leather, among others, has several ready-made portfolio products. The exteriors look just like a traditional album. Custom bookbinders can make up one-of-a-kind items.

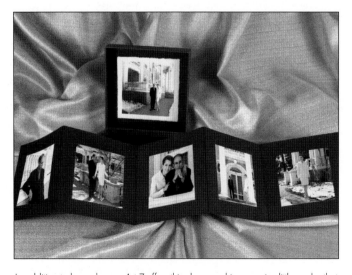

In addition to larger boxes, Art Z offers this clever and inexpensive little cache that easily holds ten accordion-folded archival paper cards for five images each.

Artistic Framing Possibilities

The majority of large prints should leave your studio in frames. Obviously, that's not the status quo for most photographers. Art galleries, however, never consider selling an important oil painting or watercolor without framing. Your client perfectly understands the requirement and expects to purchase frames, at least for wall portraits, although less frequently for smaller gifts. You do your client and yourself a disservice if you ignore this last step in the postproduction process.

Large portraits and bridal formals have been traditionally laminated to canvas and put on stretcher bars like oil paintings. Most studios seem to blindly follow this worldwide precedent of framing without matting, even for medium-size prints that aren't put onto canvas and for desk-size gifts. Until recently, frame manufacturers offered predominantly photo-finishing sizes, but now every hardware, houseware, and even drug store has a designer photo frame department—many with literally hundreds of products in all shapes and descriptions. Studios must therefore make a big effort to discover new presentation products and styles to retain, much less gain, market share in framing.

A finished presentation has a much higher perceived value than that of a loose print backed with cheap cardboard. Ensure totally finished presentation by including not only a basic level of framing service in your package but also the opportunity to buy up, with more costly imported moldings and specialty matting design. The obvious benefit is that your clients won't have to find someone else to help with the difficult process of completing the project. Instead, they can go right home and hang their beautiful portrait on the wall. Their enjoyment begins immediately.

~ SIGNED IMAGES ~

Offering a fashionable sign-in board, similar to those popular at bar mitzvahs, is an easy way to add a wall portrait to the wedding package. It could well be the couple's first piece of art in their new home. Enlarge the favorite engagement photo (from 11 x 14 to 16 x 16 inches if the image is square), and custom frame it with a large enough mat to accommodate all the guests' signatures. Sizing may have to wait until the last moment when the bride knows how many people will attend. A 24 x 30-inch mat works well for 225 to 250 guests; that's approximately a five- to six-inch-wide mat. A double mat looks far more luxurious than a single one.

The chosen mat should be pale, though not necessarily white, with a slight texture, a mottled tone, or a pale colored thread in the surface to help resist finger smudges. Signatures are most commonly in black, but dark blue, wine, dark green, and brown are also good choices. Silver signatures will appear very subtle on a pale mat. A charcoal gray or black mat gives a very high-contrast effect with gold, silver, or white signatures. Art Leather now imports a charming book with art paper pages eminently suited for signatures interspersed with eight matted previews.

The overall result of a signed portrait is an excellent memento, because many guests tend to write wedding wishes, not just their names, and they write more legibly than when they sign a register. The graphic quality of handwriting works exceptionally well in conjunction with a black-and-white or handcolored portrait.

~ WALL PORTRAITS ~

Photographic art for the wall should be custom sized to suit the composition. Matting should resemble what's appropriate for a watercolor or serigraph. Just like the album, framing provides the chance to create the feel of three dimensions.

Many times, enlargements purchased for parents are a conventional full-length pose of the couple in 11 x 14- or 16 x 20-inch size. We offer several series of metal or less costly wood frames included with wall portraits but generally sell up, to a finer quality custom molding, a silk or linen mat, and a matching carved fillet for accent. This superior presentation is never short of spectacular for color prints. Generally, more tailored, simple moldings will do justice to black-and-white prints, but sometimes we choose a very ornate silver one.

Since most matting and framing suitable for color won't complement black-and-white wedding photography, try drawing inspiration from traditional fine-art gallery presentation and be prepared with a variety of designer mattings and presentations that emphasize the medium's derivation from the worlds of art, high fashion, and advertising.

Fine interior design is another a good source for ideas. A graphic, modern minimalist style with plain white or gray matting is never wrong. High-tech metals come in a wide variety of

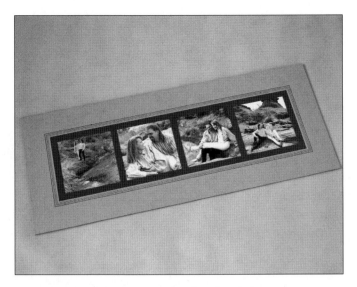

Precut mats with multiple openings, such as those from Crescent, are a great way to use a series of small portraits or favorite wedding day scenes. Custom framing is necessary due to the size, therefore subtly influencing your client to have you complete the presentation in-house.

float elevates the print about ⅛ inch off the underlay with archival foam board, all surrounded by a larger mat with the opening cut to let the three dimensionality of layers show as discrete depths.

~ FRAMING RESOURCES ~

Given the thousands of possible moldings and the peculiar needs of photography, it's hard to design custom framing without some considerable knowledge of materials and processes. Ask a wholesaler, such as Larson-Juhl, for assistance if you'd like to start a simple custom framing program with a limited number of styles that work for your type of photography. They will explain the variables, what parts of the process you may outsource, and most importantly, show you how to price easily and clearly.

The photographer wanting to offer superior framing without opening a frame shop can send a print to Gross National Product (GNP) and let their technicians create the entire presentation. The idea is to spend less of your time and yet provide a guaranteed product. If you prefer to select exact sizes, matting and molding yourself, GNP will craft the package to your specification. Should delivery time be very short, or if you prefer to have extra control by dealing locally, make a similar wholesale arrangement with a custom frame shop where the staff is knowledgeable about the specific concerns and differences in approach photography requires.

shapes and colors. Simple polished wood moldings with interesting profiles or antique patina-like finishes can be found with a little searching. They're expensive, and look even more costly than they are. Black-and-white clients are very particular about presentation and faithful in their buying habits.

Usually I'll cut a double mat, because it looks more finished than a single one. While I really enjoy white and cream, or a combination of both, neutrals are not the only suitable tones. A colored frame plus an undermat of the same color is incredible on black-and-white children's portraits. There are lots of mat boards with small colored threads or speckles in them, not to mention leather looks and other textures. Black core mats, and black-faced mats with V-groves cut into them make a powerful graphic presentation. If you don't want to bother with custom cut mats, Art Leather's Gross National Product division offers square-shaped ready-made frames that will also accept a standard wedding album mat, many with multi-openings.

You'll find that you'll sell smaller print sizes in black and white, sometimes so small as to be unheard of in the world of color weddings. Recently, I saw a series of five 35mm contact prints surrounded, or maybe engulfed is a better word, by a five-inch mat. It looked wonderful! It makes good sense to charge a bit extra for small framing, to cover design time. Sometimes, I mount the image showing its edges and about ½ inch of the mount board visible under two or more layers of window mat. A different kind of

Exposed, torn print edges—a style borrowed from watercolor and printmaking—is a distinctively new and exciting concept when applied to photography. The layered look, which involves floating the image in a shadowbox effect, will increase a feeling of depth.

The "sign in" folio is typically an 8 x 10- or 10 x 10-inch image matted in one section, while the other two or three sections are left blank for signatures. Any manufacturer's folio with blank mats will work; Art Leather will attach blank album-page material by special order. This presentation is very portable and user friendly. When not on display, it folds up and slips in a bookcase.

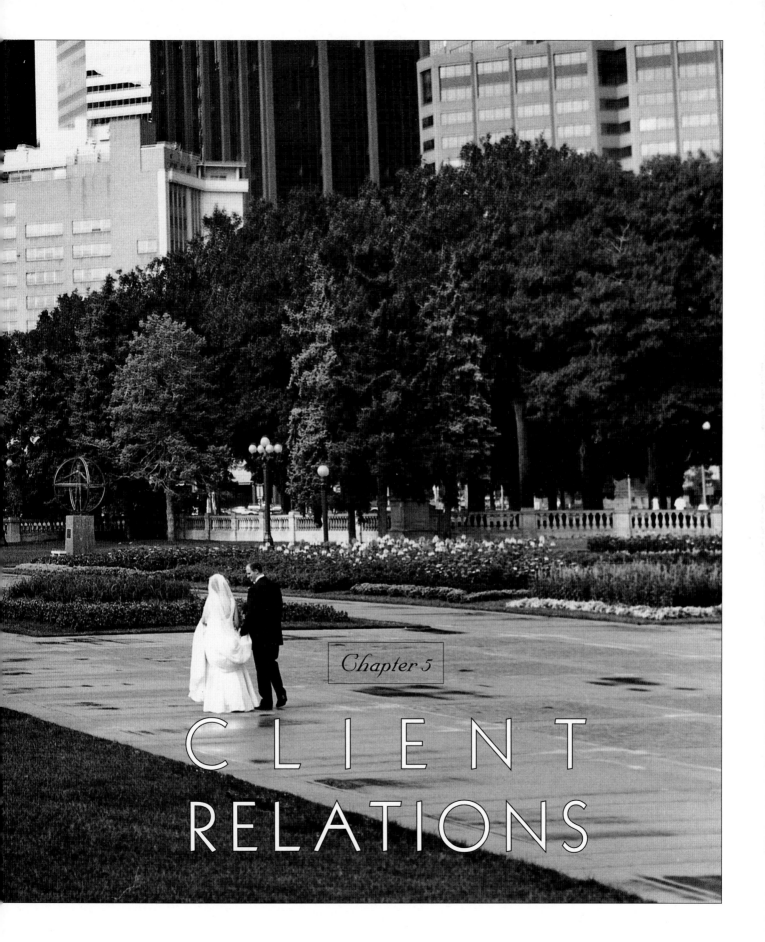

Chapter 5

CLIENT
RELATIONS

Convincing and Serving
the Client

The process of dealing with clients has two parts: attracting them and telling their story. Wedding photographers know how to speak with artistic imagery. But, did you realize that your bride and groom have something to say, too? You may be technically and mentally ready to tell one story, but your subjects may have something different in mind—or may not be ready to cooperate at all. You're not free to impose your perceptions as though your subjects were unconscious. Avoid the still-life approach in which people, regardless of personality, are placed like things against a given background scenario. The creative process of recording memories must be varied in response to the individuals.

To get clients to listen and respond to the art and quality features you want to share with them, you must first discover and address their buying agenda concerns. People buy only if they feel you are on the same wavelength and have given your total concern to whatever issue is important to them. People buy from those they trust, and they trust others who are like themselves.

By being responsive behind the camera, you'll begin to understand and succeed with the sales and customer service part of the creative people process, which actually comes first before the photography. Clients need to convince themselves of the benefit to them of your service. The benefit I sell is that people simply look better in front of my camera than they do in front of another's, probably because I rarely perceive anything negative in people's appearance. However, in order to make sales, it's my responsibility and that of my staff to convince the bride that I can really do what I say and that she will look stunningly memorable.

Body language is a major indicator of a client's personality, buying concerns, comfort level in your shop, and readiness to purchase. Observing and mirroring their posture and hand gestures are excellent ways of starting a nonverbal communication with your clients. Of course, all clients are verbal to some extent, because they want to talk about themselves. Direct, frequent eye contact emphasizes your honesty, concern, and personal magnetism as an artist.

The initial challenge is to get prospective clients to come to see you at all, because they have sticker shock in overdrive. Comprehensive service directories in which you also have published some editorial images seem to build better response from new clients who've never heard your name than do bridal magazines full of expensive, slick advertising. Web sites do much the same thing, offering a glimpse of you and your style. Consumer guides without advertising are second in business value only to a personal referral. I started my business as an independent subcontractor within a bridal shop that sold dresses, tuxedos, flowers, catering, and invitations. My very presence in the shop was enough credential for people to ask me about price and services right from the very first day.

Across the United States, there's an excess of facilities and services available. You must continually justify your price in the face of a majority of businesses willing to sell for less. Insulate yourself against cutthroat competition by developing an excellent product—an artistic edge—and back it up with service that makes clients send their friends to you.

If your clients are like mine, they both fear and hate being *sold* anything, yet they're happy to *buy* on their own terms. I find it a great relaxer to take the mystery out of the sales presentation by explaining exactly what we're going to do during our meeting.

THE DANGER OF LACK OF INVOLVEMENT

For many years, I thought I risked technical failure if I was without film for emergencies or unexpected moments. Now, I know that the far greater danger came from having virtually no contact with my clients prior to the day of the event. If you aren't personally involved in the sales and discovery presentations, how can you possibly understand what is important to your clients and, thus, do the job that's right for them?

By talking about the details of the event you help your client define her perceived needs and problems.

You must get brides or mothers to admit their concerns, needs, and issues before you can address them and advance the sales process. I use the word *admit* because most clients won't, or don't know how to, tell you this freely. Once concerns are recognized, you can proceed to phase two: the evaluation of options. At this time, you help the client learn about her own criteria for decision making. You'll probably be telling anecdotes from past weddings and be asking lots of questions dealing indirectly with quality and service. The last step is the resolution of concerns—or how you prove you're worth your fee. You must show samples that relate to her individual needs. Each quality feature that's important to you must be translated into a benefit that the bride recognizes.

～ WHY PEOPLE BUY ～

The latent guilt associated with buying just for "selfish" reasons makes everyone reluctant to buy out of pleasure. If you have a very good product that can be shown to fill a current need and prevent future problems, your sales potential will soar.

Probably the most important buying motivator for the wedding client is fear. Clients must believe the last place they want to risk their money is with cheap wedding photography, because that will mean risking the value of the total investment in the wedding and the memories of the day. The value is in the memories. I call my package plans "collections," implying that value. The total expenditure means nothing without the memories.

Additionally, some experts say that it's as much as fifteen times easier to close a sale to a referred client. The public needs and wants referrals just as badly as the service providers do. The more times prospective clients hear your name from sources that are not advertisements, the farther along in the decision-making process they will be the first time they visit your studio.

～ WALKING CLIENTS THROUGH IT ～

The stress of a wedding tends to bring out the best in nice people and make the questionable ones show their true colors. You know instinctively that you'll work well with some people, but you need to be able to get a few of the difficult ones on your side and turn them into good clients, too. One of the best ways to counteract objections is to not sell anything at all. I let the bridal couple tell me the level of service they want to purchase. Naturally, they don't know how to do that, so I ask them to fill in the blanks on our suggested time chart according to their own plans. When added up, the chart will tell them how much time they must buy.

There's a similar form for estimating gifts attached to price lists for our menu of family albums and loose prints. Everybody loves to spend money on gifts, and as they use this interactive list, they'll discover for themselves not only what they actually want to purchase but also how to use our buying incentives to their benefit. If you follow these ideas, suddenly clients will start judging other studios they visit based on the criteria *you* have set up for them.

～ SHOWING APPRECIATION ～

The only way I know to keep clients happy—in addition, of course, to producing the correct product on time—is to say "thank you" as many different times and ways as possible. Send a note when a client books. Call several times during the engagement just to talk. Provide party favors, maybe with your logo on them, for a shower. Deliver a note or tiny gift so that the bride gets it at the rehearsal dinner. Pocket time schedules for the wedding party and families work great, especially if pasted onto an engagement photo.

Thank everyone in sight, by name if you can, as you leave the reception. Call the bride's mother a week later to see if she has recovered. Call to remind the bride of pricing incentives just before the time window will expire. Call when there are questions of any kind on an order. Write "Thank You" large on the receipt. Call with updates during the postproduction period. Call to say, "Thank you for letting us create such a beautiful album." When the client comes in to pick up the album, I try to be there—not to collect the last payment (an employee should do that)—but to chat and help carry bags to the car. If several days, weeks, or months later a problem should be discovered, I take charge and say, "Thank you for calling. We guarantee everything. I'm sure we can fix any concern you have."

In over thirty years, I've been blessed with thousands of fine people as wedding clients—almost four thousand couples! I have no celebrity clients and only a few very wealthy ones. Mostly, my brides have selected my services based on perceived artistic qualities. That fact alone accounts for why my clients may seem more cooperative than average. They really want what I do! Since sales trainers preach that customers buy for their own reasons, it's most interesting that mine buy for features and benefits. Of the fifty to sixty weddings my studio serves a year now, I do 80 to 100 percent of the photography, and only about a half dozen events take place when I'm away and can play no role whatsoever.

Reassuring Hesitant Brides

Your client will come and go many times from your studio over a period of months before her orders are complete, so she'll have ample opportunity to judge how well you and your staff treat her over the long run.

If you make her not only look good but also feel good about her purchases, you'll be assured of her recommendation. Her words will bear more weight than any advertising you can buy or any publicity you may reap from awards.

The public's perceptions of wedding and event photography are that it's expensive, inconvenient, unresponsive, time consuming, and generally no fun. People don't enjoy having their picture made because they . . . :

* don't like the way they look in comparison to advertising or Hollywood ideals.
* aren't used to seeing themselves posed or in formal attire.
* are uncomfortable with posing and personal attention.
* are accustomed to a mirror image of their faces.
* find formal group posing boring and tiring.
* dislike delaying the start of the reception.
* don't get to enjoy the party because of long photo sessions.
* must pose on the photographer's schedule, not theirs; the event seems staged for the camera.

Everyone wants to . . . :

* feel instantly relaxed and look good.
* have confidence in the photographer's ability, manner, and appearance.
* be shown concern for their appearance and receive personal attention every step of the way.
* have their specific needs respected.
* have fun posing for pictures and have it done quickly.

Brides decide if they're comfortable with you within the first few seconds of entering your studio. It's the same with your telephone manner; you have just a few seconds to prove your friendliness and enthusiasm about meeting your unseen caller's needs. It's a personality contest. Congratulate the bride immediately upon hearing about her upcoming wedding. Mothers like to be congratulated too when they spill the "big news."

Speakers at professional photographers' conventions previously urged a phone sales scenario that tried to get clients into the studio by avoiding price discussions entirely. Fortunately, that day has passed! You have to ask a bride all the right questions, and be sure you don't get sidetracked from the issues that are uppermost in *her* mind by the technical information you want to give. Higher prices confidently quoted *do not* discourage the type of bride you probably want to be photographing. Once price questions have been settled, it's unlikely that price resistance will come up again.

The general public is discouraged by complicated unclear price lists, or no printed price list at all. Only a handful of arty, expensive photographers report that they don't use a price list. Employees generally find it disconcerting if they can't refer to a price list; they want to be as helpful as possible to clients, to quote costs confidently, and explain value received.

Make sure you and your staff are appropriately dressed. Check out the bridal department in any high-end department store. No one looks sloppy; all sales people are cheery, endlessly enthusiastic, and chatty with helpful hints and suggestions. You must show interest; it is said that some 70 percent of brides will lose interest in you based on even a seeming attitude of indifference toward them.

Brides value attentive treatment, prompt appointments, and concentrated time discussing their agendas, not yours. Any interruptions during consultation can cost you big dollars. Inflexible hours—just as much as inflexible package plans, pricing, and services—make it a challenge for clients to buy from you. Why make it hard for them to give you money? What you want to do is keep your client happy now and forever. Why? Because, it takes five times the sales effort to develop a new customer as it does to keep an old one, and her personal recommendation in the future will bring more clients who will buy more quickly and easily.

~ STUDIO ENVIRONMENT ~

A messy studio, unclean dressing area, or restroom undoubtedly subtract dollars from studio income. Though they may not be meticulous themselves, clients have a funny way of "keeping score" of both your appearance and that of your facility. Add to the atmosphere of a clean, bright sales area with pleasant music and smells. Offer refreshment if appropriate.

~ EASING FEARS ABOUT POSING ~

Listen twice as much as you talk; be extra excited for the bride and her event. Show your understanding of her nervousness about how to pose for the camera. Help her overcome distress with your smiles, communication, laughter, and consideration. It's okay to demonstrate poses and to touch while posing.

The Three Major Challenges

The three major challenges have nothing to do with a camera.

~ CHALLENGE #1 ~

To find out what your job really is well in advance. Don't wait for the wedding coordinator to make a schedule. Your success depends on proper information and goal-setting to meld the results of the florist's, caterer's, and everyone else's efforts. To do this:

* ask questions and more questions.
* take notes about your customer's reaction to style and poses in samples; a pose checklist helps convey what's possible.
* ask the clients why they prefer certain samples over others; perhaps they can bring in tear sheets showing styles they like.
* get a list of who's who; it is your most effective tool for remembering names, understanding family relationships, and helping coordinate with the other services.
* list exact groups wanted, especially if there are divorced relatives, and ask to be introduced to everyone.
* know when to take charge and when to be subordinate, for instance, to the caterer's serving staff.
* keep notes of delays or problems, in case of arguments later.

~ CHALLENGE #2 ~

To fix things without a fuss. People and timing are never perfect, regardless of the size and elaborateness of the event. If plans go awry, your job is to find solutions smoothly. Never take a bride aside and ask her what part of the photos to cut to get back on schedule when delays happen. Vendors are sometimes at odds with each other, or have prima donna instincts. Usually, it's the wedding coordinator's job to keep service personnel in line, but if she or he doesn't, the photographer will suffer most. So, you should:

* be prepared for extreme fluctuations in wedding day tempo.
* keep VIP lists handy.
* plan alternative locations in case of weather or time problems.
* consult with other services in advance.
* make a preliminary site visit to understand space orientation and know the availability of electrical outlets.
* coordinate delivery times with florists and decorators who may be late and slow to set up; hairdressers and makeup artists often underestimate the time required by at least 50 percent, while brides seem both reluctant to get dressed and then eager to get the dress off.

LATE? YOU BET!

Have you listened to colleagues complain about how brides are always late? After meeting as many disasters and near disasters head on as I have, I know it's annoying but hardly insurmountable. I just smile and say to the flustered bride, "Of course you're late! What did you expect? It's a wedding isn't it? You're doing just fine, and we'll make everything work." Then, we all relax and have fun together.

* bring lots of backup gear, especially small, essential parts like connecting cords; equipment failure or even damage to equipment by the client are very real risks.
* expect surprising variations in sizes of people, and also in appearance or dress.
* steal little bits of time at odd intervals if you need to catch up after unforseen delays.
* use an assistant so that you can concentrate on style, technique, and service.
* split duties whenever you can with a second photographer to compress posing time, get a second angle, or do candids while formals are being posed.
* use walkie-talkies or direct-connect telephones to help you communicate with your team.

~ CHALLENGE #3 ~

To make any venue photogenic. Brides may have cathedrals in their minds, but most churches, halls, and floral budgets are not lush. To flatter any venue:

* avoid bulletin boards, exit signs, and ugly backgrounds with creative angles.
* try the back of the church if the front is unattractive.
* practice "photography and furniture moving" by rearranging altar furniture and candles as much as permitted to hide, fill in, and enhance backgrounds.
* move flowers in from the sides of the altar or they won't be seen.
* consider a painted, portable studio background, which may sometimes be the only answer to nighttime, bad weather, or unattractive wallpaper conditions.
* plan techniques to confront circumstances of lighting or placement that you cannot change.

Location, Location, Location

This may be the motto of realtors everywhere, but it's also true for the black-and-white wedding photographer. Helping with places and themes is one of the most important services you can offer.

My clients treat me to some of the most dramatic scenery in the Rocky Mountains. Nature's spectacle helps my work take on the feel of art-gallery quality landscapes. I also photograph frequently at historic mansions. The elegance of years past certainly works even better in black and white than color.

Many smaller churches, however, along with newer giant auditorium-style sanctuaries, halls of fraternal lodges, and even many large hotels are actually very plain and uninteresting photographically unless transformed with floral opulence. A site visit will let you know if you'll be called upon to turn sterility into some degree of warmth and luxury. Check if you can move flowers and candelabra to improve altar decor for any stand-up formal poses. Look for unusual angles that will hide architecturally awkward features. Use natural light to soften and romanticize any background. While excluding anything unattractive, you must nevertheless capture a wide variety of angles and backgrounds of both church and reception hall in order to memorialize the ambience, or provide a visual frame of reference for the action.

If nice backgrounds are scarce at the chosen sites, I suggest making a series of photographs at an entirely different location. I often provde this extra service for free in order to achieve the look I know is needed—if for no other reason than to preserve my artistic reputation as a photographer. Incidentally, a separate sitting is a great way to combat the myriad time constraints clients throw at me.

I've had many brides ask for both traditional and theme portraits on location in contemporary style. This prompted me to develop a list of exciting facilities nearby that are available to the public at little or no charge. I've even arranged a suggested donation schedule with the historical society for photographic use of their properties. If you do this, remember to assure facility directors that the photographs are for personal, not commercial or advertising, uses.

With groups and portraits out of the way, I have far more freedom to work photojournalistically once the wedding starts. Sometimes, I even stretch the coverage to an extra day to be able to provide lush, interesting backgrounds. For me this concept is no strain at all, because I already include special location portraits in my packages.

Seize every opportunity to include the full impact of place in the composition of group portraiture. The mountains and ribbonlike lake (left) are emphasized by a normal lens with a camera position on a two-step ladder. Small figures against towering urban skylines (above) are always popular, here with the added drama of a recent rain shower.

LOCATION DISAPPOINTMENT

It's hard to be flexible when events conspire to challenge my search for extraordinary ambience. Recently, I arrived to work in Vail, Colorado, during prime ski season. I was inspired by the possibilities for an environmental portrait of the couple in the beautiful town, but the bride abruptly changed her mind and asked for separate prewedding candids followed by separate formals. When I arrived extra early at the marvelous Sonnenalp Resort, plans had changed once again. Photos wouldn't start for two hours. Poses outside in the sparkling snow and quaint alpine atmosphere were totally eliminated. I was forced to improvise backgrounds in and around hotel guests, create lighting where there was none, and trip over the florist. The equipment also had to be moved in the freezing dark and snow across the street to the church, where a standing-room-only situation presented the next set of challenges. However, while the location turned out to be very different than envisioned, flexibility and alternative thinking won the day for the happy client.

When photographing elegant reception décor make sure you take an interesting angle showing dimension and use a tripod for a long exposure to provide good depth of field in low-light conditions. It's okay to include guests. Florists and caterers will enjoy having such photos in their portfolios (and the courtesy of giving them these free images often results in their referring your services to others).

Pricing Considerations

Do you remember the first time you went to an art gallery and looked at the pricing? After the initial shock, it should have been immediately obvious that art has no set price. It's all perception. An 11 x 14-inch print by Ansel Adams can easily now cost $20,000. While his prints didn't originally command that price, they were never valued by the square inch. Due to the extensive menu of options and levels of handwork that are part and parcel of fine portraiture, it's not possible to totally eliminate cost variation keyed to size. Black and white is always higher, partly because of custom expense in printing, partly for difficulties in materials usage, and partly for the cachet.

I firmly believe you must charge enough money up front to eliminate concerns about time, number of images, and how many assistants you can bring with you for the given budget. The typically greater investment needed to hire the services of an artist is another factor that raises the status of both parties. Suddenly, you're more likely to get the cooperation you need, and the client is proud to introduce you to everyone. The obvious arguments are that you may scare away clients with too high an opening price or that a high dollar basic contract limits the additional sales.

À la carte and all-inclusive package pricing strategies follow cyclical buying trends. Late in 1999, I began to notice that clients were uncomfortable with the pricing and unrealistically preferred to start with a lower initial price à la carte coverage, even when I pointed out to them that they would spend more than the package price in the end. I was actually losing bids to photographers who offered less quality at higher final pricing but allowed brides to "buy in" at a low figure.

Swallowing my fear that brides buying à la carte would never order enough prints to make albums that would enhance my reputation, I began to offer minimum two-hour digital capture traditional coverage with groups at a very moderate price. Coverage includes no finished prints, and we make sure clients know my personal minimum during primetime—Friday through Sunday, May through October and all holidays.

Currently, à la carte pricing is well accepted, perhaps because clients are much more knowledgeable about actual material costs than in the past and want to see that they're paying a fair price for prints. A la carte encourages the small-event or second-time bride to buy from us, because expenditures can be easily controlled or added to at will. I am unconcerned that since the couple may be older, there may be fewer add-on sales. These clients are always interesting.

Photographers who charge a set fee for their work and then release the negatives enjoy popularity because clients think they'll save a great deal of money by having prints made themselves. The cost-per-print factor is so powerful psychologically that clients just don't think about the extraordinary amounts of problems and time in designing an album, preparing negatives for printing, collating orders for family, and assembling everything accurately and beautifully. Clients expect to pay $5 or $6 at a decent lab for an 8 x 10, so they're reluctant to pay a studio $35 to $50 for that same raw print. Retail pricing is, however, quite acceptable with the added value of retouching heat splotches on faces, cropping for impact, or lacquering for permanence. These are things clients know they cannot accomplish themselves.

Resort weddings happen any day of the week and are more sparsely attended. Total time and materials expenditure on location are, therefore, much lower than other wedding photographers. Images are efficiently presented the same or next day, allowing the placing of the photo order to be part of the total wedding festivities. Since the client leaves the resort, the photographer doesn't risk his or her reputation by furnishing only previews and negatives; clients in this circumstance hire you because you're there, and less for your artistry of presentation.

Personally, I've always found it hard to buy a service à la carte and later find that *everything* is extra. Some time ago, I decided that if the Ritz Carlton could have golf and spa packages, I could offer packages, too. If you choose this pricing method, include value items, such as a framed sign-in board for guests and the engagement portrait sitting. Sell up by offering incentives for ordering gifts in advance. Our most extensive packages include time on two or three days. Other pricing options are traditional, collage, or handmade book styles. And we *never* call them packages—they are *collections*.

A NEW WAY TO PROFIT FROM PREVIEWS

Very few brides order sufficient images to allow the art photographer to create the optimal storyteller album. Often, groups form far too prominent a percentage of the total selections and also of the allotted enlargements. Whether you use film or digital, try an add-on special for extra candids. Either finish previews to match album prints or print up digital files, which because of their casual or editorial subject matter need little special attention. In either case, a larger number of images brings freedom of artistic design that results in showstopper albums.

I add up every last expense, the actual hours on the job multiplied by my photographic hourly rate, transportation costs, preparation, tear down, and all in-house time multiplied by my nonphotographic hourly, plus roughly 10 percent for profit. If you price by this method, you place the emphasis on your time and expertise but consider hard costs as well.

If you love to give things away to clients, don't do it if it means lost revenues. If I give away an extra sitting to add to the wedding collection, this is really a thank you gift from me—that keeps the client involved in my collaboration as well as generating add-on sales. You might say that it's wrong to give away your valuable time, but that's just why I do it: Clients recognize when they're getting a special incentive. If you want to give a dollar discount, don't do it up front when the client thinks you are in a bargaining mode but as an incentive for extra purchases.

∼ PREVIEW PRICING ∼

Many photographers retain previews as studio property and don't use them in the book; this practice eliminates ubiquitous color match problems. However, the client is less likely to be careful with, or prompt in returning, photos that they haven't paid for. To offset costs, you must sell the set on speculation after the main order, on either a sliding scale or incentive basis. It's better to charge in a way that defrays preview costs. This is equally true for studios that use traditional paper proofs and for those that present work on-line or via ProShots or Montage, or buy web space from providers such as Partypics, Pictage, Eventpix, or Lifepics. Logically, I don't need to make a big profit on preview production

and presentation, but I can't lose money either. Refer to the going rate in your area for a technical professional, such as a computer programmer or even a plumber, to help determine a fee to charge for your time for in-house nonphotographic services.

Once your hard and soft costs are covered, here's how you can make money on previews. Including a full set of previews in the collection price defrays your costs and makes profit up front, and you needn't worry about them or in what condition they return to the studio. However, you may find the bride less likely to increase the quantity of images in her show album, because she "has the proof anyway." Charge for website space and preparation. Be aware some photographers report meager sales due to viewing problems or to the fact that clients were satisfied by just looking on the Internet.

With another method, the clients' favorite previews are finished and mounted in the album, carefully matching the enlargements ordered. The balance of the preview set is theirs to keep loose. The photographer can promise the client she gets everything, can contract for payment up front, and yet can offer economical pricing of the album collection because of time and material savings. Of course, the preview set must be very well color-corrected and consistent.

When I use previews, I anticipate the problems of letting my work out of the studio, perhaps for an interval as long as a year or more, and risking unauthorized duplication. No one can police these problems. My postproduction design capabilities are so sophisticated, based partly on the aforementioned add-on preview option, that all clients realize they want and need to pay for what we do, rather than risk their entire investment with a garden-variety album presentation and second-rate prints.

If a sizable dollar figure has been paid up front for the contracted collection, clients subconsciously find less need to violate copyright, or if they do, our profit margin has not yet been greatly affected. If your business plan is to charge only for time and then sell print by print, you must consider your copyright protection options more carefully.

Since many preview sets are "checked out" for a year or more and eventually come back with sizable orders, I am continually reassured that I make my money by pushing the envelope of my art and that someone recognizes it. Recently, a couple ordered their album after a gap of many years and two children. Life had simply gotten in the way. Now they were able to afford the elaborate album they always wanted.

I am simply reporting what I do; and your pricing style will differ greatly according to your services and region. I personally

PRICING DO'S AND DON'TS

The net effect of the PR packet, which usually doesn't include pricing, is that of another recommendation. Especially if you offer as many options as we do, here are the do's and don'ts of price quoting:

❖ Ask questions that make clients reveal their buying reasons.

❖ Don't confuse clients with information they don't care about.

❖ Price fairly, considering the real time you spend on an event, your level of expertise, the expectation of your community, and your actual expenses.

❖ Quote prices confidently. If you encounter price resistance, don't backpedal and try to justify features and benefits.

❖ Provide before and after retouching samples to show visual value.

❖ Keep a quote sheet so that you can document prices and promises for later.

❖ During the sales interview, ask questions that make clients put into words why they react favorably to your service and product. That is the way they convince themselves to buy. You can't do this yourself even with the most clever presentation.

❖ Make your policies clear in advance; be flexible and generous if a problem arises. Use terms that follow PPA and perhaps ASMP guidelines.

❖ Add tax and set a payment schedule with exact due dates.

❖ State an interest charge for an overdue account on your invoice; later on, you can decide to enforce it or not as you see fit.

❖ Use the word *retainer* not *deposit* in your contract. In the United States, a retainer is partial payment against cost of professional services by contract—and by legal definition is not refundable. A deposit toward a product is often refundable by law if the order is canceled within a short period. Check the statutes in your area for the legal ramifications of accepting funds toward a future job.

❖ Reserve no time, start no order without cash commitment. Split orders require split deposits. Present itemized invoices.

❖ Accept credit cards; ask for prompt payment.

❖ Offer premiums and discount incentives for prompt payment. In my experience a 15-percent discount works best.

❖ Don't let scheduled payments slide. Don't give out any work without total payment, unless a signed installment agreement is made in advance. These two instructions are, I feel, of paramount importance. Literally, the only times I have ever lost money were when I didn't enforce payment of retainers on time, or if I let work out of the studio when the client "forgot" to bring a checkbook or credit card.

prefer packages but recognize that menu options, incentives, and minimum orders drive the current buying atmosphere for both portrait and wedding photography. Whatever you do, you owe your client the courtesy of a consistent, clearly printed and worded pricing guide. I print out the price lists and copy them one at a time onto designer paper stock. I hand out only those collections and option menus that best suit the individual client needs. I change the price lists as often as I feel it appropriate to correct or refine the presentation.

Whenever possible, I send a PR packet by mail, so the bride can look it over in advance of the consultation appointment. An 8 ½ x 11-inch die-cut folder in company colors with my logo encloses a list of all the specialty items offered, a résumé, an explanation of my guarantee, comments from past clients, an explanation of the six styles of wedding photography, a copy of our review from the *Denver Weddings* consumer guide, two fill-in-the-blanks worksheets to help clients determine how much time they will really need and how to budget for gift essentials.

A Last Word

I like to compare the relationship of the wedding photographer and the client to that of the composer Sullivan and the librettist Gilbert, whose often stormy collaboration left a heritage of beloved operettas that are considered a whole genre unto themselves.

Gilbert was the very socially correct, traditional man-about-town who couldn't see how or why Sullivan, a volatile artisan, had concerns about being asked repeatedly to mechanically set doggerel to music. They argued over the entire course of their long relationship, Gilbert smugly capitalizing on his successful formula, Sullivan reluctantly turning out music to fit while privately working on his "more serious" classical compositions and all the while complaining of the sameness of what he had to do to make money. Sound familiar? Of course!

Yet Gilbert and Sullivan produced works that are constantly played in repertoire, and their collaboration is the only one of its kind where both their names are inseparably linked as the creators of a genre of theater known to almost everyone. The photographer and client are linked in a similar symbiotic relationship of inspiration, creation, and appreciation of memorable commissioned art.

Wedding photography, particularly with the advent of digital capture, is investment-heavy in equipment, materials, time, and expertise. Therefore, it's lower in profit, unless you sell a tremendous number of weddings or a larger dollar contract per wedding. All photographers sooner or later suffer economic pressures to increase volume and charge higher prices. In the new millennium, big and small studios alike will need every bit of high-tech assistance they can find to stay viable in the marketplace. This refers not only to cameras, lights, capture media, and postproduction, but more importantly in our art-oriented segment of the industry to continued personal growth and skill with both people and images. Black-and-white photography clients will often make buying decisions based on how far you push the envelope of your art into innovation.

To balance high-tech, give "high touch" service. I believe that commissioned art grows out of the rapport you develop with your client; other artists and architects have built on this secret for years. Collaboration defeats cookie-cutter photography. The wedding specialist has the golden chance to shine by extending and preserving the joy of the event. With creativity in postproduction, the whole experience becomes much more than the sum of the parts—a grand performance that magically links the art, the artist, and the audience. Black-and-white wedding photography has arrived as a niche in itself. Your pursuit of this ultimate fine-art style can make you a legend.

My intent is to set before my patrons photographs that portray pure pleasure of feelings and happy, memorable circumstances. What looks simple and spontaneous is in fact the result of very hard work. I feel like the artist Henri Matisse, who was quoted as saying, "I have worked for years in order that people might say, It seems so easy to do!" Whether frou frou or tailored, my bride deserves to be memorialized, and her setting transformed by art into a romantic sense of history. I play with light and life against a background of fantasy. I am in the business of making dreams come true.

Resources

ALBUMS

Art Leather Mfg. Co.
ph: (800) 252-5286
www.artleather.com

Art Z (Olson Design Co.)
P.O. Box 6568
Bozeman, MT 59771
ph: (800) 789-6503
www.artzproducts.com

Capri Album Co.
510 S. Fulton Avenue
Mt. Vernon, NY 10550
ph: (800) 666-6653

Leather Craftsmen
51 Carolyn Boulevard
Farmingdale, NY 11735
ph: (800) 275-2463
or (800) 366-2828 (west)

Renaissance
375 West Broadway
New York, NY 10012
ph: (212) 274-8699
also distributed by: Album X,
Levin Company, and others

White Glove
8092 Warner Avenue
Huntington Beach, CA 92647
ph: (714) 841-6900
www.wgbooks.com

Zookbinders
151-KS Pfingsten Road
Deerfield, IL 60015
ph: (800) 810-5745

ARCHIVAL, ARTISTS', AND PHOTOGRAPHIC SUPPLIES (retailers)

Daniel Smith
4150 First Ave. South
P.O. Box 84268
Seattle, WA 98124-5568
ph: (800) 426-7923
www.danielsmith.com

Dick Blick
P.O. Box 1267
Galesburg, IL 61402
ph: (800) 828-4548
www.dickblick.com

The Jerry's Catalog
5325 Departure Drive
Raleigh, NC 27616
ph: (800) 827-8478
www.jerryscatalog.com

Light Impressions
P.O. Box 940
Rochester, NY 14603-0940
ph: (800) 828-6216
www.lightimpressionsdirect.com

New York Central Art Supply
62 Third Avenue
New York, NY 10003
ph: (800) 950-6111
www.nycentralart.com

Pearl Paint
308 Canal Street
New York, NY 10013
ph: (800) 221-6845
or (212) 431-7932
www.pearlpaint.com

University Products
517 Main Street
Holyoke, MA 01041
ph: (800) 628-1912
www.universityproducts.com

ARTISTS' SUPPLIES (manufacturers)

Lacquer-Mat Systems
6816 Ellicott Drive
East Syracuse, NY 13057
ph: (800) 942-2223

Seal
550 Spring Street
Naugatuck, CT 06770
ph: (800) 257-7325

SpotPen
P.O. Box 1559
Las Cruces, NM 88004
ph: (505) 523-8820

FRAMING SUPPLIES

Gross National Products
ph: (888) 372-6346
www.gnpframe.com

Larson-Juhl
3900 Steve Reynolds Boulevard
Norcross, GA 30093
ph: (800) 438-5031

PROFESSIONAL ASSOCIATIONS

Professional Photographers
of America
229 Peachtree Street NE
#2200 International Tower
Atlanta, GA 30303
ph: (800) 786-6277
www.ppa.com

Wedding and Portrait
Photographers International
1312 Lincoln Boulevard
Santa Monica, CA 90401
ph: (310) 451-0090
www.wppinow.com

ON-LINE E-COMMERCE POSTING/ ORDER FULFILLMENT COMPANIES

Collages.net, Inc.
930 Town Center Drive G-40
Langhorne, PA 19047
ph: (267) 572-5000
www.collages.net

LifePics, Inc.
5777 Central Avenue #120
Boulder, CO 80301
ph: (303) 413-9500
www.lifepics.com

PartyPics
1300 Metropolitan
Oklahoma City, OK 73125
ph: (800) 336-4550
www.partypics.com

Pictage
2447 Pacific Coast Highway #101
Hermosa Beach, CA 90254
ph: (310) 318-3885
www.pictage.com

JUDGING INFORMATION

I evaluate the effectiveness and longevity of photographic art in terms of what I call the "triple A relationship"—a triangular framework of communication between artist, artwork, and audience. Schooling the eye for the comparative process of judging is done by looking open-mindedly at a huge number of images of all types and mediums, and then continually analyzing and discussing. Visit my website, www.photomirage.com, for insights about the nature of judging photographs and its common problems in relation to the art world.

Selected Bibliography

Alexander, Christopher. *A Pattern Language.*
New York: Oxford University Press, 1977.

Allard, William Albert. *The Photographic Essay.*
Boston: Bulfinch Press, 1989.

Bartlett, Larry, and Jon Tarrant. *Black & White Photographic
Printing Workshop.* Rochester, NY: Silver Pixel Press, 1996.

Carr, Kathleen Thormod. *Polaroid Transfers: A Complete
Visual Guide to Creating Image and Emulsion Transfers.*
New York: Amphoto Books, 1997.

Chihuly, Dale. *In the Light of Jerusalem 2000.*
Seattle: Portland Press, 2000.

Christo and Jeanne-Claude. *Christo: Surrounded Islands.*
New York: Harry N. Abrams, Inc., 1985.

Constantino, Maria. *Georgia O'Keeffe.*
New York: Smithmark Publishers, Inc., 1994.

Davis, Phil. *Beyond the Zone System.*
New York: Van Nostrand Reinhold Company, 1981.

Gassan, Arnold, and A. J. Meek. *Exploring Black and White
Photography, 2nd Edition.* Madison, WI: Brown & Benchmark
Publishers, 1993.

Gross, T. Scott. *Positively Outrageous Service.*
New York: Warner Books, 1991.

Hemingway, Ernest. *Green Hills of Africa.*
New York: Simon & Schuster, 1963.

Hurley, Gerald D., and Angus McDougall. *Visual Impact in
Print.* Chicago: American Publishers Press, 1971.

Meyerowitz, Joel. *Cape Light.*
Boston: New York Graphic Society, 1981.

Nechis, Barbara. *Watercolor from the Heart.*
New York: Watson-Guptill Publications, 1993.

Néret, Gilles. *Matisse.* Cologne: Taschen, 1999.

Neuhart, John, Marilyn Neuhart, Ray Eames, and Charles
Eames. *Eames Design.* New York: Harry N. Abrams, Inc., 1989.

Newman, Arnold. *One Mind's Eye.*
Boston: New York Graphic Society, 1974.

Phillips, Bill, and Michael D'Orso. *Body for Life.*
New York: HarperCollins Publishers, 1999.

Ratcliffe, Carter. *Sargent.*
New York: Artabras NY Cross River Press, Ltd., 1990.

Syers, Dorothy. *Busman's Honeymoon.*
N.p.: Harcourt Brace & Company, 1937.

Waldrum, H. Joe. *Ando en Cueros (I Walk Stark Naked).*
Bosque, New Mexico: Chinaberry Press, 1994.

Wharton, Edith. *The Age of Innocence.*
New York, 1948.

Wildi, Ernst. *Achieving the Ultimate Image.*
Buffalo: Amherst Media, Inc., 1998.

Wohlauer, Ron. *Eye of the Storm.*
Boston: David R. Godine, 1984.

Index